Praise for *There Is No Year* by Blake Butler

"Deeply honest and emotional, a family drama that by its end brings on feelings as complex and satisfying as those summoned by Faulkner's simple sentence 'They endured.' . . . This novel is a thing of such strange beauty [that it yields] the rewards that only well-made art can provide."
　　—Joseph Salvatore, *New York Times Book Review* (Editor's Choice)

"There is no novel like Blake Butler's *There Is No Year*. . . . Butler's prose is persistent and perfected, and he's able to sustain the shape-shifting narrative for four hundred pages. His sense of humanity bleeds through the jagged edges, and by the end you've fallen for this nameless, deteriorating family, hoping it will survive. . . . Unexpectedly riveting, totally original, and frequently funny."　　　　—Tucker Shaw, *Denver Post*

"A smoke signal on the horizon of the American literary landscape. . . . [As] if Gertrude Stein wrote the script for a Kenneth Anger film set inside of a Norman Rockwell painting to be produced for YouTube with a John Cage soundtrack. . . . [Butler's prose offers] ecstatic pleasures. . . . It bursts and cracks with inventions and constructions."
　　　　　　　　　　—Wyatt Williams, *Creative Loafing*

"An experimental prose-poem [that] pushes the boundaries of the novel. . . . Calling Blake Butler's *There Is No Year* a novel is akin to calling René Magritte's *The Treachery of Images* a pipe; both works subtly expand the framework of their respective disciplines by challenging an audience that has solidified its expectations after centuries of familiarity and repetition. . . . Butler seems to be making a statement that the novel, as an art form, needs to start tearing down walls and moving in new directions if it is going to survive. [In doing so,] it helps to illuminate a path toward more liberated forms of artistic expression."　　　　—Josh Davis, *Time Out New York* (four stars)

"Butler's sentences are frequently dizzying and poetic, and gathered in engrossing vignette-like sections. . . . A challenging, Dalí-esque spin on the horror genre, a postmodern playground . . . *There Is No Year* is also often funny and insightful, further pro~~~~~~~~~~~~~~ssive and innovative talents."　　　　　　　　　　　　　　　*~ago*

"Dystopian and sinister."　　　　　　　　　　　　　　　*~lon*

"Hypnotic, incantatory."　　　　　　　　　　　　　　　*~us*

"Wild [and] poetic."　　　　　　　　　　　　　—*Time Out New York*

"All words normally used to craft literary reviews fail. This is an entirely original work that does what the best art should do: challenge the reader. The novel is like a 4G version of fiction, if you will. . . . There are also all the elements of a more traditional book, with fully developed characters, mystery, and movement that readers enjoy—and an evocative narrative voice sustained for four hundred pages. Butler takes his ingredients and renders them into a dreamlike whorl, a highly stylized read that serves quite well as a metaphor for our new digital age. And like the best of dreams, *There Is No Year* also sticks in the brain long after the book is set down."
—*The Atlantan*

"An innovative masterpiece. . . . A haunting glimpse into a parallel universe."
—Gina Angelotti, *Metro*

"Blake Butler, mastermind and visionary, has sneaked up and drugged the American novel. What stumbles awake in the aftermath is feral and awesome in its power."
—Ben Marcus

"Butler writes about domesticity with a startling, ruthless truthfulness, absurd and deadpan in one breath. . . . [The result] feels unlike anything else being written. Butler has been a powerful force in contemporary literature for the past four years, [and] *There Is No Year* provides further proof that his own fiction is about the most breathtaking and exciting that's out there."
—Colin Herd, *3:AM Magazine*

"An acid burn of a lucid nightmare. . . . Accessible, rewarding, and engaging. . . . Undeniably worth the effort."
—Candra Kolodziej, *The Stranger*

"If there's a more thoroughly brilliant and exciting new writer than Blake Butler . . . well, there just isn't. I've literally lost sleep imagining the fallout when *There Is No Year* drops and American fiction shifts its axis."
—Dennis Cooper

"An artfully crafted, stunning piece of nontraditional literature. . . . The distinctive writing style and creative insight into the minds of one family deserve analysis."
—*Library Journal*

"An endlessly surprising, funny, and subversive writer."
—*Publishers Weekly*

"[Butler's work is] wild but elegant and smart. . . . [It] demands to be read."
—Roxane Gay, *The Rumpus*

About the Author

Blake Butler is the author of the novel *There Is No Year*, the novella *Ever*, and the novel-in-stories *Scorch Atlas*, named Novel of the Year by *3:AM Magazine*. He edits HTMLGiant, "the internet literature magazine blog of the future," as well as two journals of innovative text, *Lamination Colony* and *No Colony*. His writing has appeared widely online and in print, including in *The Believer*, *Unsaid*, *Fence*, and *Vice*, and has been short-listed in *The Best American Nonrequired Reading*. Butler lives in Atlanta and blogs at gillesdeleuzecommittedsuicideandsowilldrphil.com.

Also by Blake Butler

There Is No Year

Scorch Atlas

Ever

NOTHING

A PORTRAIT OF INSOMNIA

BLAKE BUTLER

HARPER PERENNIAL

NEW YORK • LONDON • TORONTO • SYDNEY • NEW DELHI • AUCKLAND

HARPER PERENNIAL

HarperCollins books may be purchased for educational, business, or sales promotional use. For information please write: Special Markets Depart-ment, HarperCollins Publishers, 10 East 53rd Street, New York, NY 10022.

First Harper Perennial edition published 2011.

Designed by Justin Dodd

Library of Congress Cataloging-in-Publication Data

ISBN 978-0-06-199738-9

11 12 13 14 15 OV/RRD 10 9 8 7 6 5 4 3 2 1

For Heather
& for Cal

In memory of
David Foster Wallace

There is no syllable one can speak that is not filled with tenderness and terror, that is not, in one of those languages, the mighty name of a god.

—Jorge Luis Borges, "The Library of Babel"

Everybody has a song
which is no song at all :
it is a process of singing ,
and when you sing ,
you are where you are .

—John Cage, "Lecture on Nothing"

The gateway to the invisible must be visible.

—René Daumal, *Mount Analogue*

THE HOLE INSIDE THE HOLE INSIDE THE HOUSE INSIDE THE HOUSE

Days

Into the version of the sky above my house one afternoon when I was twelve, the nearby high school released a flood of pink balloons. Maybe fifty head-sized shapes allowed to rise and flee inside the light inside the day, until they landed popped by heat or puncture, or, in time, lost their buoyancy with age. Each balloon had a message tucked in its insides, I'd heard—handwritten dispatch penned in private by whoever blew it up. Some touched down on local lawns and in the streets around the school, though most continued further—their latex bodies trailing out into the outlying air, becoming anybody's, gone.

One particular balloon, I later noticed, having found no others I could claim, became caught in the high branches of a pine over my family's neighbors' yard—too far to climb to or to lob a stick at. No one else seemed to have noticed. I knew at once I needed this

as mine—that I *had to* read the words cribbed inside it—*they were for me*—words no one else would ever see.

All that day I lay in wait. I watched the balloon above me watch me watch it. Through binoculars it seemed somehow even farther off. I held still in fervent patience. I do not remember any birds. I felt no time go by until there was no longer light enough outside to discern the tiny shape among the trees' limbs, their mass a dark relief on muted skyface pale with diffuse human glow. Even then I stared into the outline—I had to be made to come inside and leave my secret thing in the unseen.

I don't remember anything that night about my sleep or dreaming. The time between the day and day again is void. Most all nights up late alone in homes seem shaped this way—unremembered beyond a gloss that holds the darker hours all together, an edgeless orb.

The next morning the balloon had disappeared: popped against the branch bark, perhaps, or blown off elsewhere, what direction. The trees stood smug in morning calm. They knew and would not speak—or anyway, I did not ask, and found no remnant on the ground beneath them. The surrounding air and dirt went on so far, among continually diminishing horizons. The words in my balloon remained any words—sentences hid from me and sent instead into another, or to no one—symbols eaten by the light. What those words inside me could have said, I wonder—where or what I would have gone or been today having them absorbed— somehow ending up another person—smarter, further—this, gone forever. And still, here I am. Now.

Such kind of aimless mental spin—all without answer—is the kind

so many nights that keeps me up long after I lay down, stuck in inevitable fixation over nothing, pointless thinking—the day again once come and gone and nothing new—each day passed the way that days do—walls, windows, websites, faces, food—each repeating in no obvious pattern, without pause. This thankless thinking thinks itself, and begets in its wake only more frames in frames, doors to nowhere, filling the days.

What's worse is that I'm certain had I managed somehow to find a way to get that balloon, unveil its letter, I wouldn't now remember it at all. Instead of words that changed my way they'd be more junk among the whatever, a useless blip, in the make of every other hour crammed in clicking by transfixed. Likely I wouldn't even remember the day of the release of the balloons either, or all my want about that certain one, or how the sky since then seems at once that much more flat and deep—so full with all the light and what it's sucked up that most nights it appears absent of all stars beyond the biggest, framed with human-given names.

Beneath this shifting veil, like under eyelids, we people keep our own shapeless array—a moving, needing human network without center. Each day the numbers in the cities rise, bodies pushed from bodies in the hours, screaming, new blood—our flesh mass rising on the hour despite the other bodies becoming popped or shriveled up with age like the balloons sent nowhere—the masked stars burning out on their own gas—any of us nowhere, really, ever, among it, except *now* and *here*—unless we trust the likewise rising mass of relics of what we've seen and thought and felt and said, days transcribed in shapes and symbols arranged and rearranged each in small dementia among the same containing air of earth—a continuous, insurmountable revision of what was and is and will be, of the dead.

And with each hour, more newborn people, *babies*, more bodies having passed, *unto the soil*, twin tallies rising higher on both sides, each new layer's residue applied by act of simply passing in time's silence, under the replication of the image of our selves: the films and the recordings and the buttons pressed and who when where, the shed skin and hair and teeth, the sperm and egg, the seas. Each in our own head our thoughts surround a *me*, each mind the center of a version of a version of the world, surrounded, packed in side by side in air and days. Each day more input, output, from each body—the more awake the more confined—while the volume of the earth's air remains the same, each location grown engorged with psychic fat—histories of happenings and gatherings and births and deaths of heads, the names and limbs and numbers—each in their own way become covered over, no one, a further rung of what.

]

]

]

That same year as the balloons, as if in mourning, some day I hid a white box under the ground. I'd gotten it in my head, maybe from TV, to make a time capsule, something to hide and so preserve, though I hadn't yet begun to think of days as disappearing. My selection of what went in was rather rash, selected from the growing archives of crap collected in my closet—I could never bring myself to not hold onto anything a day gave: ticket stubs, postcards, used utensils, notes I wrote to myself inside my sleep. Into the box I placed an address book full of names and numbers

of the people that I knew. I put in a softball signed by all the players of my older cousin's league, all of them strangers. I put in a ream of dot matrix printer paper covered with error garble, which the machine would eject in malfunction sometimes in the night, and which I always found myself entranced by. I put in a ring I'd bought from a garage sale that would open to expose a little hidden space, in which for some reason there was a hunk of resin. There were other things I buried, I am sure, though I can't remember. I think I thought I'd hide these objects underneath the soil, leave them there for years and years, maybe for a future version of me to dig up, or maybe I imagined I might die and this would be my archive—this crap.

But I couldn't wait that long. Maybe four months passed before I went and unearthed the box myself. I found the plastic lid had cracked. Grubs and dirt stunk in the folds of what I'd hidden, and there was moisture. The stuff inside had grown a little mold. Instead of joy the relics had turned nasty. I had to throw the whole thing in the trash—except the ring. I think I kept the ring, the one thing not mine, though I can't today remember where it is. So much I can't remember, and can't remember to wish that I remembered, and you and yours, and all in all and on and on with each day, repeating hours piling up unseen. It only grows.

Among this casual prolonged squashing, we learn to hide inside the sound because we must. Today while bored looking through websites about torture—my own blank often evoking an inert want to see the worst—I notice how many common modern methods used on captives often sound like hours in our cities, if reframed: *Forced positions, Prolonged standing, Continuous exposure to bright light or noise, Witnessing torture of others, Cold exposure, Solitary confinement,*

Threats,[1] each practice by now normalized to seem for the most part simply part of the experience of urban life. It is a feature of our survival via numbing, ignoring, contextualizing, counteracting this silent blitzing—by sleeping, eating, drinking, laughing at the jokes—that the more minor daily tortures are made common, incorporated, even loved: skin of advertisements, entertainments, socializing, awe of money, unique objects, motion, the expectation of the wish of wanting more. With the internet now too we can at any hour access electronic versions of anything all at once—speech feeds of the bored or awake or paid or lonely or aspiring or horny or worshipful and more; databased images of explosions and sick and murder alongside the shopping and the family albums and the free games; avatars of family and strangers and friendly fronts of corporations; boundless text and sound and image of what might have otherwise remained covert—and each hour only growing, fed by countless bodies pressing buttons at the flat face of millions of machines.

Over time, in such consumption, the body suffers—in aging, thinning, breaking, building calluses, or bruise—each angle of which serves to disrupt quality of sleep—our only temporary exit—and thereby over time further emphasizes those distinctions through exhaustion. Our attention feeds through totems toward the hole. The product of prolonged lost rest in effect operates against the body again like torture or dementia: *Anxiety, Depression, Fear, Lability, Introversion, Lethargy, Fatigue, Loss of memory, Inability to concentrate, Sleep difficulties, Nightmares, Headaches, Visual disturbances, Vertigo, Paresthesias, Sexual disturbances.*[2] These rup-

1 From "The Most Commonly Used Torture Methods Applied to Victims Seen at the Danish Centre for Rehabilitation of Torture Victims" (Roth, 1405).
2 Ibid.

tures gather in gross packets, one feeding another, causing one's defenses to become numb or dull while still aware, and opening the flesh to sickness or predator, toward death. In the daily gush the waking hours often may seem to feel more like one's sleeping and one's sleeping held more shallow, ruined, awake.

It must come in, too, through the blood. There's something inherent in our human aspect that feeds the will to make and want and make and want and still need more—that same gush that drives us among others to want something where there is nothing, to want calm where there is noise. Often we become bored when the familiar ways no longer seem to hold some unnamed magic—some unconscious chance it might explode or shapeshift right in our hands—glee of the new—though this is also the kind of repetition that makes us feel comforted, lets us rest. The further waking of the wanting comes on often as a product of itself—a taste of the unknown or glee or terror causing in the body the birth of a receptor that now requires it be fed—or to be buried—lacing the familiar with something slippery and alien, driving—the object filling out its name and not the other way around.

]

]

]

Often as an infant I would not recognize my mother in the night. She would come to me there in my crib and see me screaming, skulking from her as she stood. She'd reach to lift me up and I would cower, a bright terror mirrored in my eyes. Other nights

she'd find me walking blank along the hallway, lit unconscious. In the living room I'd stand and shriek, "I WANT MY MOMMY I WANT MY MOMMY." *I am your mommy*, my mom would say, in a younger version of her current voice, and yet transfixed inside of nowhere, she was no one to me at all. Other nights I'd wake to find myself having moved inside my sleep to different rooms, or upside-down or backward on the mattress, or underneath it, not knowing what I'd done.

Today, when I ask my mother about my young sleep terror, she reenacts me walking backward from her in the low light, her eyes stretched wide, mimicking mine. My mother in recent years has been getting shorter, her size sinking back into itself. Seeing her perform the reenactment even now to me seems horrific—the idea still vivid enough in her I can almost see who she was then in her eyes. The years have not stuttered her recall. Her skin is paler, her fingers thin. Her silver hair reflects all light. Her eyes are just the same. In my asking how I'd been then, in my sleep trouble, she describes the way I seemed unable to see her there before me, how I seemed to not even see the house. "Terror was real to you and that was it," she says, her other self there just inside—the other selves of all of us surrounding all of us, each of us at the center of our own being, each aging in our own frame, sprawling forward into each instant going, gone; every minute the most packed minute, the furthest point along the curve.

After explaining my young terror in her language, my mother goes to look more for the baby books in which throughout those years she wrote us down—sentences rendered in her looped handwriting, making claim of what she'd feed me, how I'd laugh. It's a practice she still has not given up—each evening before bed now ends

with her writing out the full day of her life, word by word. She is often up late into what is called the witching hour, sewing, singing, awake alone in the house, as my father has always been prone to nodding out early. My sleep complications, as is so much of me, are likely sewn from her: aura transferred into flesh in bridging time— a pattern printed on the lengths of lymph that make my brain and lung meat, which, if I decide to mate, I may too funnel into another body, here, a child. My mother's journals—there must be a dozen of them now, each fat with ink and clippings from her hands: I already feel my skin tightening against me at their existence, as my incessant selves insist on realizing how one day, under the event of a thing I will not name here, those pages will become a tunnel back through and into her, her own sleeplessness, her longing, her days in step and click—the words the image of her thoughts and ways and ideas given from her as each day passes, written into text instead of me—as for every instant I am not there, her child, or anything I was not there for her to say, will be another wall that breaks my body in a maze that will not end.

]

]

]

Whereas sleep may be an exit from the hours, a temporary forgoing of our ability to respond, while unconscious we are alarmless until something breaks the seal. By earliest definition, in the first edition of the *Encyclopaedia Britannica* from 1771, sleep is the body "perfectly at rest, [where] external objects move the organs of sense as usual, without exciting the usual sensations." Here the

body forgoes of the silent suspicions of the terror, such as of the many openings in any home: those we recognize and center around (windows, doors, and vents); those we in certain times attend to, incompletely (entrances for insects, rodents, wet); as well as those we imagine perhaps somewhere, those we never know (dream holes, fantasies like Santa's entrance, power connected via wires and other air); through these holes come the outer air; the sound and light each night drunken into the prone body, feeding. As well, the house around you goes on unwatched. We assume by default that nothing shifts under our absence, inside our body, still right there—no shift of drawer or door, nothing unforeseen rising up or breaking in among the night. We relinquish all control to sleep, slow pulsed and breathing, off but open, taking in.

All throughout this, somewhere in here, in us each the *me* goes on: the mechanism at the center of the meat. The me becomes a thing in us that there repeats—a module both automated as a flesh thing and in full selecting larger motions as we do each instant what we do or do not do: fidgets, scratching, walking, thinking, talking, looking, and so on. The repetition of repetition of the trending patterns of these actions makes days seem nearer, more ours, in our own image, less a clothing, more a skin, from more general preoccupations (rising, working, marriage, travel, ideas, passing on our names), down to smaller, taste-based gestures (humor, impulse, preference, pleasure routines, habits of how to sit or stand). Comfort comes in copied action as it makes our surroundings feel like somewhere we have been. The self emerges through holes in the self's body as speech and gesture, spatial relations with the bodies and objects in our field, the days of trees and heads and houses, of glass and clothes and our machines we select to make the space around us seem slightly more like ours.

For years when renting movies with my family as a child, I often picked the same tape every time. Among the reams of new and unseen, I wanted the one I already knew I liked, and anyway each time it could seem a little different, little bits picked up different or from other angles or burned better with reiteration. The movie, as it stands, was *Flight of the Navigator*, a Disney picture about outer space. We must have paid to take the thing home at least several dozen times, never bothering to pick up our own copy—sticking instead to the versions shared with all the unnamed others having had it too in their own houses, touching what I touched on the cartridge, doing what they did before the screen. As an adult now, despite the repetition, I can't recall more than chunks about the film: something about a kid inside an alien orb guided by a talking machine eye; the boy's body shuttling through time, ending up returning to a future version of his home having been thought disappeared, his family all quite aged. The story in my mind beyond that basic outline is all a blob, lost among junk I've watched and done since then. Even all that seeing, wanting, staring, did not bring the thing inside me, beyond my knowing of its entrance; though it is in here, somewhere sleeping—it has been part of my body and will be and is and is.

Also inside the video store was an aisle labeled Horror, which I remember mostly for its long array of sequels of *Friday the 13th*, a finite but sprawling archive of oblong dark cardboard cases in numbered order, which, assembled as one body, freaked me out: Part One's image of a hollow torso holding a blood-lined knife, its innards replaced with the image of a forest, four smaller bodies looking back into my gaze, a lake, a moon. Each edition spawned thereafter in a version of that same image, a glow on black, sometimes the body full instead of letters and a thick blank, sometimes

simply the image of the mask with the knife stuck inside its eye, or sometimes an intense light gushing from the mask's holes, unholy glow. These black cases and the cartridges inside them held further rooms in replication, enveloping their own odd objects, a new arm waiting to be brought on into any house, though they scared me more by simply being, a doorway waiting through which many others too had passed, doors which made the doors inside my own house seem that much thinner, holding at night whatever passed around there out. Their presence alone in the light of the store kept me awake, left me up late in the hours fearing what could be coming in the silence, something seeming always on the verge.

Of me at two and a half years, my mother writes: *sometimes thinks there's a giant in the bedroom when it's time to go to sleep.* The entry ends there, without interpretation—she does not mention there was not a giant in my room. She doesn't need to, does she? For her to say so on paper might seem insane—might seem, to someone reading, as if she were explaining the idea away for herself. And yet there seems something ominous about the implication—my childish thought unanswered remaining there an unsaid door left open, perhaps leading on into some long hall. The very word *giant*—as opposed to, say, a werewolf or demon, or the vague and yet for some reason widespread young fear of the term *robber*, or whatever other beasts might terrify a toddler—seems particular for its threat of malformation, a shape too large to fit into the house, a thing that coming in would break my very home wide open, shuck the roof off into the night, allowing whatever else might also want in to flood the space there, eternally exposed.

I can't help but admit that all this thinking about the rooms and what is in them makes me suddenly hyperconscious about the

room behind me even now. I don't want to have to let myself turn around and confirm the fact that there is no one other in here—notwithstanding all the rooms beyond this one, through the walls, and on and into other houses, none of which from here I can see. *Why am I in here, what am I doing.* Any instant of any day as an adult one must simply assume there is no giant, mostly before the thought ever occurs. Today, I let me look . . . and of course there's no one, just a bookshelf and a bed, an empty room—the room the way it's always been for years—and yet now I know inside my looking there's this other space I can't see behind my head, the focus shifted—something always left out of the frame—as when the body does its turning, the unseen space behind you is turning too—anywhere, all day. The use of mirrors is problematic in its own way and with its own terror—the deepening, the double. To go on, you must concede—every hour, as a human requires constant unexamined minor concessions, otherwise you'd never move—to attend such things is considered ill—each moment passing all surrounded by whatever in its silence—an irreducible, indestructible, indescribable undefined all through all hours—the ever-spinning, all wide open, unto every instant, any door—a mouthless, baseless, unnamed hole surrounding all holes—god of terror, and of boredom, both. The resulting logic of the need for something palpable, recorded, in the face of any minute, is the same evidence many use against the presence of a god—*where is nowhere—where am I—how can I prove that I exist and still exist.*

Among all these ongoing unrecorded ways, sleep operates as the definitive product of any method of want for rest—another fleshy house with unlocked doors always impending. We nod out to allow time and space to feed, regroup, turn off. A restriction from this wallless, doorless room—insomnia—which might turn on under

a variety of means—denies the body of its respite, turns the flesh sickly, makes disruption of the brain, forcing the waking body into diffusion, invoking a sleeplike helpless state while still aware. In not finding rest where we would want it, we end up straining even harder after something always the most where nothing is and wanting more—and in the having of something that is not sleep, never coming to feel quite full—wanting more doors to the house to fill the house with, ever-expanding, giving deeper presence to something that isn't there. Even the fear of having trouble sleeping, or the fear of the fear of it, the fear of drifting off into something stuck beyond our self, the want for nowhere, for a silence, becomes stronger, fills through the body via the same corridors of emotions such as want or love.

As if in wish to precontrol such ways of access, at age three, I would refuse to leave the house without a ring of keys. I'd see my parents need their keys to open doors and wake up machines and for this I knew I would need them too. My mother issued me a white loop with several differently colored and oblong chips of plastic forming toy teeth rounder than my thumb. The keys directly locked or unlocked nothing, and yet with their shape inside my pocket I felt I could open any door that was not there—the doors the house was hiding—locks I meant to keep locked or unlocked, or to lock or unlock soon in the future. With these keys too I'd open other portions of the earth. I would rub the nub of the green key against the end strut of a shelving unit at the grocery store and hear the sound of some whoosh burst from my mouth. I would insert the red key's tip into a knothole in a bit of backyard fencing and feel through my body where a space had opened up. I spent many hours in the evenings also with the keys shoved in my mouth, sitting around sucking on their ridged sides

one after another or in fat packs, after the keyhole in my head. That these keys all did actually open something I feel now rather sure—though at the time their potential and perhaps their false form held me imagining my body locked, helped me move pleased and safe among the unnamed air.

Every inch of me like these my mother transcribed in years before I in my own head can remember has been somewhere inside me ever since. So much of this I would not have recalled without devices, the photographs and speech. I only know what I have done so many days and hours of my life because there is the image and the word passed on, held in totems, symbols, other bodies. Most of these moments remain unnamed. The day passes fast and silent, unseen. Even up to here inside this sentence, typing, there are minutes having just blipped by that I will never think about again—this instant my *right now* and then my *gone*, and the instant ever-coming, still there buried in the blood, and cropping up in glossed ways in incidental scrimmage or in my sleep brain, where all days feels the same day, and how a house at night might seem to pause. I do remember countless nights when, alone, still up haunted by doors or tapes or thinking well after my parents had killed the lights and gone to bed, I lay still inside the air holding my own breath, gauging our home's false-seeming sense of silence for any small intimation of sound, watching the empty space for what might suddenly occupy it—the blank by now far more terrifying than the touch. In such a way I could not go to sleep some nights until the light had risen up again and my parents were moving in the house around me, proved again alive, and light filled again the spaces of the night surrounding, *night not gone but covered up*, always in the process of returning, the body aging, growing tired, *sometime sleeping*. The house around us going on.

I can remember with equal prowess standing as a preteen in the large open room of the library we always went to with my mother down the street—in particular a day of warm light in which I stood near the main room's center and looked along a shelf at where someone had propped a hardback copy of Stephen King's *IT* so that it stood to face the room. The way the title—large blood-red letters, all caps—seemed to brand themselves upon my eyes, and above that, the coal-gray, also all-caps letters of a man's name against a nothing. The image of the sewer grate—an open mouth into some tunnel. On the book's back, the huge replica of the creator staring back at my own head. That day I carried the book out to our Buick against my chest, feeling its weight sat on my lungs in presence, and something itching at me through the pages, which by peeking into with my breath held, I'd see the pages all those other fingers before me had already touched. Maybe bits of hair or food or oil in there, even, though that I don't remember. I remember the plastic sleeve over the dark jacket, making the book's face seem as if removed from what it had been once: a copy of a copy, under glass. Back at home I took the book to my bedroom and I locked the door behind me. I sat at the desk installed into an alcove in the wall and laid the book down at the center under the long fluorescent light. For some long period in its presence I could not bring myself even to move. I could not lift the cover. I sat before the book and looked. I went and lay down on the bed and felt the book seeing me not looking. At some point I might have gotten up and tried to read the first sentence, tricking open: *The terror, which would not end for another twenty-eight years—if it ever did end—began, so far as I know or can tell* . . . All throughout the night the book was there. It was not changing. It could see. The whole evening went on this way. And late into that evening, when the light through windows turned to nothing leaving the neon bulb only to shine off

of the horrid fat thing's sleeve. And even with that light off I could not sleep with the book still there, unopened, worming its way into whatever future sleep sometime might try to come. To this day the book remains in me unread, the first of many objects seemingly having been designed to keep me awake, aware, forever, a shapeless presence feeding itself on itself inside my flesh.

And as more time comes and is and is, each day gives us more of us to hide, more crud to exist with in the same space we walk around in every hour, more terror welled up in the self itself. Soon and for years inside the night with walls around me I found I could not bring myself to face a mirror in the dark, seeing not the mirror or me in it, but the space where I knew the mirror there must be, its reflection hidden, something unnamed caught behind its glass. Other evenings I would find it hard to look out through a window, sensing people out there walking past the house, or watching cars churning by onward to wherever, people soft beneath the windows sitting there in the machine, people I would never come so near thereafter—each night in this way the same shape, spent repeating—the present, passed again—if there among it somewhere, in the passing, a silent common air, an indexed map—space through which the shape of who we are each instant in our aging must come and go, while in the shifting light we hope to sleep and wake a bit and sleep again. Among such shifts the sleeping keeps us cleaner, allows brief repose as the air of all around goes on alive, underneath us and surrounding, in all houses: a spreading corridor of furtive magic masked in the common, any day—an instant stretched beyond its present as when (a) approaching a room's mirror, the lurch between the act of expectation and the seeing of the self; (b) the text of all the books surrounding, never opened, in any home or store, those sentences in terror silence; and as well, the words

slipped by the mind when in really reading, the mind blanks out, and *still can see*; (c) the milliseconds surrendered between blinking, which when added up assume a portion of one's life; the brutal intrusions of fact; (d) the frequencies of sound we cannot hear but that come against our skin and in our ears regardless; (e) the presences behind all walls and walls unseen, within inches without seeing, and contained as well on all our film; the body behind the window in the scene inside the film we've seen the most, and the film we fell asleep in, and the film we've never seen; (f) the groan of trees, the scream of meat; (g) the corridors of sleep space left unremembered, or as fragments, drowned awake; the unlisted (h) and (i) and (j), and going on and subdividing further, beyond (z)(z)(z)(z)(z)—all of this surrounding every hour, smushed and smushing, in an air-shaped kind of frameless case, the skin and cells we walk around in, hovered among days.

And still the selves go on regardless, aggregating, blanking.

And still the self itself cannot be seen.

NOTHING

"You just arrive in a place," said the painter, "and then you leave it again, and yet everything, every single object you take in, is the sum of its prehistory. The older you become, the less you think about the connections you've already established. Table, cow, sky, stream, stone, tree, they've all been studied . . . a vast ornament of space, nothing else. Humble backgrounds, vast replications—you see you were always lost. As you get older, thinking becomes a tormenting reference mechanism . . . I say 'house,' and I see cities with their seas of roofs. I say 'snow,' and I see oceans of it. A thought sets off the whole thing."

—Thomas Bernhard, *Frost*

What a House Is, How a Body Fits Inside It

The initial wanted instinct upon first hitting the pillow is to be

blank—as near as possible to nothing, silent, sloping open to the night. For many, on normal evenings, the effort ends where it begins. There is no deliberation. The door opens, becomes gone. If I'd never slept near other people, on road trips in hotel rooms with friends who hit the pillow and instantly black out, I might have never realized my dysfunction, despite night never seeming right: always most awake at points of ending, then rising tired to the world—a continuum reversed. Whereas for some sleep is a question of becoming horizontal—entering *the rest afforded by a suspension of voluntary bodily functions and the natural suspension, complete or partial, of consciousness*—for others, when we hit the bed, the head begins; the brain coming on inside the worn down body as if to spite it, to remind the flesh that it contains something inexpressible, uncontainable, to itself; the persons hid inside our person coming on at our softest moment, ready, at last, to reign. The brain inside this shape might seem to seethe against the inside of the skull, warming hard against the pillow in the gel of uncontrollable impending thought: the body's fleshy defense defused by its own system of alarm. *Hello*, it says. *How are you. I knew you'd come around. Here you've been pretending I and all the thoughts you've been avoiding weren't here, or could fuck off. Now you're tired. Open. Now you're mine.*

Prior even to the laying down for sleeping in want of blank mind, the house and what it holds go on and on. The walls, doors, ovens, knives, etc.; they don't sleep, and do not wish to. They are there. In each room, each inch and object holds a hundred thousand potential questions, each of which might overlap: who why moving in what space and who before them and who before? Even in homes sequestered to their own walls, sharing nothing, there is the residue of shifting forms, the sounds that move within a house at night, those other people there, awake. There is place and there is time

though both are always changing. Regardless of to what degree one may or may not attend these minute methods of every hour, they remain alive, awake around the body.

The bulk of any house is made of air. Subjects in sleep lab testing procedures have been found, out of their usual element, to exhibit the same mood and personality shift whether they had trouble sleeping there or not, despite the fact that the unsleepers did indicate higher heart rates, higher body temperatures, and accelerated nervous systems.[1] Even lab rats, when placed in cages previously occupied by other male rats, have been found to experience a longer period of sleep onset (fifty-nine minutes versus an average, regularly thirty-two) as well as hyperaroused EEG recordings.[2] In humans the subjective complaints are more difficult to read, even from inside the self, and yet the space of where we sleep, regardless of internal condition, clearly distinctly matters. Upon the air, beyond its elements, there travels sound and light and the unseen: cells we breathe in without knowing, cycled among the buildings, over years—dust of human, breath of human, hair of human, bacterial surge—as well as the flood of signals beeping back and forth between us, communication of the objects, silent speech—transmission, higher pitches, the presence of a presence, or the idea of the presence, or the intimation of something coming nearer, waiting.

Sound: we give names to anything in ways we share, or the tremor of an object's wobble, or system of the night. In their later years, my grandmother knew my grandfather still stayed around her in the evenings after he had passed, hearing his breathing, a residual

1 Bonnet and Arrand, 9–15.

2 Ibid.

of what was so long known. Children might be soothed to calm by music playing, as if the sound itself is someone there, or perhaps designed to cover up the teeming billions of all others looming in a silence: how much more terrifying a house can be when nothing's moving, as if every instant is the instant before some awful lurch. Even there within the pillow, if one listens clearly, there is the encroaching sound of some parading ream of drums, a rhythmic echo pushed out from the body into the pillow, the intoned heartbeat replayed into the head. Every bump or blow or itch of room around the body is magnified by several times. Most nights I run a white noise machine beside my bed: a singular screen over the stutters of the surrounding of the night. The context of the sound carries its purpose: if I am its master, it might sing to me, while if it is beyond control, it owns my air. A perfect silence might seem ancient, graceful, though also, by its facelessness, in some, a menace, aimed to eat, pervaded as by a thing that shines too bright.

And therefore, *Light*: in each phase of those nightly nighted hours, there looms the premonition that the sun will not come back—that, in its burning, it will burn up at last, those last hours therein unknown for how the light still travels across such time—and thereafter leave the breadths and widths of our sunk cities therein forever under, wadded, stunned. Light of billboards, headlamps, streetlights and signs and human-held lights briefly unblinking, create false tunnels of the space that seemed so plain and clean in day, the light of passing, turned on rooms and bars and businesses, scanning some small part of the immense face of a dark mountain. Forget the moon and drowning stars, so worn out against glowing that they often appear not at all, or show up dead. At night, the earth does something different, as if underwater, a mottled mirror of the environment of day, as through the same spheres and bowls

and bells of buildings, windows, streets, arches, and cars appear, same in their sinking to the no-light as in any shining, in the night they appear other, covered over, thick. In dark, the new folds to any room, the innards of a previously translucent body become suddenly opaque. We learn to spend most rotating states of light in day and evening as one negotiates the features of a skin, a home. And yet, always more doors. Always odd sounds. Another hole within a hole within a hole, in and around any home, a disease communicable through any body without symptom. Light is that by which we might know or not know what is just beside us. Go or do not go toward. The cloak and the revealer.

In the house I grew up in I was always looking for an extra door: a split or seam or button in the building that had been hid there, waiting to be invoked. Awake late, in the silence, I spent hours rubbing along walls, reaching armlong down an air vent or under cushions, after all. In absence of finding any new surface, I would summon up my own—affixing keys from machines or bits of wires onto the household, waiting for where they might sink in, or digging in the yard for something just there beneath the surface. I dreamt many nights of excavating the whole yard, surrounding where we slept with mud drifts down to nothing, to the center of the earth. A map I drew one year of my mother's parents' house featured a long corridor on the far side of the concrete wall, which I fantasized of finding some way into, never to return.

Other young nights, caught up again in faceless terror, I'd crawl along the floor into my parents' bedroom to curl hunched in the space below their bed. Each evening I would wait a long enough period after they'd stopped watching TV and retired that they might fully be asleep. I was supposed to be by now old enough to keep to

my own bed; as soon as enough time had passed—time I waited through feeling the whole house around me, as if about to shake, I would crawl and wriggle careful along the lip of hallway from my room to their room, each slow inch by inch pushed forward in as close toward zero sound as I could manage—my mother had always been a light sleeper and would often sit up while I was en route, demand me back into my own (not always, sometimes, she let me, she understood), these catching moments requiring me to move even slower the next time I tried, even more silent. It might take twenty minutes moving the eight feet from their door to the stretch along the low foot of their bed—they had a poster bed by this point, king-sized, about two feet off the ground—god it seemed so much taller then than when I go to stand before it now. In the fold of night I would not go underneath the bed but tuck myself just far enough up near its butt-end that I could not be seen from where my parents lay face up above me, closed eyed heads aimed toward a skylight cut in the ceiling, glowing through the room.

Once in position there on the carpet, still in silence, I would begin to position my flesh into some comfortable contortion, bringing my head and arms and body together in minute positioning, still being careful not to move too fast, erupt in sound. This period was often, perhaps surprisingly, the one in which I would most often be apprehended, some shift near the bed itself bringing my mother into sudden awareness of her nearer air. I had to be extremely attentive to each inch of my arms' or thighs' dragged moving, rubbed on the carpet, friction sound. I had to adjust myself, even just to gather the semblance of a sleep position, pull by pull and pick by pick, slowly dragging the extremities and angles of my body into fetal, nighttimey. In that way it might take twice as long as it had taken to crawl from my door to the floor there to get myself tucked

into a half-position I could therein begin to try to eke my way off into sleep, absolved at last of the coiled fervor the house enforced around me awake alone at night except in the presence of my makers. Sometimes I'd manage to drag along a blanket or pillow with me, but often these accoutrements made it more difficult to pass by without being heard, so I would abandon them for simply arriving in that blank-of-terror space. There—slow, careful, as if not underwater but held close against some massive still—there, however many minutes, hours, later—I at last, within and for myself, could sleep—if at the same time teaching my blood to enjoy the elongation, to rest only after some extended vapid thrall. Those were the nights I remember feeling safest, nearest, most open to the sound. Those, of all the nights I've slept, despite the odd shape, were likely hours that, if I chose out of all those I've glued through, would be the ones I would put on pause, and replicate in texture and sound forever, every evening, stretched right as the greatest kind of warming light.

]

]

]

One third of America, at some point, has been locked out of sleep by mind or mood. Insomnia is "the most frequent health complaint after pain."[3] It is twice as common in women as in men until the onset of old age, at which point this paradigm becomes reversed—a swing explained for some by menopause. Though, in general, the

3 Morin, 69.

rule is: the older you get the less you tend to sleep—*our thickening inside more time*—more than half of those over the age of sixty-five suffer the insomniac complaint. For many, enough nights in this thick circling can be enough to make a person, over time, wish for sleep's older, more endless brother mode, the one with a front door we all know how to access: *the big sleep*. Dead and gone. *Death* and *sleep* are used interchangeably throughout the Bible, referring to each as instances invoked by god. That dying brings the same shape of turning off as sleep does—a final, most precise iteration of the mode in which we are truly dissolved of our wants and shifting selves—seems at once terrifying and sublime in the same hold. We can, ultimately, always end our own lives, if life turns to that, another constant door waiting to be opened, if in silence. And we remain surrounded, by so many easy sleepers, in their own bodies. And the more you want sleep the harder it becomes.

According to the *DSM-IV*, Primary Insomnia—that is, insomnia not caused by another mental disorder, a medical condition, or substances—"is often associated with physiological or psychological arousal at nighttime in combination with negative conditioning for sleep." Often it's not even the major presences that keep the circle spinning—the catastrophes, the major loom—as these kinds of motion often move in such broad strokes they sit upon the brain like wet. Two other forms of Primary Insomnia—Idiopathic (related to functions established in childhood) and Subjective (where the sleeper misperceives the sleeping state, feeling awake when not, or in shallow holes)—are also considered learned or conditioned states, not of trauma but sunk into the flesh by make of habit or cellular comprise, rather than in trauma of interaction with the air. Instead, it is more so the tiny particularities involved in those big ones, and the routines, as well as reflexive fleshy response to the

physical effects of no rest: body aches, slowing of reflex and re-sponse rate, jumble of tongue; memory trouble, functional trouble, job absenteeism, higher health costs, depression. These conditions may linger in the body for years, returning even ten years after the main fact of its hold. "In certain respects, insomnia is a euphemism for free-floating anxiety," writes Henry Kellerman in a 1981 study of sleep disorders, "that is, the insomnia is only a symptom of some more serious underlying disorder that can eventually merge in an unexpected form."[4]

A range of secondary insomnias—also termed *comorbid*—come related to extrinsic factors, not necessarily inherent in the flesh. These include sleeplessness as a result of psychiatric, medical, or central nervous system disorders (panic attacks, dementia, bipolar, to name a few—all in all a set of roughly 75 percent of all psychiatric patients—as well as arthritis, osteoporosis, cancer: "Almost any form of brain insult disturbs the sleep-wake cycle, often causing insomnia at night and hypersomnia during the day"[5]); substance dependency (nicotine, caffeine, alcohol, and marijuana being most common); problematic breathing (apnea, snoring); environmental cues (sound, heat, illumination, space); sleep-wake scheduling disorders (circadian rhythm, restless legs and moving limbs); and parasomnias (sleepwalking, night terrors, nightmares, and so on). Paradoxical insomniacs misperceive the way in which they actually are sleeping, and actually are awake, caused by flagrant intensities of the room around them—louder sounds and brighter light. Psychophysiological insomniacs are often held awake by intense worrying of day and sleep and time, while otherwise free of factors

4 Kellerman, 199.
5 Morin, 39–40.

that perpetuate the ruining. The manifestations of these effects also vary in the way they are turned on. There is sleep-onset insomnia, where the entrance to the sleep period takes longer than thirty minutes after head hits pillow; there is sleep-maintenance insomnia, where the subject does fall asleep but can't seem to stay under for more than brief bursts, or wakes early without sufficient time elapsed; there are as well a variety of extremities and mixtures of these conditions, a veritable salad of sleep methods in which the sleep light might be deflected.

There are many common ways by which these sleepless forms might in anyone turn on:

- General physical symptoms, e.g., old age, female gender (especially after menopause), or a history of depression—*a depressive, mothering, ancient door.*

- Abuse of substances such as psychoactive drugs and stimulants, taking fluoroquinolone antibiotics, or abuse of commonly available sleep aids—*a door forced open by the inhuman.*

- High stress caused through anticipation, fearing, health trouble, poor relationships in love or work, thoughts of money, thoughts of career, thoughts of direction of the life—*a craggy, blood-filled hole; a face.*

- Unfulfilled or absorbed grieving for a loved one, even years after the fact—*complex haunting, holes in holes, holes in holes in holes.*

- Mental disorders, e.g., schizophrenia,[6] bipolar, OCD, or as well from neurological disorder in bumping or in lesions, damage—*a room accessed by error, via burp folds in the flesh.*

- Bad sleep conditions, self-inflicted or elsewhere, such as jetlag, and, e.g., light, discomfort, noise—*something burning in the windows, something unsoft inside the mattress, screaming sound.*

- Fear of sleep, from nightmares, or in not knowing, fear of death while in the mind, or of fucked dreams or of unconscious violence carried out on or in the body—*fear of nowhere, nothing; fear of the body left unto itself.*

- One rumor suggesting the presence of flesh-laid parasites causing internal disruption: discomfort, noise—*doors inside us.*

- The internet, or fake light given off of it, or TV—*00101000000110000000000.*

It is entirely the fact of this wide array, and its lack of distinction, overflowing, that there is no one clear culprit for the nature of the loss of sleep. It is an indeterminate disease, tailored per person, if one that might have equally unnamable solutions, ways back out. This, in part, is what makes it so troublesome to nail down, to turn back onto itself, undo. Something inherent in the cells about a person that leads them the wrong way down long halls, certain hours of whole evenings caught under unnameable personal or more general terror overhead—a state of unself-breakable containment, resigned

6 A study of schizophrenics found they sleep on average two hours and twelve minutes a night (Gove, 790), a figure comparable to the sleep of a giraffe.

to a room composed of collaged unwindings of the brain, wherein one cannot so much simply stand up of his or her volition, but must wander for some exit to be sprung, trying drugs or drinks or new behaviors, passed from mouth to mouth and head to head. Each night there in a shifting maze of hours and houses, looking for the door, while in the other air, the body waits. The mind against the mind for too long begging only to turn off. Be briefly gone. Sleep as needed practice, the body surrendering its ache. Sleep as eruption, interruption. Sleep as infernal internal camp, where the mind goes to pour itself out, glee in scramble, torment the conscience at last full in its grasp.

For me, even now, on bad nights, the act of first getting into bed is as if searching for a puzzle into which I can fit my piece—submersion into a shallowing pool that may or may not let you continue wading deep. Arranging the body at contact on the mattress in my strange frame becomes more than simple math. There is a certain combination of pillow to head wherein the right stretches of the pillow's bulk fit well with the space around the shoulders and up along the short curve of the neck, fitting in well also with how the skull curves and where the ear feels cupped but not pressed too hard upon. Finding the correct combination of flesh to stuffing can on some nights come fortuitously, on contact, hitting the right grooves in first coming down, or in early iterations of adjustment. Sometimes it takes a little longer still than this, and the rummaging of pillow, skull, and limbs therein continue, disrupting both the comfort-space of whatever regular bedmate you've acquired and, when alone, whatever pleasance you might have managed to work yourself into before approaching the bed itself.

In addition to the pillow most nights I sleep with an extra blanket

tucked in around my head. First it was the white and yellow baby blanket my mother sewed for me while I was building up inside her, adorned with alphabet letters I promptly ripped off as a young child. I managed to grow so attached to having it there pressed at my ear holes and against my cheeks that I used it most every night until I was twenty-five or twenty-six, clinging to the sound I'd worn into it, all that rub and spit, at which point the thing had been rubbed and rolled and wadded so hard and long and with such heat from my cranium and face that half of it had disintegrated. Its skeleton is sad—a collage of ragged threads and enormous holes, no doubt a colony of sick cells. Now I use another blanket, another my mother made for me, this time out of old shirts I used to wear. Perhaps in hotels or other bedrooms this explains the sudden flatness of that space, the drift or supposition of lying down on something foreign, othered, cells shat into the threads not mine and seething dry. Regardless, the utility of having a whole other surface in addition to the pillow with which to manipulate the comfort of my skull has become vital to my sleep comfort—at home it is something I can't imagine nodding off without—if ultimately a further form of complication, in that it allows me that much more optional leeway, and that many more angles and ways of wadding through which I can customize my resting skull, the beginning of a sliding slope of further and further want for self-optimization, to the point the self itself begins to blur, always making more.

As once the head is secure there is the body. There are the arms, the legs, the hips, the chest—and therein, for each sector, further minor flesh divisions—there are the wrists, the fingers, the feet, the toes, the penis (or what have you), the knees, and so on, each of their own, and shifting in connection to each other. Each element of the body, for me, must seem corrected, made right in its

position on the night, the comfort curling on its surface and inside it as the time around the self nods on. The restless body, rolling, finding partial conditions, in continual correction, begins to feel simultaneously thicker and thinner, stuffed and hollow—like a wet but drying bar of soap, hard at the center, soft around the edges, mushy, comes off on your hands. The fidget begets more fidget. The wanting mind, inside the body, makes more bread. And again, again, again. So many nights I've wished I could remove one of my arms, their awkward context, that sprawl, become a body not a body, but a blob—it has not happened yet. Some of these caretaking elements, also, we imagine, can take care of themselves in simply lying down, getting it right—the way so many easy sleepers seem to out of pure instinct, or perhaps of never worrying at all. Most nights, though, in my dumb body, I find that the majority of the at-least-an-hour timeslot that usually kicks off my bed entry and winding down to nowhere is characterized by a constantly recursing wave of awareness of current or potential discomfort in my alignment, for each entity, and all at once.

For instance: feet. Usually I like feet to be allowed out a certain bit from the end of my covers. They should never feel constrained—never wrapped up inside the blanket, locked of rummaging access, which is also a general rule for how my body must be when winding down—not butted up against or tangled in or even pressing lightly against another plane, which includes my girlfriend, if I have one, or the absence therein, or the grain. My feet often also should not be out so far from the blanket that they are fully exposed to whatever presence or air is there unseen at the bed's end inside the room, as then eventually I will end up feeling vulnerable or cold (this is all assuming the bedroom is an aver-

age, slightly cool temperature, around sixty-eight degrees, which is my optimum setting for sleeping, and when stirred from these preferences may or may not cause further error in various ways). Furthermore, the way the feet come into alignment with the end of the mattress (I am 6'2") and with the lower edge of the blanket (brushing, say, just above the ankle) should not feel unusual or confined—the configuration of blanket to flesh, as at the head, must fall nicely in certain lay and texture with my body, if only so that it is pleasant enough that I can then forget—the body must be forgotten—at least long enough that the arrangement ceases feeling as it did in first coming into it, or the blanket moves by further moving, or its context is otherwise disrupted, blamed, or deranged.

Replicate this obsession with each manipulable appendage across the body and what you've got here is a potentially overwhelming 3-D puzzle of the self—4-D if you want to count the constant inner monologue that usually accompanies it, the frustration, the grunt—5-D if you want to add on the awareness that what you're doing during all this shifting and mental shitting is also a noise-maker barging into the potential comfort of those sharing your local space, who are also trying to find their own ways into sleep, the guilt and pressure of which some nights will hold me trying to hold still there in an acknowledged as not-perfect configuration, waiting slowly to find ways to suggest myself into better modes without stirring the bed, waiting, for instance, for that other person to shift herself or breathe or otherwise show she too isn't fully gone, the prolonging of which only builds more and more inner frustration, which when finally the crust breaks and you make the impending shift regardless, as you have to do if you want to ever go, you do so with a simmered gusto, an extra compressed fury in

your turn, which unfailingly seems to be just rough enough to stir the other person at last anyway, thus ruining the whole reason you stayed still so long at all—6-D if you even remotely begin to nod into the time you are eating off of your sleeping, and what else you could be doing, or what you're supposed to do tomorrow, or so on—7-D if . . . —8-D if . . . —and so the Rolodex compiles—soon at 15,000-D, just like that, amalgamated in one self.

More precisely than the fear of death, insomnia seems a hyper-sensitivity to the condition of being alive. For years the presence of sleep trouble in a body was held by science as an emotional, mental problem, a self-imposed roadblock in the night. Only after years of wonder, study, did the clearer effects of the state begin to become named, a hurt not only stuck in the moment of no nod off, but accumulated in the body overall. Personality traits including depression, extraversion, histrionic behavior, hysteria, hypochondria, hypomania, internalization, introversion, neuroti-cism, perfectionism, psychasthenia (inability to resist maladaptive thoughts), schizophrenia, and somatization (tendency to trans-late psychosocial stress into somatic stress) have all been shown to have clear links to insomnia.[7] For many, though—the self-tortured, in rooms set within their waking homes—these are only temporary lockouts. Transient insomnia, defined as spread over less than three days, is often the product of temporary error in the environment or body, new stressors in sickness or in sound. Chronic insomnia holds on longer, defined over arcs, in patterns, becoming maps. In order for the antisleep state to be considered chronic, by definition it should recur on average more than three nights every week, over a period of more than six months, and

7 Van de Laar et al.

should affect the daytime procedure in manifest problems in energy, motivation, moods.

These characteristics are as well relative to the subject's own needs and inset criteria for what is needed to be "well rested." One body might need only five hours to feel fully made new, while someone else might need nine. All factors are known to change over a lifetime, as the cells and information in the body shift and wrinkle and bend in. Problem sleepers often interpret their rest conditions to be more severe than recorded sleep times and depths may, to someone outside that skin, make them seem. In some self-perceived "insomniacs" there might be no sign of a disrupted state at all—and yet, in their mind and flesh, they feel arrested, turned out, scratched. In many instances, the effect is attributable to microsleeps, short periods spanning somewhere between a fraction of a second and up to thirty seconds, wherein the body cuts in and back out of a deep sleep due to exhaustion, a blink too short to quantify. In this way, though the person never experiences a full-blown, calculable sleep session, he or she does transgress the phases of consciousness, blurring the mind, allowing rest. Many claims to extensive insomnia are, then, not only questionable, but perhaps even delusional. It becomes difficult to say.

Even in more prolonged, intense phases, the sphere can come uncircled. "A person who becomes disorganized due to acute distress is likely to accept his psychotic experiences as real. . . . The person may feel that he is 'losing his mind,' but unlike experimental subjects, he cannot leave the experiment. He is therefore suggestible and may accept his experiences, particularly if they provide an 'ex-

planation' for, or a relief from, a difficult situation."[8] In this way, too, the memory might flicker, confusing waking rooms with memory and film, obfuscating where one has and has not been, in what way, with what markers set upon the flesh as ridges, and as color, as text inside a book that will not desist in its shift. The repeated rooms of waking, leaving, outdoors, indoors, transportation, evening light begin to betray their minor differences in repetition, the angles seeming each day to form the same boxes and expanses, air, but under the certain tutelage of dream context find little divots, smearings, burps (the dream replacing day space like a mask). The world in wormwood, in hidden liquid, known as trance—these tendencies, however hidden in daily rhythm, in the stilting position of being locked inside one's slowing consciousness, begin to lurch—like obscure buildings under a coastline, rising up as the breadth of water becomes shallow, drying, an exposition by removal, by what remains among and underneath.

Therein again subdivided in the reverse direction—of the self-regulating his or her self via postures and over-aimed insides—there is the ongoing customization of our sleep apparatuses. There are bedclothes (pillows, blankets, comforters, sheets, each of intensely varying grade); there are nightclothes (pajamas, lingerie, eyewear, headware, gloves, goggles, and socks); there are countless under-teeming extras one might bring in to further modify the sleep space (scents, colors, panels, electronics, sound). Beds that might have once been made from earth or leaves or straw by now have turned to intuitively and scientifically fine-tuned machines, so selective—from brand to size to shape to make (air, water, or spring: *What kind of spring? How many?*) to thickness to firmness

8 Gove, 793.

to surface (and interior) texture—to flipless mattresses, to stain re-
sistance, to what's the best bang for your buck, to pillowtop or
no, to "Choose from memory foam, egg crates or natural latex
foam toppers," to "Healthy, all-organic quilted cases! Non-toxic
& Handmade in Seattle"—to even further in-the-minute custom-
ization, where through use of electronics one can at any minute
further tamper with one's lying place to make it more conductive
for best rest, therein forgoing that often not needing to choose
is the most restful state. Can even not our beds make their own
decisions? Could there be a bed that takes me wholly by the skin?
There are so many possible combinations and adjustments to the
becoming process, and the interim between finding one and fall-
ing in, that many nights can quickly swim into some limbo of bad
alignment, flipping from one set of poses to another, stupid kabuki,
burning a whole night by, unto light, before finally, in some de-
feated haze, the body gives in, unto dawning.

Or not at all. Even once we've done the work of getting ready in
mind and body and shape and sound and space to do our best to
move toward the sleeping door, the world still goes on around us.
The unlit room is still the room, and beyond the room is all of
elsewhere, other bodies, in their way. And so, just as you've begun
to find your way to fall into the nothing, perhaps, the phone rings,
or someone's knocking at your door, or the person in bed with
you gets back up or begins talking or turns on light, or you are
itching, or you remember something unavoidable you have to do
before sleep (you forgot to brush your teeth, you have this e-mail,
you have a due date, you don't want to forget to take this certain
book with you the next day). All around the perimeter of this
process is the potentiality of other-incursion, disrupting, reset-
ting, turning in. Even if most nights nothing happens, there is

the continual field of potential at all times around one's head, and the more one thinks of what could happen, what might happen, what we didn't do, the worse the context gets. For every definitive thing that has happened, that you can lash yourself to, there is a continuity of other-else. Ramifications. The unexpected. The on and on. This is in some ways reflective of the endless proliferation of attention-hoarding objects made manifest daily, spooling physically and as *ideas* in and around and outside the house. The more you think the more you're thinking, and the more there is to think about.

This act of "sleep catastrophizing" is ten times as commonly reported as other disruption stimuli, centered in our tendency to dwell on the worst possible outcomes of a given situation.[9] The self around the brain—a larger meat sleeve, wearing being—knows the brain knows more than one could fit in any minute or hold full in one frame. And so the frame shakes. And the self shakes. And in the self, so shakes the blood, the mood, the night, disturbing, in the system, further waking, further wanting, if for the smallest things, the days of junk, reinforced on both sides—inside the mind and in the flesh—an endless and constant shifting phasing phrase of how one might sit inside one's body, inside one's air, inside the inside . . . It is this act of minor replication, the rolling thinking, which in bulk gives want its weight: layers upon layers, cells rubbing against cells, recursed. Many of the most common, overarching sleep catastrophizers concern sleep itself: "I will feel bad the following morning"; "The backlog at work will build because I cannot concentrate"; "I won't be nice company"; "I will have low self-esteem"; "My boss will shout at me"; and so on.

9 Harvey and Greenall, 12.

As the chain of days deepens in this thinking, its resonance upon cognition tends to increase, digging a thicker hole.[10] Some nights the self seems to flood so thick it might never turn off—no clear center, overflowed—a sudden nod turning to surging—small juts of adrenaline, like a grenade of sun against the chest upon the cusp of X-ing out, eyes spinning in the black meat of the head—*I am not asleep now. I am not asleep now.*—looking somewhere heavy in there for some traction, a truer blank inside the blank. In the same way as an evening in the grip seems subject to a periodicity of night, so too do these patterns propel themselves over spans of several days, packages of ruin followed by, at last, perhaps, a recovery evening, in whole crash. And even further out, over weeks or months or years, or into packs of years, in decades, the condition might unfurl, become quiet, massive at once, sudden, returning in the wake of its seeming disregard, a flooding flood of flux and flux of flux, unto any inch of self becoming questioned, blurry, some faceless lock without a key.

10 Ibid., 15–17.

The Uncontrollable Reflection

It might begin in any way. In fighting its own exit, on the pillow, my brain at night will cling to anything it can corral—however dumb or old or overreaching. The idle thought initiates itself. The feeling of the thought sometimes seems to spin or worm inside my forehead, or I might roll mnemonically inside it, as in a terrifying drunk. Then the first thought begets the second, following its sound. Usually the thought is not of something massive—the bigger worries of the day already so embedded they are as if part of the air—but instead the mind often comes to take hold of the smallest bolt or jut of time—then the thought births the next thought.[11] I might think, for instance, of what happened hours before the want for bed came, again online, sitting with my machine killing hours clicking in endless queue of electronic day—how I ended up again in Facebook's[12]

11 Each sentence a container for each other sentence.

12 A book of faces, face of bookends, butt ends, endings, air.

black hole—jumbling through nothing, staring at images of head after new head, until maybe I landed on a particular friend's profile, someone who I've mostly only ever known online, and who as a result I know differently than friends as bodies—their words, their wants or ideas, each day in silence fed[13]—and here inside the night inside the hour I leave a comment there about them on their electronic wall, words passed herein by pressing buttons into a board I used all day to press letters into other names in other ways, perhaps a random observation spent in passing or maybe a congratulations or inside joke, text for nothing but transition, *these are the words that came into my head today when I thought of you*,[14] another small memory totem of the era, soon to be pushed down in tally as others also comment, the sentiment to be blinked on for some small moment perhaps and then sent archived into the never-ending electronic mush,[15] another hiccup in the night. This inane quasi-interaction, the likes of which occur for many at least several dozen times a day, in e-mail and in clicking, should have ended just at that—though now hereafter, in my own space, I find the thought returning in my head, the presence of the pressing somehow still there in me in stupid residue clogging portals in the place where I would like to be now entering a sleep—it occurs as if from out of nowhere, certainly not chosen[16]—and now suddenly this small

13 In silence, yes, as it is inert, but with furor thereafter in such spillage that it might be thicker in its size by seeming to have no true dimension up front, and yet quasi-unending, of tiny slivers that fill the face.

14 Words bouncing other words out of them in a silence, refracted by association, filling out the flesh around the flesh inside the head with what.

15 Each day the same websites refreshed over and over, seeing nothing new and nothing new, though the flutter of the possibility of a newness having appeared since the last refresh causes some internal corridor through which I eventually return and find myself again refreshing, and refreshing, the site inert, to which I kneel.

16 "The abstract machine crops up when you least expect it, at a chance juncture when you

amusement has somehow become the one that will not leave me be, the offhand phrase remaining haunting in my head without my trying, not jolted but simply *in there*, reoccurred now because I know that it exists—and now in wanting such a thought gone the thinking of the thought brings it back again further solidified, spreading out in strobe upon my attention for some reason beyond the at least several billion other instants like it, at least, among all the other days—and from there on, my frame, roiling out into further mental furies in abstraction, the thought begetting thought again because it can, replacing whatever calm or wear I'd felt before bedtime again in me turning on, filled up with something other than the nowhere that I want—and so now inside a thought inside the thought I might imagine this manifested person—who, again, I hardly know beyond some abstract premonition based on their profile and whatever else they've flung into the void—I'll see them in my head sitting there somewhere before the computer just like I do but here rendered in my head in their own home,[17] a version of it somewhat based on where I live, I imagine, though skewed into how those ideas of who they are might make them reflect in the surfaces by which they are surrounded—I will see them seeing the comment I have left in my own typing between us through the wires[18]—I will see them in their own body, in their chair, sometime between the time of when I posted it and in the minute of my imagining, an event which might not have even happened, they might not see their machine again for days, might not even give a shit to look at Face-

are just falling asleep, or into a twilight state or hallucinating, or doing an amusing physics experiment. . . ." Deleuze and Guattari, *A Thousand Plateaus.*

17 These people removed of body, organs, removed of touch and sound, translated into symbols, numbers, smudged of tone.

18 Why am I still thinking about this. Why am I still thinking about this. It's a Facebook comment. Why am I still thinking about this.

book for some long time, and yet there inside me, there they are—I will see them sitting in the glowlight of the machine seeing whatever words I've made, however stupid, that small nothing, taking the symbols of the words once used to form other words into their eyes, their brain taking those words in and translating to their own brain, all words mutating both in how they're read and over time[19]—I will imagine that person in his or her house with whoever they live with maybe drinking water, as had I, the computer light also against their skin shifting as they click over from the page that brought that comment to another, any one of however many million websites they could choose to, white to blue inside that one silent and sharing glow, or in conflict with other lights inside their house and other voices,[20] all the other light around the house, and already this whole thought is stupid, I begin thinking, realizing I've been in this hole of thought for several minutes[21] here at least, and why am I thinking of this above all things, why in the mass of squirm that sits in anything will I find myself centered on someone inside of a machine, where is the silence that fills other people, and why won't I at least stop here having recognized I'm thinking on into such dumb, to give up and enter sleep now in a clean mode, shut off the thought from spreading any further in this manner, smearing even this simplest of actions,[22] though then just as quickly I am again thinking perhaps again about that person, perhaps how inside their own home or air they spent their day,[23] what they did today while I did

19 Inside the sentence, each word or image shits another; and from each of those, again, again.

20 All these people's words inside my words.

21 What are minutes. I've been in here all these years.

22 "My mind wanders too much to drive." Andy Warhol.

23 Their own hours at the glowbox, typing into nowhere, node to node.

what I did with mine here, out where I am,[24] two twin systems in a system of systems, spinning on, and all those other lives in bodies going on beside them also, or what their life is like on any day at all, days that both begin and end so fast and are so slow, though often in finding I can't imagine them beyond the machine or in my own patterns I realize I have no idea what rooms there are beyond this room, and who are these people really and how did I come to bounce about them anytime at all, who am I even talking about really, what is this picture, how could this be going on and on[25]—and yet, inside the image of the body of them in this spinning I will still wonder if I imagine the person of the image of the person today or any day is happy[26]—happiness or sadness being one room off the human almost anyone could understand—are they happy right this minute or in a broad sense, why or why not, what if they are not happy at all, happy with their life here, their life of which I have so small of an idea, what would make them happy, what could I do, me, what could someone other than me do, could this supposed person who I've mostly only ever known in pictures and small typing ever be the kind of person that could kill his or her self[27]—how would that feel—how would they do it, how would it feel inside their heads, how would it affect me—why am I wondering if this person is going to kill his or her self, this body I hardly know anything about them anywhere at all, what do I know about them, or any person, I imagine, what do I know about my mom, what do I know about who I was last year or ten years back or who I am right

24 Where's that.

25 "*Where are these thoughts from?* Rudd wondered. *Who is crammed in here with me?* Within him someone was speaking, leading him further and further out." Brian Evenson, *The Open Curtain.*

26 The drift between each instance of any word that much larger than the word itself.

27 The knives in any house.

now, what happened to all those people I used to see daily at school or in other rooms, what happened to anybody, who is alive, what if this person who I've hardly or not at all met did something awful, what if tonight or right now, and then there inside my mind I might see this person shifted, in my image[28] of them, hair and teeth and cheeks and eyes, I might see him or her here place a gun inside his or her mouth, he or she standing in a bright light in their white tiled bathroom that looks so much like mine, a room that does not exist at all in shape or form, but instead is a potential room,[29] one that could appear in any house in any evening more or less, a room with one long mirror and a door, yes that's how it fits there, I'll see this person's versions of his or her eyes both in their head and in the mirror go huge seeing themselves with the gun aimed, I'll hear a click and then a boom, the sound inside my head enough some ways perhaps to shake me, reflected in my flesh like something crawls— then in the image of the false room I'll see the quick blood[30] come out the backside of his or her skull hair[31] shooting from his or her body in a plume, the body dropping to the tile in silence, slo-mo— because my head can, like a movie, disrupt time—more blood washing thick along the tile of the false bathroom and the mirror and maybe sloshing up to cover at the lens of how I see, and the room around me in my own house might be far gone enough at this point that I will forget that I am there completely, but still in my body, like entering a room that is not sleeping,[32] *sleeeeeepppppiiinnnnngggggggg,*

28 No two pictures of a person ever seem to really look the same, even exact copies.

29 There is no such thing as metaphor.

30 All blood, except quite up close, looks the same, despite its codes.

31 The chains and chains of cells grow out of the brain, draped on air and draped on floors we together walk upon.

32 These thoughts tend to rarely transcend their box—they mostly only ever serve as reinforcements for the semi-impermeable distinction between mind and skull and skin—encir-

but made of gel, the word *sleep*[33] itself alone inside me shaking with a terror and slow-erupting, my need, my murderer, my maze,[34] and here I am again in here again drifting off into a state I've shaped so many times, very much equal to wide awake but underwater or with different colors in my teeth,[35] where in the wash of blood my brain will be there then suddenly thinking of the suicided singer[36] of a band I loved as an obese teen[37] and how that guy then was four

cling the self with gradually increasing spiral, stitches in a blanket, cells inside a shield.

33 Slumber, Shut-eye, Sleepyhead, Sleepy time, The Land of Nod, Nighty-night, Sleep tight, Sleep light, Oversleep, Shut-eye, Haven't slept a wink, Fall asleep, Go to sleep, Go to bed, Go bye-bye, Go night-night, Turn in, Zonk out, Knock out, Roll over, Drift off, Pass out, Doze off, Conk off, Nod off, Forty winks, Sleep on it, Sleep one off, Crash, Collapse, Bedtime, The big sleep, Lights out, Shut up, Catnap, Get a nap in, Catch some z's, Count some sheep, Siesta, Snooze, Sack time, Slumberland, Bed down, Bunk up, Saw wood, Hit the hay, Hit the sack, Hit the lights, Retire, Death, Die, Doze, Drop, Dream.

34 Sleeping gas, Sleeping bag, Sleep mark, Sleep goggles, Sleep Inn, Sleep King, Sleeper sofa, *Sleepaway Camp, The Big Sleep, Sleeping Beauty, Sleepless in Seattle*, Sleeping in, Sleep out, Sleep over, Sleeping around, Sleep with the fishes, Good night's sleep, Sleeping soundly, Sleeping well, Sleep sores, Sleep aids, Sleep deeply, Power sleep, Sleep it off, Sleep standing up, Asleep on the job, Asleep behind the wheel, Crash, Crash out, Sleeping together, Sleep pills, Sleep drugs, Sleep meds, Sleep like a log, Sleep like shit, Sleep like a baby, Sleep like the dead, I'll sleep when I'm dead, No sleep for the wicked, 24/7/365, The city that never sleeps, Sleep herbs, Sleep shirt, Sleep Nazi, Sleeper, Sleeper car, Sleepwalking, Sleep trouble, Sleep Society, Sleep advice, Healthy sleep, Sleep patterns, Master of Sleep, God of Sleep, Sandman, Orpheus, Sleep perchance to dream, Shhh the baby's sleeping, Sleep on the sofa, Sleep on the street.

35 "To build a wall, the mason adjusts his stones one after the other in a logical order, in this case beginning with the bottom and finishing with the top." Jacques Dupin, *Giacometti: Three Essays.*

36 How many times a day I say aloud "I am going to kill myself," each time seeming as if this actual cog in the arc is enough to bring one down, even as caused by such logs as crappy traffic, stubbing big toes, and so on—the mind filled with all those however benign images of ways I could imagine my body being done under—water, razor, rope—in some way fixed with virtual structures of what someone else has visioned for us, through false bodies—I am Jack Torrance, I am the camera, I am BOB.

37 Cells I made and carried, cells I needed, cells I did not, cells I burned to take my mother's

years younger than I am now inside my current mind today right now as I am thinking, if getting older—and how inside his body then when I was sixteen and he was twenty-seven he was so famous, and how his name and shape have mutated even still since then,[38] since the long passed afternoons playing his music in my bedroom[39] or in friends' houses, different lights, days when we would sit inside for hours against older machines[40] or in games barfed cleanly from our heads as mental mechanisms that would never be played again, crammed in among all the other music, days of afternoons that seemed to last six times as long as afternoons do now, in someone's backyard where we would cut open Wiffle ball bats and fill them full of Super Bounce balls,[41] covering the bats themselves in electrical tape to make them heavy so we could beat the balls far into the sky, and in our heads still there, the music, those words still there, the recording of the voice, the looming image of the poster of that to-be-dead man in my bedroom those years that would watch me sleeping flattened 2-D on the wall, surrounded in replication with all the other cut-out images of people I could hold inside my head sometimes and would never meet though one could want to, one

hand, cells as storage of my thought, destroyed.

38 A Google search for "Kurt Cobain" finds 4,280,000 results, which is actually not that much in consideration, as for how his image has faded even since then—fewer hits than James Joyce and Abe Lincoln, more than T. S. Eliot and John Wayne Gacy, less than Sting.

39 "Come As You Are" places me in hours half my life ago sitting beside the speak of a light— a certain texture of the air I relate to Sunday and to heavy blue tone and my mother in the kitchen down the hall.

40 The season after season of our self-named, self-generated rosters of teams in *Baseball Simulator 3000*, all still saved somewhere in that cartridge, a catalog of buttons that we pressed. Buttons touched for whatever reason. The space lodged inside the game.

41 They never bounced as high as I thought they should—they should have never come back down.

could imagine in the skull,[42] and all the other days inside that white room passing, the days watched by the eyes, the people who came into the room and were beside me, nearing, the day in that room a friend I hardly knew watched me in the mirror brushing my teeth[43] and the gumblood was running in my mouth as I made pressure and she asked me if it was always like that when I brushed my teeth and I said often, yes, that the blood would pour a lot, yeah, some days, from my soft system and would pool inside my mouth, the taste of the blood there in my teeth and giving color, and her posture and her eyes seeing me see, and that's all I remember of that day then as one might say it and why would that ever be anything to me, why in all the hours of then would these ones be the words or actions I held in me over all,[44] my brain now spinning so hard in my head I don't even feel it, and am nowhere here now closer to being gone, if anything I am more alive inside this second than any other I have walked through in this day, and still it does not stop, and still the thinking chain runs like a wire from the door unto the doors, how in the same year as the blood poured and the girl saw I acted at school in a play,[45] and now as the instant of the thought around the

42 The kid I knew in middle school who'd ripped the heads off all his posters in an anger; the kid whose room was wall-to-wall with women in their underwear, for every inch, how I can still remember the way the skin formed the room into a flesh shell, how I always wanted that for mine; my own posters rolled now into cylinders or stacked flat in piles in closets, hid of light.

43 I swear I brushed my teeth not twenty minutes ago and my mouth still tastes like blood.

44 "If we had the true and complete history of one man—which would be the history of his head—we would sign the warrants and end ourselves forever, not because of the wickedness we would find within that man, no, but because of the meagerness of feeling, the miniaturization of meaning, the pettiness of ambition, the vulgarities, the vanities, the diminution of intelligence, the endless trivia we'd encounter, the ever present dust." William Gass, *The Tunnel*.

45 The spit I spit onto Scott in the scene we performed together alone on the stage, the endless quotes therein regarding time.

play hits I cannot stop thinking of the play, and the way the warm light came down from the ceiling on the curtains and white tile, how it felt to stand near the stage's edge lip and look into a shade of forms I could not fully see, surrounded, eyes veiled and watching behind the bright, how that year backstage the girls would take their tops off and walk around in bras inside small rooms while changing clothes, false hair and costumes and thick makeup, and how I never kissed any of those girls then, felt no sound inside their mouth, though maybe I could have if I'd tried, being a shy one, afraid for so long to bring my head near to another head and breathe, and how many girls I could have kissed or touched those years and did not,[46] and what I would be like if I had, what kind of life, and where those girls are now and if they have learned to love someone and if they are happy with what has ever happened, and if they ever think of me too, how pathetic, and what of all those others from then somewhere, nowhere, sound, maybe those people I had known once and now have found again inside my head are also icons inside the machine, maybe somewhere they are there, and should I get up and try to look while I remember and here I am again fully awake, and here I am again at once inside my body and my eyes are open and I'm red, why am I thinking about this, of all things, at this hour, please Blake, please shut the motherfucking shit of yourself up,[47] you time-wasting sack of dogshit, you empty ape of god's dick, time is screaming, life is over, unending night is coming on so hard and in no sound, how am I ever more awake now and more manic than I had been at any point in the whole long disappearing day,[48]

46 Each now another closed door—I imagine—I have passed by and in passing become changed.

47 "In the sentence nothing is incidental but in the world sentences certainly are." Tony Tost, *Complex Sleep*.

48 This onslaught having begun from a point of nowhere and having approached through

look at the clock dickface it's almost three now, which means in order to feel rested I will sleep until at least ten, which means I won't be up, showered, and at my desk until at least ten forty give or take some, that's assuming pleasant traffic and nothing else new in your way, ten fucking forty, dude, that's almost lunchtime, by then so many already have gotten so much done, getting started by then it would be as if the day had already begun before me and gone on and how quickly the day again would have to end, by then it might as well be time for dinner, might as well be midnight, might as well be time again for bed the way these days go, in such transmission and blinking unless they feel fucked and then they seem to be so long,[49] and all of this about the time for this beginning with this much rest under my belt by then is all assuming that I start counting sleep time from this exact minute, this seeing the time it measured in this blinking, which is changing again right now again,[50] and so really I'm even further behind than I was just then in passing unless somehow right now I can magically nod out, as if somehow the whole unending trend of my sleep patterns in my life might magically be altered in reverse, and so, realistically, since I'm keeping tally, which why the fuck am I doing that, I have to at least assume it will take another thirty minutes rolling, heaving, waiting, before I conk out somehow, that's if I get started falling asleep immediately, right now,[51] and so I must end this thought now, and

casual acquaintance a state of near hysteria, in the clothes I should be using to seek rest, the way that people do.

49 "A man can do what he wants, but not want what he wants." Schopenhauer.

50 "The plane of organization is constantly working away at the plane of consistency, always trying to plug the lines of flight, stop or interrupt the movements of deterritorialization, weigh them down, restratify them, reconstitute forms and subjects in a dimension of depth." Deleuze and Guattari.

51 "Learn to leave your worries outside your bedroom door just as they did their shoes in the

hear no more thoughts, and be this time truly silent, of the blank, though in the mind inside my mind[52] I know no matter what or how simple from here forward there's no way to not already be behind tomorrow based on the way I've spent my time today, specifically the way I spent my time here lying in a bed where anybody else would already be sleeping, everybody, it seems everybody else in every room surrounding me for miles is nowhere, dreaming, in a whorl, the whole world in fact seems asleep and pleased in silence besides me here, except I guess in countries where most people are awake,[53] though at least those other awake people are probably being productive, at least moving, and not just lying here caught in a curl of waking nothing, aching brain, and anyway I have not been to most any of those countries, or seen much of those people, and all those other people in their lives, or what they want inside their lives tomorrow, who they were once, what they're eating, loving, having, everything they've ever done to someone else or done at all wrong, and I really have to stop thinking about this shit now or I'm really going to crush it, I have to stop thinking about thinking about this shit[54] of life of absolutely everything but nothing and just really just dissolve myself, go on, and though I know I know there's clearly no way to do it but just to do it like I've done on calmer, cleaner nights in certain ways and so on, and so okay, for real this time, let's have this, let's get this done, let's go . . .

'good old days.'" Webb.

52 *Speaking now only or wholly ever all in borrowed language.*

53 "I am the witness, I am the only witness of myself. This crust of words, these imperceptible whispered transformations of my thought, of that small part of my thought which I claim has already been formulated, and which miscarries." Antonin Artaud, *The Nerve Meter.*

54 "True sadness, said whoever wrote it, is when you have nothing left to say, or nothing left to add, when you have exhausted, he said, all the resources of language, to make understood, something, to someone, who understands nothing." Christian Gailly, *Red Haze.*

]

]

]

Turning over on the bed to again lay on my other side I search again for the station where my head fits best in the pillow's folds. I flip the pillow over to make it cold. No matter how comfortably the pillow and surrounding blankets fit my head at first I'll always again have to tinker as the condition settles and becomes less new—it might take three or four or seven or eight adjustments of the blanket and the pillow in cohesion to form a set of vertices at which I feel most settled in each iteration of the turn, then my legs and arms will have to be right again too. I need my feet sticking out from underneath the far end of the blanket just enough to cool the rest of my body off, but not so much that they are cold themselves, also the blanket has to fall on them in the right way, did I already say this? I know I've said this. I've said it all so many times, so much inside my head it becomes hard to tell what is the word in welling and what is nowhere and who I ever am. I always have to start over—to reset myself, finding some pattern or progression—though the selves inside the self are all right there—they may go silent, they could fry out, entering hiding—and yet they are in there. There they are. And just beyond the rim of flesh of my own body, too, the reams of others there in concert, rerepeating, held inside their own skulls with their own endless music, silent from here, but alive. Each one's own mind's squirm one of billions, folding in a churn:

- Average number of thoughts per waking second: 10.

- Therefore, per hour: 36,000.

- While one is sleeping, the rate moves a decimal to the left.

- Therefore, per day, per human: 604,800 thoughts.

- Current estimated world population: 6,446,131,400 folks.

- Therefore, per day, our sum output: 3,898,620,270,700,000 human thoughts.

And so here appears another night inside another ream of what. With or without your will, it waddles on. The more you try to stop, the more it's screaming. Each night, we work our way toward a sleeping's pausing hole. By the time I've found a comfort space inside the restart of my fidget, I'll likely have been tossing for eight to eighteen minutes, maybe longer, though I don't want to check the clock again, as that would reset the mode another time, and in seeing what I've seen I might find it's indeed even longer and in not looking I can imagine it's been hardly any time at all, though every minute sometimes seems ten minutes and sitting up will lose the progress I've made inside my skin, and if I have not begun to annoy her in the bed beside me in her own sleeping then moving more will surely do it and then I've inflicted my stupid night parade on her, and maybe I have already, I must, I at the very least have begun to worry that I have, and what replication of this shitstorm in another body might birth from mine and therein spread in magnet systems, infecting her not only with private complications, but so too in reflection against my own, a teeming network that in the worst modes can infect a whole home's air and emotional operation within, and in the cleanest maybe just be something more for me to spin and shit around with overanalyzing every inch, so I begin trying to limit my reactions to the ways I have not situated myself

rightly in the meantime, and I begin to try to force myself to calm, to demand the calm this time by truly calming, becoming flatter, letting the air out of my mind, my body this time truly centered in a sinking and no sirens, but most often I am not in the correct position, and the longer I wait trying to be calm the less calm I am. Some nights it is better then to get out of the bed and walk around as if the day is there and let the selves sit and think of other words.

At certain times throughout the day, inside the stilling, that warm hand of the sleepmode coming up from in my mud, I might lie down on a sofa or a floor and fall into the blank without even nodding. It strikes sometimes as if infected, in a cloud. Even during my worst periods of evening insomnia, there are times I could fall into modes or against certain surfaces and go out in the loud light of the day, sleeping instantaneously, hard and with total absence, for several hours, sleeping the sleep of underground, waking later in the room in just as quick an instant, thinking nothing, disremembered of how I ever fell into such a perfect hole. This phenomenon is common—the texture of cartoon. In the 1953 Disney film *How to Sleep*, man-dog Goofy finds himself nodding out everywhere—work, while walking—excerpt when in his bed, causing him to lose his job and dream while waking.[55] In his diaries, Andy Warhol mentions nodding off in the bathtub while in his bed he cannot sleep—the water, in some way, like a second body enveloping the skin sacs and the spine—a rewinder—the unconscious threat of accidental death from perhaps slipping underneath the warming lip. In the same breath, in that flat tone, Warhol mentions rereading a passage in a book where Jackson Pollock rams himself and his lover dead in their car into a tree. Warhol's creative body's apparatus in the same way lurks restlessly, som-

55 Iranzo, Schenck, and Fonte, 534.

nambulating shut off, operated by appendages of no definite will, creating replication of a nothing in which human error leaks and is smeared over and is still there and never not alive despite its tacit, intentionally reflective sphere—each hour gloaming in the presence of the nothing, another contribution to the orb of light and sounds and hours pulling on the body from the outside by simply being, gathering around the blip. Even in full-on seeming waking, the body wants constantly to see blank: the average person blinks 17,000 to 22,000 times per day, each blink lasting 300 to 400 milliseconds, which means, on average, we spend nearly 114 minutes of each day unseeing and awake—a black rind over variation of the daily light, a lidless partition, undreamed.

Regardless, in this bed-mode, surrounded by such states, in want of some kind of recognizable evening routine—and knowing too that in expectation of that incidental nod-off it will almost always never work—the designated sleep space often becomes alter-charged, looming with its years of shaking every evening regardless of how gone. In bed, after the combination, I will flip back and forth from side to side and on my back and at some point onto my chest, a necessary cycle in the spinning though I never fall sleep on my chest and any time spent that way is just more time circled, though I still usually at least have to test the position each night at least for a few minutes, all positions must be tested, all limbs adjusted in their minor manners unto each set of new vortices and folds, and meanwhile, inside, my brain rolled on again for its own stable condition therein floating in the void wherein my center's hid, the brain inside my brain knowing that by now it is at the very least 3:30, which is thirty minutes from the last time that I thought about the time, and thirty minutes less now even from the time I'll have to do anything tomorrow, less still from what I had when I thought

about it last, and it's probably later than that already really, which means tomorrow is already even worse and quickly ending before it's even started and I still am nowhere near to sleep.

By the end, most nights, in my attempts at locating the drift position, I finalize turned up flat on my back, though I will most often wind up turning again onto my left side before actually sleeping, the final click into the lock. This interim on-my-back period is a good period when I find it, as in it, post-commotion, I actually will begin to find the first kernels of the *nothing*, the true nothing in which there is a silence, and in which one of the remaining doors leads into sleep. Beginning on the back, though, rarely works right: part of its feeling right, nightly, is the unfurling, the sprawl. Each night I still must find the door to sleep among the other doors remaining, the doors which lead back into more recursive thought, though at least knowing that the sleep door is there and potentially ready to be opened brings some rhythm to my pause—a series of infinite undoings, re-becomings, so Thomas Bernhard: "We're constantly correcting, and correcting ourselves, most rigorously, because we recognize at every moment that we did it all wrong (wrote it, thought it, made it all wrong), acted all wrong, how we acted all wrong, that everything to this point in time is a falsification, so we correct this falsification, and then we again correct the correction of this falsification and we correct the result of the correction of a correction andsoforth."

If this all sounds ridiculous—this flopping, this awful waddle for what could be such a simple key—that's because it is ridiculous—it's self-created, really, though of a self not specifically the self—instead it is the self in congregation, the sets of sets of strands of images, ideas. It comes on from no center, in a chorus with no specific off-switch or delete. It is in the muddle of my blood—a

blue lining in my body that cannot be shot or taught away, but simply slipped from, somehow. There are practices one might be suggested into—methods, medications, breathing, exercises, studies, more machines—which might work, but often too in overfocus can become part of the problem, in the mill.

It's hardly helpful to hear science say I'm not alone. Sleep onset latency caused by "busy brain" is often named the most common form of insomnia complaint, if, among each person, a wholly different ream of concerns. From a study conducted in 1979, the year I was born:

(1) A.W. was a 37-year-old man suffering from very severe anxiety, referred for treatment of chronic guilt ruminations concerning both real events and unrealistic worries from his past life. He was constantly fearful of having given people "wrong information" and showed a variety of compulsive checking behaviors . . .

(2) B.E. was a 27-year-old man referred for treatment of ruminations about death, hell, evil and disease, and traumatic fantasies about a car accident he had witnessed 10 months previously. Anxiety-arousal included letterwriting without checking the envelopes for harmful material before sealing them, and writing literally damning phrases about the therapist (e.g. "go to Hell").

(3) J.T. was a 40-year-old man who was obsessed with the need to verbalise covertly all the possible arguments for and against most of the decisions of his daily life. He had recorded many of these arguments on long rolls of paper lest he forget the exact words involved.[56]

56 Leger, 117.

Each of these three example patients was included in a thought-stopping study where they were taught methods for supplanting their anxiety thoughts with other thoughts and modes of relaxation. Of the three, results found no improvement in subject one and, in vast contrast, a marked improvement in subject two's ability to control his thinking. The third "could not be contacted." These widely scattered results demonstrate even more directly the wide and infinitely personalized effects and measures in one's personal coping with sleep disruption, making the very manner of prescription, aid search, and so on more of a crapshoot, a waddling in the dark.

Though for some stretches I might find a long way out of this serial condition for weeks or months in passing—somehow slipped around the ledge into the lake of something if still not seamless, more at ease—it always seems at some point to return full bore within some stretch, as if at all times waiting just above me, falsely unprisoned—as if never fully gone.

]

]

]

In the documentary *Derrida*, Jacques Derrida talks very specifically about the extreme terror he sometimes feels in the half-sleep between waking and sleeping, a space wherein his mind questions the aggressive or "new" things he has written during that day, challenging them as inadmissible, horrendous, offensive, despite the fact that when he is writing them he feels confident, capable of all. He explains this odd duality by saying he believes he is actually less con-

scious during the creation period, more asleep, and it is only when he is half asleep, toward the exit, that his panic, fear—what he refers to herein as *truth*—is stoked, manifested, revealed, screaming, "Stop everything! Burn your papers!" Thus this between area seems more public than the creative shell, more vulnerable, if also somehow more strongly connected to waking contexts, as if the writing itself is where the author, in want of speaking from the unknown, the nowhere, is channeling the deeper state, the lock of sleep. The self, in becoming aware of the self overridden by existing half in one consciousness, half in the other, begins hates the self for what it does not know about its other—hates its production, fears the new. This kind of inverse relation, in my own body, often leaves me feeling as if I am more truly awake when I am asleep, and more asleep when I'm awake—opening the question of who in me or through me is doing the writing, and who in me or not in me is the one to which other people speak.

In a series of examinations of the brain's processes of control, D. M. Wegner outlined a bimodal system that is activated in the governing of thinking.[57] As a person comes across a thought he wishes to control, as those that distract one from clean sleep, the brain's regular, active *"operating" system* (OS) becomes activated, to carry out the control. A second, effortless *"monitoring" system* (MS) runs in complement to the OS in search of cognitions to funnel toward, a system of inherent, readied distraction. For an average, daily person, this process for the most part goes on easily, without blip—the function carries out itself in silence, under flesh. In a body of above-average stress, though, the OS can become overloaded, flush, placing further strain upon the locomotion of the camouflage maneuver. As well, the new thought provided

57 Ascher and Schotte, 76.

by the MS, when the OS is under strain, may add further noise into the system, coagulating as in a river's mouth with leaves and logs. The spark of anxiety feeds its own hole—altering the usual process of distraction within one's self to one of accrual, crudding up—allowing the system to become further damaged, fatter and fatter, toward a hyper, opaque state. Thus the sleep period becomes a paradox—a state you want so bad you cannot have it, the effort of solution refreshing the problem, again, again. Quickly, in this accrual, one can begin to feel more awake, in wanting sleeping, than one does at waking up. The day beginning as it ends, and therefore, in continuation, ending as it begins.

Proust, perhaps the most notorious of all writing-based nonsleepers, does well to illuminate this throng of awakening within and further in. "Such grave uncertainty, whenever the mind feels overtaken by itself; when it, the seeker, is also the obscure country where it must seek and where all baggage will be nothing to it."[58] Thus, the self is both the creator of its terrain, and the holosphere around it, the atlas not the sum of all its pages but an object, a clog of maps, which perhaps in certain configurations, and in trolling the relief points and deeper sinkings, the wormholes in the flattest face, that something still unnamable and nowhere can be if not centered, pulled to closer focus, grown as pressure in the chest, "face-to-face with something that does not yet exist . . . this unknown state which brought with it no logical proof, but only the evidence of its felicity, its reality, and in whose presence the other states of consciousness faded away."[59]

58 *Swann's Way*, 46–47.
59 Ibid.

At early or temporary periods of unsleeping it is this very clicking presence of dying time that keeps one going, ever-conscious of the counting-down clocks, the furor of the leak, but deeper in, as one resigns to scrying, it is the blank of time that feeds true heat—longer, wider, shapeless nothing—how knowing within in knowing that day and night time continues on and on, and that there in that is truer blank. "God channels this through me at night," said Michael Jackson. "I can't sleep because I'm so supercharged." In the light, his waking body shifting beyond his control, photographed and malformed, filtered through recordings of his sound and bodies fainting as he walked into a room, which could be argued as a fuel for the spasms and gestures that comprised the dance-paroxysms that set him most distinctly in the flesh of his own flesh—looked at from afar in wonder, an entertainment, comprised of an unnameable fit-routine. "But the madness of an action was precisely determined by the fact that no reason could ever exhaust it," writes Foucault. "The truth of madness was in an automatism that had no logic behind it, and the more an action was empty of reason, the greater the chances that it was solely the result of a determinism of madness, the truth of madness being in man the truth of all that was without reason, of all that resulted, as Pinel said, from 'an unreflected determination, devoid of any concern for self-interest and any motivation.' "[60] The self appearing in a blacking sphere around the brain, resigned to form the self again around the self again, of coagulating impetuses and blood tendencies and unconsciousness of pose. So that, with no point of cut out, no space or differentiating meat between kinds of minutes, a kind of borderline or wall of sorts thickens around the waking day and nodding night making each the same and that much more compressed into a faceless, flattened logic. Time for the

60 *History of Madness*, 520.

unsleeper becomes one long going and going feed, wherein all is noise and light and all is sound, each welding to the self and turning the self outside the self at all. Even the dark at night becomes lit up; every silence screams.

By now, inside the cycle of my self-settling, the calming order of more structured thoughts giving my blood a space under which to calm, perhaps having fallen quick inside some quiet that seems toward the coming door, often by unseen slip of mind or in elaboration,[61] the brain thoughts again will glow alive, beginning again at the beginning,[62] if slightly deeper and set in its spinning,[63] or maybe even worse, responding to an outside factor such as new sound, or any of the countless reasons for anything to go wrong— neighbors, cell phones, excess noise out in the street[64]—or an out-side real-world brain eruption such as the sudden remembrance of something I need to remember about tomorrow,[65] about tomorrow, about tomorrow, which I must get out of bed and write down for fear of losing, and the more I try to convince myself[66] I will remem-ber it without writing it[67] down,[68] the more sure I am that I will not

61 "A person who thinks all the time has nothing to think about except thoughts. So he loses touch with reality, and lives in a world of illusion." Alan Watts.

62 Really? Again? We have to? Do we have to?

63 "But I haven't told everything." Clarice Lispector.

64 Even if you close the book, the book goes on.

65 Go to the bank, the post office, call that woman back, eat some candy, write the e-mails, run, walk, talk to someone, do something, make something, cell phones, doorways, door-knobs, doors.

66 Should "myself" always be written out "my self" or even "my Self," or simply "self"? Would I smack or want to smack somebody asking me this question out loud? What is the best way to smack the me inside me?

67 Writing, writing about writing, writing about writing about writing. Holes.

68 Down as a direction, as a way, as an expression, an emotion, color, down as something to

actually remember, though I seem to always remember everything without looking at what I've written down and more it is just the fear, again, over anything else,[69] of losing what I want the most while everything I could not care less about sticks to me in unending seething, no digestion, which reminds me of the Mitch Hedberg joke, *Sometimes in the middle of the night, I think of something that's funny, then I go get a pen and I write it down. Or if the pen's too far away, I have to convince myself that what I thought of ain't funny*,[70] those words often repeating different hours in my head,[71] words stung from another breathless dead one,[72] another removed of blood,[73] and yet with thoughts that still transmit through other bodies in the bull air, some nights, while the conduits of those remain, each year likely stemming smaller, and his dust done, and about what it must have been like inside his body near the end[74] and how much food he ate during those last days and days before those and how it inflected in his head and what he smelled like before he died and in his coffin and how long it had been since he ate McDonald's[75] and how that might have changed him if he'd gone there

wrap the body in, Down as a shitty rap rock band from the nineties, I think. Down as down, the opposite of many other things, all with variable expressions. Down. I'm down. I'm in. I'm there. I'm in there.

69 "Writer sitting and/or talking to himself being no more than renewed verification that he exists." David Markson.

70 I can never remember any jokes, good or bad, in any situation, even having just heard one; in and out.

71 "I look at a tree and exhort myself to remember a specific leaf whose odd shape and burnished colors appear unique, because I'll never see that leaf again, I tell myself, but then I forget it, remembering just the admonition not to forget it." Lynne Tillman.

72 Mumbling, drugs, death, talking, microphones, drugs, sound.

73 Another thought begetting thought begetting thought begetting.

74 Other men have dicks, and balls.

75 I should have run longer today, a little further, burned more skin off, burned more weight, what is actually inside a guy, I mean a gut.

once again and how long has it been since I ate[76] McDonald's[77] and should I go now and god I'd really like one of those vanilla shakes and a twenty-pack Chicken[78] McNuggets[79] like when I was a child and overweight, or as my mother called it *husky*, those were the best days, I should let myself become fat again,[80] resounding, crammed full of all those other doors, doors that as the flesh swells seem to serve to silence one another, in the warm flesh, how much harder I slept when under mounds, and probably I'm well[81] on my way to larger since I didn't get time to run today in midst of all the other crud compiling and nothing feels worse than when I do not run[82] and I will have to run some extra[83] now tomorrow[84] to make up for that that I did not do, to make up for these extra sets of growing cells, which I can feel for certain on my body, heavy, I am getting heavier every minute, I can feel it, I can feel something crawling in my mouth, something silent and unending, and by now it is at least 4 AM,[85] and I am still thinking here again, about my thinking, and about the thoughts inside the thinking that come gunned, and

76 Body portal, full of teeth, saliva, bacteria, slick gums.

77 The first burger served to whom in which room?

78 The meat that isn't even meat, the steam clogged in the crack, the fake veins, the tumor that woman pulled out of one, the gushy bite in, teeth, incisors, ouch.

79 The idea of eating something referred to as a "nugget."

80 The collapsed ex-body inside my body, wanting, wanting back into the light.

81 Seems like I should get sick more often than I do. Seems dumb to type that and leave it typed there. Seems dumb to say it's dumb and then leave it typed there anyway. Seems.

82 I like to stop on the treadmill with the LCD reading 432.1 calories or 33:33 minutes or 4.00 miles, and, on more crystalline days, some incidental cross of more than one.

83 I prefer like in *Sling Blade* when they say it "extry," seems to mean a whole lot more.

84 This day is gone as it begins, even before I get to begin to waste it. Run around.

85 Am. I am. Swam, or swimming. Swat team. *A-Team*. Guns. Fire. Forest. Mountain climbing. I can't imagine fathering a child. I can't imagine my child ever reading that I wrote that, if I do have one. The complex history of personal hate. Hair. Money. Pigs. Sun. Superpowers. Stop.

every thought has so many other thoughts strung on it, any thought could lead out any way, the head a box of batter and such scream-ing, and I am no better off than when I started trying again to go to bed,[86] why did I even lay down at 2 AM[87] to begin with if I was just going to lie here and roll around in damning bullshit fuckface party the way I always always do, the way the night curls like someone's face skin just above me burning my skin silent and laughing up my balls, who am I here, unfurl, unfurl,[88] all this time tonight *unfurl* I could have been using here to do something good or toward some-thing else outside myself *unfurl* like write or read[89] or if nothing else stare at more internet or the TV, any machine, any hour, any whorl, I could have been anywhere at all instead of lying here pretending I was going to sleep right or even quickly in white silence,[90] a nightly prayer that hardly ever does come true, never except for maybe when I'm drunk or so exhausted days are nothing and there is hardly room to move to breathe, and I don't feel either of those things tonight at all, and all this body, and fuck, now I have moved so much I've woken her up too, I watch her trip inside the black room moving heavy to lie down on the sofa, somewhere far way from me, once again because here again I can't stop thinking *unfurl*[91] and now I've done this and her night is shit too and tomorrow her day will feel less full and of a throb and she and I will both be tired again

86 "The time from going to bed at night to rising in the morning is all continuous, with no interruption, no suppression of consciousness. . . . The nightmare continues uninterrupted and, in the morning, start what, since there's no difference since the night before? That new life doesn't exist. The whole day is a trial, it's the continuation of the trial." Cioran.

87 You've got to start somewhere, might as well be now.

88 "Each fall made a channel." Joyelle McSweeney, *Flet.*

89 "In my desiring perception I discover something like a *flesh* of objects." Sartre.

90 The words and sound and light I could have packed into me. More cells, more smudge, more hair. *Why doesn't hair grow hair? Does it?*

91 The word repeats until it never does again.

and probably we'll fight about something stupid and I'll be stupid and in the end we'll both have lost comfort in this house, unto the night that ends us daily getting thinner and more throbbing,[92] and still here I am exactly in this dry and endless furled unfurling when, this when there waiting somewhere just above us and soon coming, always coming, nothing, something soft without a name,[93] its thick face shitting in endless squirm-moves through silent tunnels hidden on the night, ripping hard and roared toward anywhere surrounding with the presence of a hammer to a fontanel, a blood spot in a rover, how any hour any every other could be oncoming and there would mostly be no way to know, no signal shot from silent objects scrying until there they are upon us or within us and still here I am again, again again,[94] in the endless presence of coming letters, speakings, bills, of people moving in and out and around your own life, and the lives near to you, and theirs, and theirs, how any move in any one of countless mirrors could reconnect to yours in demolition, unabolition, detonation, and tomorrow it will only ever be that much harder here again, and now the new oncoming day is already just a sliver in the ass[95] of the days of weeks[96] of years unpeeling into tomorrow and tomorrow and tomorrow[97] these days' aggregating boltlines[98] of black inertia swollen into each and every

92 Stop.

93 "A system of mirrors that would multiply my image to infinity and reflect its essence in a single image would then reveal to me the soul of the universe, which is hidden in mine." Calvino.

94 Stop.

95 The light rind of silent hair, the butt ridge, the anus.

96 How a week used to feel like some strong unit and now feels more like two or three days. The halving and halving of the halving. Having. Hey.

97 The day beginning before I even go to wake, technically, that click of hour between 11:59 PM and the hour default and blinking in new clocks.

98 Next next, oof off, boom boom. Hey hi. Hello. Ding dong. Bah bah. Baby. Hey. Hey.

and again, as I will, I know, go through all of this again again again again again,[99, 100] each time starting even further behind than already I have been, and appended with whatever extra crap there is to think about that hugs on that consequenceless[101] and what from that I will uncover coming out, each time working worse in silent screaming ways of vast backlog until I unsee it, and I will never, so until there is something in me still, or at least unto when what will come for me inside the next day's next day's next day's roar of hell of expectation in the time I have remaining in that light,[102] and why can't I just stop this, even in darkness, even naked nowhere on the bed, all of this repeating in bold silence, all of this said in never and not never not unbeing unsaid and unmine,[103] on and on for hours, night in night, on, in cricking branches, until the light again, the night again,[104] the shift between where every hour becomes pure shriek,[105] becomes an edgeless, nameless silence permeating every inch of every hour come and here and coming, the louder the more you listen, in spheres of time unending and all end.

Hi. Stop.

99 Cycle, cycle within the cycle, cycle within the cycle within the cycle, holes.

100 "Correction of the correction of the correction of the correction."

101 "What variety and at the same time what monotony, how varied it is and at the same time how, what's the word, how monotonous. What agitation and at the same time what calm, what vicissitudes within what changelessness." Beckett, "Texts for Nothing 9."

102 "The connections are the important thing they don't exist before you make them." Ronald Sukenick.

103 "That's right, wordshit, bury me, avalanche, and let there be no more talk of any creature, nor of a world to leave, nor of a world to reach, in order to have done, with worlds, with creatures, with words, with misery, misery." Beckett, "Texts for Nothing 9."

104 "All nights are equal." Jean-Luc Nancy, *The Fall of Sleep.*

105 "Whose voice, no one's, there is no one, there's a voice without a mouth, and somewhere a kind of hearing, something compelled to hear, and somewhere a hand. . . ." Beckett, "Texts for Nothing 11."

MACHINATIONS OF ATTENTION

A Condensed History of Night

Until about the last 150 years, human comprehension of sleep had largely been blank science, lost in the trough of by what methods the end of our waking day comes on. We all know we lie down. We close our eyes, the blood slows with the breathing: the body letting go, unto a state of no time, walled with collages of words and images held deep. There must be, between these two spheres, some median of click-out: a point of A at which we are aboveground in our minds, and a point B at which we've entered somewhere gone.

Those who could not sleep soundly, we thought for so long, must be otherwise diseased, held of an error in the body, akin to coma, stupor, looming toward death.

Fourth leg in the continuum of deep-seated human physical instincts, and perhaps even more so than what one might call the other three—eating, shitting, fucking—sleep seems the one room

always overhead, of its own will. Sleep is the start and end of any set of hours, bookends on voluntary motion, the eyes through it most always closed, set instead to the flashing, patterned panel waiting always underneath the lids. *To be dormant, quiescent, or inactive, as faculties. To be careless or unalert.*[1]

The Old Testament frames sleep as a metaphysical commodity, located only through the grace of god: "In vain you rise early and stay up late, toiling for food to eat—for he grants sleep to those he loves" (Psalm 127:2). Once granted, though, it is a state not to be dwelt in, or overused—there must remain an attentiveness to life's toil: "Do not love sleep or you will grow poor; stay awake and you will have food to spare" (Proverbs 20:13).

In sickness, as in sleeping, the body wants the bed. As early as the Neolithic Age (~9500 BC), the first mattresses are made of grass and leaves wrapped in skinned hides. Later, in Persia, beds are goat-skins filled with water; in Egypt, palm boughs piled into the home; in 200 BC the rich come to prefer feathers, plush linings stolen from living fowl: the dress of bodies borne for flight. Other early beds are bags stuffed with wool or straw or reeds or hay or down. It's not until the mid-eighteenth century that anything resembling the flat, stitched, and bordered fiber boxes most common at the turn of the twenty-first century appear.

Regardless of what the beds are made of, there are those whose bodies shake upon them, stricken waking, open to the night. Many go uncounted. Days then contain the same duration as days now.

1 http://dictionary.reference.com/browse/sleep.

In early Egypt, for those stricken sleepless, there is bloodletting, dream interpretation, enema, opium, magic, prayer to angry gods.

In India and China, there are vegetables and herbs.

In Greece: attention to architecture, water, light, and nature; balance of body fluids; medicines from snakes and geese.

The Greek god of sleep is Hypnos, son of Nix, the god of night; brother of Thanatos, the god of death; husband to Pasithea, the goddess of hallucination. When Hypnos and his wife touch, godflesh to godflesh, it was written, "from slumber woke all nations of the earth."[2]

In Rome, the god of sleep is Somnus, said to have one thousand sons, many of whom could assume different forms.

Likewise, the houses, as the beds have, continue to evolve. Architecture teaches these rooms more solid ways to keep the outside out and inside in. Roofs are slanted to let rain roll off and soften earth for farming. Pipes carry heat and water from other buildings beneath the house, into the house, lacing the walls. The bodies within the morphing surfaces carry on.

Around 400 BC, Hippocrates first specifies the state of dreaming as a medical condition. "Sleep is due to blood going from the limbs to the inner regions of the body," he suggests, characterizing the resting body as a volume drawing inward, absorbing cells and warmth toward its hub.

2 Adapted from Smyrnaeus's epic poem "The Fall of Troy."

In 350 BC, Aristotle goes against Hippocrates, correlating sleep to consumption. He claims the transference and conversion of food-stuff into the body produces fumes that filter up and remove heat from the brain, at which point we nod out. Sleep then ends when digestion has been completed: a cycle based on the nature and the volume of what is taken in.

Six hundred years later, Galen of Pergamon synthesizes the self as fleshy system and dreaming as a reflective transcendental presence. He writes: "For it is likely that in sleep the soul, having gone into the depths of the body and retreated from the external perceptions, perceives the dispositions throughout the body and forms an impression of all that it reaches out to. . . . For those who have this impression that they are passing time in dung and mire either have their internal humors in bad condition, foul-smelling, and putrid, or they have an excess of dung encompassed in their bowels."[3] Sleep for some therein becomes a developer of guilt, a window into their nothing that might bring them embarrassment, or fear. The function flutters in a silence.

For the most part, among these early ideas of what its shape might be, sleep as a function passes unexplored. Night goes on in silence, riding blankly. The flesh contains itself.

It's not until the seventeenth century that Descartes outlines a theory updating Aristotle's, a "hydraulic model" in which sleep arrives when the pineal gland ceases holding the brain up from the inside. During waking hours, the brain is filled with *animal spirits*

3 Galen, "On Diagnosis in Dreams." (http://www.ucl.ac.uk/~ucgajpd/medicina%20 antiqua/tr_GalDreams.html).

that give it volume; when these spirits dissipate inside the flesh, the pineal makes the brain's ventricles collapse and we fall asleep via the absence of our primordial forces, somewhat like an inverse model of the male erection.

Soon after Descartes, Thomas Willis and Thomas Sydenham begin to outline troubled sleepers' inherent neurological symptoms, including nightmares, restless legs, and the accelerative effect of drinking coffee. Sydenham in particular ties the recurring condition to an act determined by the actions of the self, which he considers unique from the acute.

People of this era are urged to smoke opium and kill witches. Epidemics spread. Interest grows again in bloodletting, and in careful control of one's diet. Some speak of spirits or poltergeists that might occupy the body and thereby snake into the mind: formless presences attached to earth locations, patrolling air. More houses have more doors.

In 1623, "insomnia" is first termed, from Latin: *in* (not) *somnus* (sleep). Rather than its negation, the state is simply anything the other thing is not—the ongoing world surrounding. In his English-language dictionary, Henry Cockeram defines: "Insomnie. Watching, want of power to sleepe." This want comes among a growing league of other surrounding wants. There is more now to watch and clamor for than ever. Soon, too, there will be more more. There will be.

In 1757, Frenchman Robert-François Damiens is tortured and eventually drawn and quartered for his unsuccessful attempt to assassinate Louis XV. In the midst of his handling, which includes

red-hot pincers, sulfur burning, and molten lead poured into open wounds, Damiens claims his greatest anguish is not the burning or beating, but his being deprived of sleep.[4] His life ends with him looking on the removed parts of his body, screaming, "Kiss me, gentlemen!" at his dispatchers, and calling on the name of god.[5]

In 1772, oxygen is discovered, a shared blanket wrapped around the earth. Plants are found to have biological rhythm, opening and closing with the light, which then affects our view of our own bodies. Atrophy is recognized in muscles. Dreams are thought of as disease. Some find respite in *mesmerism*, mirroring the sleep state inside the waking self, turning open to implanted suggestion, or to visions. Someone invents quinine, the telescope, the pressure cooker. Smoke rises off of things. Electricity is found to exist not only in the air outside the body, but moving through us.

We get artificial teeth. We get circular saws, steamboats, and carbonated water. Lenses in split frames help us to better see each other, anywhere.

In 1781, Kant conceives the disintegration of the self owned by the self, claiming: "Consciousness of self according to the determinations of our state in inner perception is merely empirical, and always changing. No fixed and abiding self can present itself in this flux of inner appearances . . . [Thus] there must be a condition which precedes all experience, and which makes experience itself possible."[6] There is something, then, it could be said, lurking inside us, many

4 Stearns, Rowland, and Genefke, 349.

5 *Discipline and Punish*, 3.

6 *Critique of Pure Reason*, 138.

kinds of something, perhaps, modes that make us who we are, though we have no clear title for it or way to place it.

Regardless, in 1790, we get the U.S. Patent Act, allowing each object in creation a number and a name, its purpose tendered, tallied, and on file for commoditization.

In the nineteenth century, we get local anesthesia. We get the revolver, kaleidoscopes, gas stoves and bikes, the tuning fork. Photography teaches us to pose in ways we want to remember, captured just that way, replicating among a light. Landscapes and houses appear doubled in our images behind us. Some see the pin-sized hole of the camera's eye as a magic conduit of Satan, though this most of us will learn to disregard. Machines are replicating also, customizing to our more and more particular kinds of needs.

Water beds are invented to help prevent bedsores in invalids. The stethoscope allows us to listen in on what's been going on inside us all this time: sounds we mostly haven't located in our bodies before, except sometimes at night, when with our heads pressed into the beds we hear the reflection of our heartbeat, the breath around our heads.

In the new light, of sick people, we become aware of the spreading of unseen cells. These cells are given names. They've been here all this time surrounding, begetting our disease. People die now for reasons we can more aptly put a face to. We use their death to inform the growing duration of our lives. We learn surgical operation, opening flesh. We get the telephone, the typewriter, ice cream, and badminton, and these too are not enough, and we make more.

In 1795,[7] Johann Blumenbach becomes the first person to actually observe the brain of someone who is asleep. He finds that in this state the brain is paler than at other times, thus suggesting, to him, that sleep is caused indeed by blood flushing to the skull. Various vascular theories, including those by Alcmaeon, von Haller, and Boerhaave, all revolve again around Hippocrates's idea of sleep as related to the flow of blood. Luigi Rolando cuts the cerebral hemispheres from birds and finds the creatures then become perpetually sleepy. Further research is performed on subjects with fractured skulls: "When she was in deep sleep the organ remained motionless beneath the crest of the cranial bones. When she was dreaming it became somewhat elevated and when she was awake it protruded from the fissure in the skull."[8]

Thirty years later, Robert MacNish says it's more about the blood's brain pressure than about the flow. Another dozen years and Johannes Purkinje says that in sleep the brain's corona radiata become pressed upon by blood-cell congestion in the basal ganglia to the point neural expressions are cut off, thus suggesting sleep is more like a mode of cerebral blockage than an emptiness, mere drain. In 1865, John Jackson finds that the flesh of the eyes also go gray in sleeping, and therefore suggests sleep is not a result of the brain's loss or gain of mass of skullheld blood at all. A guy named Hammond comes back and says sleep is more like an anemia, the decrease of hemoglobin. Theories by Fleming, Donders, Durham, Howell, and Hill continue to support the concept of sleep as the product of the blood's evacuation, though they disagree on where this blood

7 Much of the historical details regarding innovations in sleep theory found here was derived from Thorpy and Yager's *The Encyclopedia of Sleep and Sleep Disorders.*
8 Hammond, 19.

goes when it leaves the brain. More and more people publish papers containing their own tailored projection, flailing new thought into the light. In the meantime, we get celluloid, allowing cheaper, quicker, better replications: the replications are replicating.

In the second half of the nineteenth century, via Camillo Golgi and his successor Heinrich Waldeyer, neurons are identified and named. Rabl-Rückhardt suggests that sleep may be caused by a state in which these neurons become paralyzed and therefore temporarily cease communication. Lepine and Duval say this too. Santiago Ramón y Cajal says not only is this perhaps the cause of sleep but it could also explain hypnotics. Ernesto Lugaro takes the opposite face of the same coin, and says it's not paralysis, but an expansion, the neurons growing to speak to one another more directly via sleep.

Exercise becomes more popularly encouraged, as do baths. "Healthy people always sleep well," we are told. Sleep trouble, then, must come from something wrong within, a condition "self-inflicted," rather than the simple disdain of a god. We begin to become hyperconscious both about the exercising, and about napping, which divides the sleep space, weakening the evening's exhaustion, breaking time.

Our houses, in this manner, become more divided. Indoor toilets let us shit in smaller rooms beside the rooms in which we sleep. Production of a cheap plate glass allows homes to invoke windows, often called "wind eyes," through which the sun and sky and night from overhead might see into the house. Later, the shape of glass will be found to flow in undetectable modes of motion, deforming over time, though at such a slow rate that a single pane's approach

to equilibrium would require 10^{32} years, several times longer than the estimated age of the universe. We continue to employ glass in our surroundings.

Our rate of growing grows. We get safety razors, roll film, cars. Freud notes how our paralysis in sleeping keeps us from acting out our dreams. Despite a sudden rash of manuals for parents, none of them addresses the nature of children's sleep—instead they take concern with bedding, with sleep positions, frigid feet.[9] We get blue jeans, chewing gum, and dynamite. Physicians begin to outline the average number of resting hours needed in a body, specific to a range of ages, bestowing practical, routinizing life advice. The saying "Early to bed, early to rise" brings new enthusiastic pressure to the method, like *nod out now or you will fail*. To remain productive, upbeat, making, there seems a clear method, though not all people seem equipped the same way to make it work.

We get linoleum, stock tickers, and the player piano. We get heroin, loudspeakers, typewriters, roller coasters, the alarm clock. We get DDT, barbed wire, machine guns, gasoline engines, contact lenses, escalators, zippers, the box spring. Catatonia is discovered. We get tuned wireless communication.

In an echo of Aristotle's food fumes, Wilhelm Sommer in 1868 theorizes sleep comes from brain asphyxiation. The brain is shown to suck in more air while we are resting, breathing in the room, of a shared air. Other theorists like Thierry Preyer begin to attribute sleep to the body's accumulations of kinds of harmful cells throughout the days: lactic acid, cholesterol, carbon dioxide, toxic

9 Stearns, 345.

waste. There are all these chemicals inside us, stuck, resounding, with more being pumped and funneled through the air. Leo Errera explains sleep as another strain of these undesirable substances, referred to as "leucomaines," getting passed up to the brain to be broken down, fed through the body unto depletion, at which point, again cleared, we wake up. Abel Bouchard specifies that these toxins are made into urine in the sleep state, and that the agents in the new urine cause us to wake.

In 1869, the sedative properties of a compound called chloral hydrate are published. Its ease of manufacture and ability to lay a person out make it quickly popular and widely prescribed. Over the next 150 years this chemical will come to be used in date-rape drugs and in a mounting medium used to observe organisms under microscope. It will eventually be found in the blood of the bodies at Jonestown and in John Tyndall, Marilyn Monroe, and Anna Nicole Smith. The bodies, laid beneath the soil, might be seen by some to mix.

In 1880, Thomas Edison—himself a chronic problem-sleeper—patents the light bulb, taking credit for a long string of inherited versions and ideas. This new ability to control the kinds of hours of light indoors and out grants new democracy to our actions, and thus a glaze of uniformity to the phases of the day. Under contained glow, by machines, we can now work longer, late into evenings, in early mornings even, in the smallest, most unwindowed rooms. Bulbs on streets and in rising buildings will obscure the dark all through the hours, blurting the smaller stars out. Rooms inside of rooms will shine encombed. This development will be pointed to, by some, as years rise, as the number one cause of troubled sleep: all hours are the same.

In 1882, Nietzsche declares god dead: "God remains dead. And we have killed him. How shall we comfort ourselves, the murderers of all murderers?" The same year, U.S. Patent 268693 describes a "Device For Life In Buried Persons," a periscope-style tube allowing the interred to breathe from underground and signal they are there to those above.

Around the turn into the twentieth century, we return to sleep's cause being founded in ideological and spiritual ideas. Brown-Sequard and Heubel suggest that sleep is an inhibitory product, a space wherein the body cuts off its sensory stimulation, in the name of performing upkeep on the mechanisms of staying alert. Many minds, like Osborne, Gayet, and Mauthner, try to pinpoint to specific places inside the body responsible for the shift between sleeping and waking—Gayet pinpoints the brain stem; Mauthner notices the rapid movement of the eyes, but many don't give credence to these findings—instead, we begin to tune in even nearer to our sleep-related behaviors. Mothers are advised of night-lights for fearful children, as well as taking care not to over-coddle every cry. Children are fenced in inside stationary cribs rather than cradles—new isolation.

Meanwhile, great advances are made in the awarenesses of new kinds of anesthesia, various -ologies pinpointing refined informational systems related to the body's ways. We are more vigilant now than ever over bacteria. We wipe surfaces. We avoid. People start looking for answers to sleep disruption through new medicine, mainly centered around hypnotics: bromide, paraldehyde, sulfonal. We simultaneously acknowledge the vital healing aspects of sleep as a function, and the rising wave of stress. We get radio transmission and the magnetic tape recorder. We get methamphetamine.

Around now pictures come in color, our replications that much more like us.

In 1898, we get the remote control, so we can stay in bed for longer and still see into rooms beyond the home. People sometimes press buttons they had not meant to press and see things they had not meant to see. Gelineau names "narcolepsy," a relatively common condition wherein the body is overcome with sudden, extreme fatigue, often causing blackouts and public collapse. The name is based on two Greek words that mean "a benumbing" and "to overtake." Another widespread condition, later termed sleep apnea, involves interruption to the sleeper by abnormal breathing interruptions, causing poor rest. The more aware we are of what is in us, the more difficult it might be, in ways, to disregard, and so therefore, to remain calm.

Entering the twentieth century, we get the tank, the bra, the vacuum cleaner, vitamins. We begin taking pictures of the brain. Death during childbirth is at an all-time low. We get machines that cool the air inside our homes and machines that burn our skin so we look healthy. William L. Murphy invents a bed that can fold into the wall so you can walk around where the bed would be usually during the day, a new concealing in the name of more frequent open air. We get sonar, cellophane, the neon lamp, and helicopters. At last the self-starting automobile is perfected. People no longer have to stand still for hours to become pictures: it is more instant. It will become more instant someday still. Harry Houdini, having hardly escaped alive from a magic trick of his own devising, says, "The weight of the earth is killing."

Increasingly, doctors warn against the overstimulation of the child—the lingering attentions of the parent, the rising rigor of

the public school system and extracurricular training, not to mention books and film. "The fundamental requirement," we are advised, "is to keep the child free from over-fatigue every hour of the day."[10] In 1910, the Child Health Committee, supported by the Bureau of Education, institutes a standard of "13 hours of sleep for children 5–6, 12 for those 6–8, 11 for those 10–12, 10 1/2 for those 12–14, 10 for those 14–16, and still 9 1/2 up to 18."[11] Many experts argue about those numbers, some demanding less, some even more, the common denominator being that the child's life schedule should be rigorous and in tune with the caretaking adult's. More manuals beget more parental worry beget more attenuation to the child beget the child's increasing attenuation to the self. Set regular bedtimes. Consult your doctor. Be wary, and prepared.

During World War I, "sleeping epidemics" in the form of encephalitis lethargica spread. In Africa, parasites with trembling membranes enter the flesh and multiply, infecting humans, horses, cows into a deep sleep from which they cannot be aroused. We are encouraged more often to recycle, feeding old shapes back into making new. There is more tangled air in all the speaking, eating, seeing by the hour. Houses grow to hold more artificial glow. Freud starts talking not only about what dreams mean, but how within them our limbs are paralyzed so as not to allow us to act them out. People are regularly X-rayed, photographed inside the body. We get automation and sound film. Each day there are new walls built, old ones torn down. Joseph Jules Dejerine says, "Sleep cannot be localized."

10 Ibid., 350.
11 Ibid., 352.

In 1928, we get sliced bread, antibiotics. Pavlov demonstrates the programmed automation of the animal by making dogs respond as machines, demonstrating how we humans also are. John Watson notes how "*perfect* homes had no outsiders dealing with infants."[12] Cribs proliferate in design, beginning a league of further trends in parenting that fluctuate and flow like the procession of stylish clothes. Your child might be judged on what he or she is wearing, same as you are. This is a reflection of who you are, both morally, and in mind. Older relatives less often live inside their offspring's house, keeping their own air, or relegated to group homes, where they spend the last years of their lives. Children get their own rooms in the growing houses, as do each parent their own bed. "It is much better to sleep by yourself," they say. They're always talking. "You can rest better and breathe fresher air if you have a bed all your own."[13]

Someone invents the radio. Someone invents the TV. There is a new term: *chronic fatigue*. Several major U.S. cities ban elementary school homework, in coalition against our children's growing night anxiety. The earth, turning, makes no sound as far as we hear. More and more stimuli are considered factors affecting sleep. Opiates, once considered easy sleep aids, are found addictive, frowned upon—in their place, a growing population of new meds. Neurochemists test their ideas burning portions out of the minds of rats.

In 1929, Hans Berger records the electricity of a human brain, leading to the use of the electroencephalograph for tracking the activity of sleep. Aserinsky and Kleitman birth the phrase "rapid eye movement," and link it to the seeing of the mind inside the

12 Ibid., 357.
13 Ibid., 359.

dreaming state, which is soon thereafter subdivided into regions, shifting states. Now sleep as a place is polarized. Everybody's still looking for the specific organ or the cells responsible for nodding out. We are told to consider light and sound, with new emphasis on airflow and uncrowding of sleep space, and so our brain's air, and so our emotional well-being. Dr. Spock says kids' bedtimes can be varied, attuned to rhythms, as long as presented in a pleasant way. No matter which choice you make there are those who will say the opposite is true.

In 1932, Ranson shows that placing lesions on the brainstem makes a person sleepy. Three years later Bremer shows that lesions placed specifically on the lateral hypothalamus cause drowsiness by deactivating the "waking center"—the first directly named finding of a neurological insomniac cue, if caused passively, and by prodding. Sleep maintenance is linked to serotonin, the substance that later, as the century begins to close, will be taught to birth out of a pill. Forel studies systems of bees and talks about circadian rhythms' effect in humans. Bedtime prayers involving latent fear are warned against for causing anxiety before bed, no more *If I should die before I wake . . .*

In 1938, we get LSD. We get the ballpoint pen. Scholars perform experiments in isolation underground and in huge caves outside of light and speech and sound to show that there are periods innate to the person—that time is in our blood. Among children, it is cool, frontier-like, to stay up later. "Certainly one would never want to teach a child to be dependent on being held or rocked to sleep," they say.[14] Antonin Artaud coins the term *la réalité virtuelle*, which in coming years will be used to sell video games. At least 15 mil-

14 Ibid., 355.

lion bodies become murdered based on words emerged from one man's mouth.

In 1945, we get the microwave oven, the Slinky, nuclear weapons. In 1946, we get mobile phones. Certain people are easier to find without their cooperation. Their bodies radiate the heat. We become targets, followed, complexly haunted. Carcinogens collect in pockets, at our cells. People start finding and naming even more sleep disorders, which beget more clinical diagnoses, which beget more and more and more medications. There are more books, more words within them, more ideas relegated to what a dream might mean. In 1950-something, Samuel Beckett writes: "Name, no, nothing is namable, tell, no, nothing can be told, what then, I don't know, I shouldn't have begun."[15]

In 1951, Eugene Aserinsky records his eight-year-old son's eyes through a whole night by EEG and EOG. He notices two phases of the eyes' movement: twenty-minute periods when the eyes rapidly jerk around behind the lid, as if in seeing, and sixty- to ninety-minute stationary periods occurring regularly between. Based on this information, the basic model for sleep is renovated to include two major modes: when the eyes are still (non-rapid eye movement, NREM) and when our eyes move as they might in seeing while awake (rapid eye movement, REM). A single night's sleep typically involves four to six periods of strobing between these two. Each lasts, on average, seventy minutes to two hours, with variation.

Later, the NREM period is further subdivided into four stages: Stage 1, in which the shift between waking and sleeping begins—

15 "Texts for Nothing 11."

becoming drowsy, the brain's alpha waves turn slow; stage 2, in which the alpha rhythms slow down further, into theta, punctuated by small bursts of electricity called "sleep spindles." These first two stages are often brief, but may stretch longer for the busy-brained, and may seem to some not like sleep at all. Stages 3 and 4 are known as delta sleep, the brain slowing down to high-amplitude, low-activity delta waves; muscle tone turns lax; the heartbeat quiets, decreasing metabolism; these stages serve as a door into REM. REM is further found to differ from the NREM in that the brain becomes dramatically activated in electricity and metabolic rate— blood flow to the brain increases 62 to 173 percent; flesh holds a cold-blooded mode; vast jumps occur up and down in breathing and pulse; we experience vivid dreams. Through these facets, sleep now at last has some ground of operational understanding that will hold on as scientific fact, though for the most part we'll proceed almost nowhere in the way of knowing why any of it happens, or what it means.

In 1949, Egas Moniz wins the Nobel Prize for popularizing the lobotomy. We further customize our homes. Ranch-style homes become popular for their open floor plans and larger windows, allowing in more light. The first U.S. local TV station opens in Pittsburgh.

In 1952, David Tudor performs the premiere of John Cage's *4'33"*. "There's no such thing as silence," Cage says. Sales of teddy bears increase. Bedtime stories are commonly cliff-hangers. People binge eat inside their sleep, not remembering why their refrigerators in the morning look so empty, why they want. *Playboy* unveils a kind of flesh upon the stands. Six years later, the Barbie doll follows with its own malformed body image, its representational sex organs removed.

In 1960, we get the laser. We get hypertext and the wristwatch. There are more and more machines each day counting the time, with mixed results. Watches not watched will die and stay stuck on one specific time. In the night, in rooms, the working rotating second hands can be heard to click. Small distractions often loom longest in the face of what seems nowhere, and yet is everywhere at once. We feel we need more information.

"What madness gained in precision through its scientific outline," writes Michel Foucault, "it lost in the vigour of concrete perception; the asylum, where it was to rejoin its truth, was not a place from which it could be distinguished from that which was not its truth. The more objective it became, the less certain it was. The gesture that set it free in order to investigate it was also the operation that disseminated it, and hid it in all the concrete forms of reason."[16]

In 1961, the Association for the Psychophysiological Study of Sleep (APSS) is founded, initializing the first official institution of organized sleep medicine. A series of national sleep disorder centers opens across the country, all of them together brought together in 1976 by the Association of Sleep Disorder Centers (ASDC), one year after Ed Roberts coins the first personal computer. Soon, from that first node of centers, there are born even more sleep associations, such as the Sleep Research Society (SRS) and the Clinical Sleep Society (CSS), so many that in 1986 they all band together to form the Association of Professional Sleep Societies (APSS), which changes its name to the American Sleep Disorders Association (ASDA) in 1987 and again to the American Academy of Sleep

16 *History of Madness*, 471.

Medicine (AASM) in 1999. Quickly the federations of associations spread across the globe, each with its own abbreviation: the ESRS, the JSSR, the BASS, the SSRS, the LASS, the SSC, the BSS—all these organs in one massive body.

In 1962, Walmart is founded and opens for business—nearly fifty years later, one-third of America will shop in one of the chain's 4,000-plus locations every week—among a strong unwinking white light, consumed with sound.

In 1965, we get the digital clock. Depression spreads, begetting ritualizing of regular visits to the shrink. A farmer in Kiev uncovers the oldest known constructed dwelling, dating to 10,000 BC, comprised of mammoth bones.[17] We understand there could be older houses underneath our other houses, or maybe graves. More light sinks into our lymph. In 1966, locked-in syndrome is discovered, a condition in which a person is conscious and awake but cannot move his or her body beyond the eyes. The Air Force begins to train their men in target practice using simulation-based machines: programs in which the images of electronic men are murdered and, when reset, will live again. The Super Bowl begins. In 1968, regarding his near-death experience being shot by Valerie Solanas, Andy Warhol says, "It was just as if I was watching another movie."[18] The gold standard for U.S. currency is repealed.

"You must never sleep," writes Anton LaVey in 1969, "never daydream, never be without a vital thought, and never have an open mind." We define jet lag, conditioned insomnia, problem snorers,

17 http://www.infoukes.com/history/inventions.
18 Goldsmith, 219.

noise pollution. Charles Manson is on TV. The Death of God is now a popular theological movement, appearing on the face of *Time*. Years, for many, as they pass, feel less like years, shorter in spanning and longer in the minutes of the day. Parts of songs begin appearing inserted backwards in popular music, advertisements, infecting our idea of what we hear in what we hear.

In the 1970s, we get digital photography, videocassettes, pocket calculators, instant noodles, space stations, e-mail, and karaoke. For the first time, narcolepsy is diagnosed in a dog. Reverend Jim Jones installs speaker systems in his Peoples Temple commune in Guyana, broadcasting his ranting at all hours, through the night. "A lot of people are tired around here," Jones says, "but I'm not sure they're ready to lie down, stretch out, and fall asleep." Kales associates insomnia with a state of "constant emotional arousal," whose physiological effects include high heart rate, restricted veins, raised rectal temperatures, and an increase in body movement while trying to nod off—all, for him, by-products of internalizing one's emotions and environments, absorbing them into the blood. We get microprocessors, Ethernet, the personal computer, the Happy Meal. We get stereo, the Walkman, the Rubik's cube, DNA sequencing, the digital camera, Gore-Tex, Atari. Gary Gilmore, facing his own death, demands, "Let's do it." The world population passes four billion.

In the '80s, we get CDs, flash memory, the artificial heart, hair metal, digital audio tape, the internet. A record number of people tune in to the soap opera *Dallas*, caught up in a conspiracy of who shot the central character—the programmed death of such manifestations, as well as who is fucking who in pretend on screen, will continue to be primary reasons for tuning in to anything for a lot of

people. "The succession of the seasons and the superposition of the same season from different years dissolves forms and persons and gives rise to movements, speeds, delays, and affects," write Deleuze and Guattari, "as if as the narrative progressed something were escaping from an impalpable matter."[19]

In 1981, the sleep drug trazodone is approved by the FDA. It will come to be known by many other names, like a god: it will be Beneficat, Deprax, Desirel, Desyrel, Molipaxin, Thombran, Trazorel, Trialodine, Trittico. During the next thirty or so years, the presence of these pills will replicate in name and manner of effect, including: zolpidem (increases sleep time, and in some cases has been found to revive patients from a minimally conscious coma to a fully conscious state), zaleplon (reduces awakening), estazolam (maintains duration and quality of sleep), flurazepam (helps sleep induction), quazepam (to be avoided in elderly patients), temazepam (decreases awakenings but distorts normal sleep pattern), and triazolam (known to cause adverse effects on memory). Each of these agents as well, like trazodone, enjoys a sublist of other equally mythologically dreamlike names by which they are marketed to users: zolpidem is Adormix, Ambien, Ambien CR, Edluar, Damixan, Hypnogen, Ivedal, Lioran, Myslee, Nytamel, Sanval, Stilnoct, Stilnox, Stilnox CR, Sucedal, Zoldem, Zolnod, and Zolpihexal; zaleplon is Sonata and Starnoc; estazolam is Eurodin, ProSom; flurazepam is Dalmadorm and Dalmane; quazepam is Doral, Dormalin; temazepam is Euhypnos, Norkotral, Normison, Remestan, Restoril (found in the blood of Heath Ledger on his deathbed, along with the OTC pill Unisom), Temtabs, and Tenox; triazolam is Apo-Triazo, Halcion (Jeffrey Dahmer's brand of

19 *A Thousand Plateaus*, 268.

choice for sedating victims), Hypam, and Trilam. Each pill as well might have many names saved for the street: "terms for temazepam include King Kong pills, jellies, jelly, Edinburgh eccies, tams, terms, mazzies, temazies, tammies, temmies, beans, eggs, green eggs, wobbly eggs, knockouts, hardball, norries, oranges, rugby balls, ruggers, terminators, red and blue, no-gos, blackout, green devils, drunk pills, brainwash, mind-erasers, tem-tems, mommy's big helper, vitamin T, big T, TZ, and others."[20] This for each goes on and on, language bifurcating around the object. In each word lurk several dozen; from each pill spring more pills to observe, and more pills manufactured in competition, begging which is best to suit your head.

In 1987, we get the Sleep Number bed, allowing the consumer to choose a setting between 0 and 100, as fits one's comfort; eventually, consumers will issue complaints about how the air pockets in the Sleep Number mattresses grow mold. Sleep deprivation procedures are used by David Koresh in his Branch Davidian compound, and later, from the other end, by the CIA against the compound from the outside in an attempt to force its inhabitants to surrender. Each year computers keep getting smaller, smarter. They are taught to talk in human speech. Meanwhile TVs grow in the reverse direction, though also aimed at more correctly replicating the things we see, sized as we are, or even larger. Our atmospheric volume stays the same. Rats in labs are subjected to sleep deprivation and grow lesions and bacterial colonies in their flesh, losing weight despite increased eating; later the rats die. The most common sleep position is found to be fetal. How one sleeps is said to reflect one's personality, mirror one's fate. Every minute there are more ideas, theories,

20 http://en.wikipedia.org/wiki/Temazepam.

and classification systems of the intricacies of waking and of sleeping, and therefore of sleep trouble, polysomnias, meta-thoughts, than ever. Photographs of night continue to exist during the day.

The cities sprawl. In 1989, the Guinness record for world's longest movie is an eighty-five-hour-long creation titled *The Cure for Insomnia*, which consists almost entirely of a guy reading his 4,080-page poem of the same name, occasionally cut with heavy metal and clips from porn. The next year, Adobe Photoshop 1.0 is released into the public, popularizing direct manipulation of the image. In 1992, we get *memory foam*, which learns to mold itself around our bodies. "I am tired" becomes so common a phrase it's no longer even worth admitting.

In 1995, the direct cost of insomnia in the U.S. for medications and health care services is estimated at $13.96 billion.[21] That same year the fourteen members of the Order of the Solar Temple doomsday group are found dead in a forest in the French Alps, arranged in a star formation, most with sleep drugs in their blood. A year earlier, another forty-eight of the same group had been found dead, many in a mirror-lined underground chapel, arranged into a circle and full of sleep drugs, with plastic bags around their heads to protect against the plague they believed was coming for all humans at their exit. Deleuze throws himself out of a window.

By the end of the twentieth century, reports say sleep time in Americans over the past hundred years has decreased by 20 percent. Reports show that the errors caused by our lost sleep result in more than 110,000 injuries and 5,000 fatalities every year, not

21 Colten and Altevogt.

to mention incidents such as Chernobyl, the *Challenger*, the *Exxon Valdez*—the damage leaking out into air and water, back into our blood. Sleep loss is shown to cause obesity, diabetes, cardiovascular disease, anxiety, depression, and alcoholism. The queen-sized mattress at last passes the twin as the most popular American size of bed. Lack of sleep will soon be linked to weight gain. We map the human genome.

Days continue to act within the length of days. We get Google, YouTube, Myspace, Facebook. On each of these sites, and many like them, new data is added by the second by the bit, with multibillion users awake and online at any time. Pictures of people's heads appear on further websites, aggregated. We have all these passwords to remember, and questions to answer to retrieve the passwords, and codes written to try to trick the passwords from our heads. Spam mail accrues in folders often unaccounted, relaying sentences such as "I went to sleep, woke up, and there was more money in my account." We get breath strips and Bluetooth, satellite radio, the artificial liver. People are diagnosed as having sleep sex and sleep e-mailing in the manner of somnambulism. We get human-approved Botox, which 150 years prior had been known as sausage poison. The largest shopping mall ever on the earth opens in China and remains perpetually 99 percent unfilled. Fewer people need to walk or speak more often because there are machines that do it for them. People laugh, still. There are parties. Certain men announce themselves as god returned in human form and they are killed or kill themselves. Kids are also killing other kids in schools more often, and eating pills more often. We get the birth control patch, the Date Rape Drug Spotter, GPS. We get the iPod and its competing replicants, each version smaller than the one before. Bodies make more bodies and those bodies make

more too—the method of the making, at least, doesn't change in how it works upon the body, though the body is no longer officially required. People continue to write their own sentences and record music and say words and take more photographs and they consume and they emit. Artificial flesh is developed to replace destroyed limbs or regulate the systems in specific hearts or heads. Electronic pets popularize among the young, though the electronic pets can still die. Tanning beds are deemed "as deadly as arsenic and mustard gas" and still are popular as ever.[22] There is such sound, so much that when it's silent some feel the most fear. There are more books than ever, more albums, movies, more ideas, coming from more bodies and machines within further and further subdivided air. All of this information, every hour, goes on in light or no light, while in automated buildings we sleep the same way when we can, eyes alive inside the head and body held still, if interrupted or on pills, waking mornings with the taste of nowhere in our mouths and crust around our eyes. We rise and find our shapes imprinted on the bed's make and the mattresses conforming over years, filling with living cells of those in feed, and the surrounding walls made slightly thicker with cosmetic paint and a kind of psychic crowd—each room a room where someone else might once have lived once or inside the night come in, packed with an air that goes on before and after anybody, at any instant with and without where, unto whatever.

22 http://www.breitbart.com/article.php?id=D99NORBO0&show_article=1.

What Not Sleeping Starts To Make

> And I also have no name, and that is my name. And because I depersonalize to the point of not having a name, I shall answer every time someone says: me.
>
> Clarice Lispector

For several years between the ages of eight and twelve, I saw the same dream every night. The trick about the dream is that I was not dreaming, or asleep. The vision was of my room. In the vision I lay in my bed the way I did when waking, in my blue bedroom in the half bunk bed with the head end against the wall. From in the bed I could see above me a large stone boulder hung in the ceiling, through our home's roof, lying lodged. The boulder was large as half of my whole room was, and seemed to negate any air. I mean

in the room I was not breathing, and did not need to. I could not close these second eyes behind my eyes.

Each night, the boulder rolled. I could feel it edging forward slightly in its dark mass, so slow that it almost seemed not to move at all. There was a low sound to the grinding, its frame against the house's frame. Over hours, the boulder would roll toward me looming, approaching closer and closer to my head. During this whole time I could not move my arms or legs or blink my eyes at all. I could not force myself to come back fully into wake, nor could I lapse deep enough into the nothing that there was nothing I could see. I could not unlock myself from watching, through the whole night, as it came forward, end over end, the space between us slowly pressing, growing closer inch by inch. Soon it would be so close above me I could feel it breathing where I wasn't, its face the only element left in my sight. It would grow and grow there, just above me. It would be a yard away, and then a foot. Then it would be right there eye to eye against me, like some whole shapeless sky just at my face—a gray and endless thing with sound inside it. *Nowhere.* Up close the sphere had the same texture as it did from far away, hazy and cut with long lines.

The dream ended the same way every time. Having spent the duration of the night in hellish approach, there would at last be nearly no distance left between us. There would come a point where if the boulder rolled even one slip further, it would come against me, touch my skin. There was the clear threat of becoming crushed. Then, just as that last increment, which would end me, continued rolling, I would wake up again in my bed—waking in the same room where I had been during sleeping, though with the boulder no longer there, our home's ceiling and the air beneath it again

intact, an unbroken clean white surface holding out the night, complete with the fake, yellow nightglow stars I'd assigned above me like so many other kids then, in patterns to replicate the sky outside.

I did not wake with a start inside these moments, or with quick inhale, but just with a simple blink, returned. It might by then have become morning, or sometimes only several hours had gone past, and yet each time it seemed as if inside my sleep I'd gone through many days. Some nights the night would seem to have lasted longer than I'd been alive already, and yet I had not aged, as far as I could tell. My waking body always felt the same—as if I'd left it and returned there, leaving the time under the boulder somewhere else, or perhaps crammed into a crater on my inside, another wormhole in my brain. In this way time could become split: living longer inside these packets of my brain and body, if in pure torture, while on my flesh the days held human days—a space there captured between instants of the human, elongating in some fold beneath the conscious. In another way, this time extends eternal—I've never quite been able since then to shake the image of the boulder there above me, the slow grind of its low light—it is always in me—where?

After the first few times the dream repeated, I remember beginning to feel a great sense of impending anxiety about my bedtime. Into the late evening, hidden in my bedroom, I would try to stay conscious longer, to stay on, consuming my brain with reading or watching TV. I recorded tapes of myself reading books aloud—a practice installed in me at an early age by my mother—and would play them looping by my bedside to try to keep even my sleeping brain distracted. Not quite a violent and insistent need to avoid the

dreamworld, as in the *Nightmare on Elm Street* movies, where the sleepers are literally staying awake to avoid young death, but more a growing fear of the sleep state itself—ever the boulder, and its impending visitation.

Though the boulder seemed the beginning of the presence of recursion and strange noise in my sleep patterns, from here further the sleep disruption quickly spooled. The evenings peeling forward from this period hold stored in my mind not as a string of sequential hours, but as anomalies and drifts. Most nights awake alone seem to blend together, making one enormous long night of their thread. A single sky the blank of waking makes of darker hours spent not sleeping in or around the house or bed. Many nights from there on, under the boulder, seen or unseen, inside my own home's version I would stay awake for hours fearing the idea of what would happen to our house when my eyes would close. It could seem as if, at every second I was not seeing, the house would fill with silent strangers, standing above me, their mouths or other parts just inches from my eyes. Behind my eyes, where colors spun from how I put pressure on them holding my lids down hard as I could, the house would shift with sound and things between it. I did not want to have to look. And yet I had to look, and when I would there would be nothing. The room went on being a room. The hallway led on from my door into another. There were all these places they could hide. There was so much to see and hear for in not hearing. Every inch potential. Every light both a mirage and a guide, spooling outward into something, ever larger.

In her essay "Every Exit Is an Entrance (A Praise of Sleep)," Anne Carson describes her own experience of appearing in a dream of her childhood living room. In the dream she awakes in her sleeping

bed and rises, goes downstairs to find that familiar space left with its lights on, composed so "nothing was out of place. And yet it was utterly, certainly, different. Inside its usual appearance the living room was as changed as if it had gone mad." *Gone mad*, she writes, this room was, this *living room*, the space often most familiar to the habited motions of a family. The sense of the room's psionic reorchestration is evident only by its impression on her body, its image returned and altered by what she herself had felt or done inside the room, recurred. Carson's memory here serves her not as an object of terror or unveiling, but instead it is as if the room itself had been asleep, as if the air and outline of this room she no doubt came and went from daily in her sleep mind had a mind too, a consciousness, even, perhaps. Confronted in this brain field, Carson finds the room's shape "supremely consoling . . . sunk in its greenness, breathing its own order, answerable to no one, apparently penetrable everywhere and yet so perfectly disguised in all the propaganda of its own waking life as to become in a true sense something *incognito* at the heart of our sleeping house." Through her sleep's eye, where the room has amassed around her, Carson learns to see her life anew from strange angles, to find comfort in a terrain that might no longer be accessible through her body, but that herein exists in cells awakened in her conscious mind's release—access to terrain upon a map that connects to no concrete door, but a button in the head—one that, once aware of, one might find it harder or more fraught to interact with, or to reckon—the door to sleep now not a simple door, but one with many different kinds of locks and peepholes, eyes.

Years later, I found my limb-frozen experience described by science as the hypnopompic state—a branch "of consciousness leading out of sleep . . . emotional and credulous dreaming cognition trying

to make sense of real world stolidity."[23] The term *emotional* here is particularly compelling, in that it touches on an element of my particular dream's recursion that might not manifest itself directly on its face. In placing myself back in my body in that vision—which I find myself capable of doing without much of any interference—and allowing the image in me again to grind on, I feel a kind of calm but manic feeling coursing through me: a sense of immense stillness combined with a low, unwinking doom. The sensation of my impending demolition under the boulder's weight is not so much a threat or fury, but an eternal, pervading frame, as if all time held passed inside the moment and time to come could exist there in the hung present, nowhere, all sound and no sound, beyond death. In relief to each hour right now where I sit typing, and the rooms tonight where I will be when I move from one into the next, that space of being beneath the boulder remains exquisite, each instant of the nothing turned up so loud and wanting in me that to walk outside it into days makes what goes on around my flesh seem that much less real, obscuring memory and bodily function in dereference to the context of such light—eternity in the nowhere versus here-I-am-again today, in this old home whose walls go on and on without me, and outside it there, the world.

The result, if one allows it, is a kind of supercharging of any hour. Each instant of our being, eating, seeing, walking, wanting, is surrounded, consciously or unconsciously, by what we've hid inside ourselves, by where the dreamworlds we would have lived on and on inside forever if we could have go on without us—we locked inside our bodies out here without a clear door. The rooms where one is everyday, then, might seem foreign, or as strangers, a place you are

23 http://en.wikipedia.org/wiki/Hypnopompic.

because you are, and not because you ever really wanted, and they know. They hear you think. They have no arms or action to take against you, but they can hear your body, and they respond by being, going on, while you—you come and go again and again until you can't. Your home, in its long silence, maybe more than any other knows always exactly who you are, who you've been, and who you will be, what you have and have not done—and therein, in each day's eventual returning to the sleep field where the house is most alive, a kind of unconscious accruing of another kind of hidden, silent light that makes sleeping and waking seem to blur, to become closer to one another between hours, disrupting time inside of time.

That I am writing these sentences in the same bedroom where this dream came for me seems only fitting—that old bedroom now converted in my parents' house to a makeshift office where I come most days to be around to help my mother care for my father in his dementia—a constantly degrading state in which he less and less can recognize his surroundings or himself and how to move within it as he had—though no matter how hard I try, the ceiling of the room here now is just short and flat and white. There is nothing visibly disrupted in it. The nightglow stars have been removed. The walls, having been painted over purple and populated with my mother's things, are different enough that the room itself seems not that room from back then here at all—though in the air, the presence, I can feel it, I'd rather not let it know I do.

]

]

]

Once an awareness of the silent terror of selves in sleeping rooms and rooms inside of sleep is activated, it can be tricky to turn off. The fear of sleeplessness breeds more sleeplessness, and the locks begin to change around the keys, the mind turning activated inside a tired body, full of no distinct direction. The air of what wants out or on inside the head in growing tired and staying tired makes days seem brighter, thicker. The house around the self might seem to grow. Walls of rooms that might have been in spots before for so long might seem shifted slightly to the left, or of another color, gone. As well, in context with the body, the skull might seem thicker made around the eyes, or softing. The pupils set just deeper in the head now, new fat black edges around the seen. One might feel degrees warmer inside one's self, though the skin itself is as any day, as if cooking too deep beneath the outer surface to be detected. The head may seem sunken in itself, unseen layers laid over layers, like a helmet or a gown. Early on, especially, it can be difficult to decipher the unslept person from the other as there is little visible physical effect but in the face or around the eyes, and who, these days, does not look worn out? We need not to have not slept to seem some way destroyed, as there is enough air to be packed in or at or against any body to cause the body to decay. We know.

What do we know? As here, in speaking, too, the voice feels deeper set within one, heavy, rubbed with charcoal, *not quite mine*. This speech is often stuttered, skewed with burps of repetition or false replications of familiar sound. Suddenly, the light of words that had sat forever in their pattern, without question—one's name, for instance, or the numbers directed to dial through phones into one's house—begin, as with relentless repetition, to seem arbitrary, blank—sound carved out of nothing, hieroglyphic, shells. The voice

from deep within one's self, set lodged there, of an other, toned out through the lengthy corridors of skin. The speech, particularly in passing into others, might not come out as you'd meant, or even at all, in the range or urge of your intention for standing in a room. Contact with bodies is someone else's. Machines learn to trick you. Lights are loud—and the night, its saddened trick like someone placing a blanket over the cage in which for all these years you've been, inside yourself, corralled—room to room to room forever, mazes in a map, inside a video game made of air and buildings, no beginning and no end.

The default thought in light of all this, again, is to try to think of *nothing*. We are told, in sleep trouble studies, to try to clear our mind, to feel the stress and ideas pouring down out of our body. Silence. You're supposed to let everything go. The idea of thinking of nothing then quickly becomes the thought of trying to think of nothing, and the thought of that, and that. So begins the landslide, as to think of nothing is to think of everything at all. White space screams, "Complete me." Silence waits for how it will be filled. The very expectation of this nowhere coming on in definition works harder than any particular thing itself, filling around the want of blank with a hot vacuum, magnetizing mind.

In "Nothing: A Preliminary Account," Donald Barthelme approaches nothing's endless explanation by presenting a list of things nothing is not. "It's not the yellow curtains. Nor curtain rings. Nor is it bran in a bucket, not bran. . . ." The list goes on in loops of undefinition, hurrying itself forward to pack in more and more of nothing in the short remainder of our time, until soon, pages later, at all points failing to complete the list, it finds itself speaking of itself: "But if we cannot finish, we can at least begin. If

what exists is in each case the totality of the series of appearances which manifests it, then nothing must be characterized in terms of its non-appearances, no-shows, incorrigible tardiness. Nothing is what keeps us waiting (forever)." The elucidation ends, again, opening unto identity via blank, here made ominous in the knowledge that before any kind of such expectation could be completed, the duration of our lives here must end, which Barthelme again negates in his final iteration, "Nothing is not a nail." So here again is endless branching, reaching unto nothing and finding exactly that over and again where it is not, and again we feel exhausted and have gone nowhere, though perhaps in the meantime we have bumped up against some light.

John Cage reckons this silent, destructive expanse of nothing one step further in his "Lecture On Nothing," which opens with its own collapse:

I am here , and there is nothing to say

This sort of nothing, though, has definition, structure, interior lattice, flow:

 there are silences and the

words make help make the

silences .

 This space of time is organized

 .

Cage's simultaneous acknowledgement of the nothing's presence, and, within that presence, a nameless architecture that both makes the utterance futile and gives it shape, lend to the entire program a kind of noiseless pressure, an expectation both of the nothing itself and where the nothing seems to lean toward a break. The lecture continues in this strange progression, asking questions with no answers that then turn the frame onto itself, acknowledging the circular, independent, vexing, self-destructing mirror-hole of time. Each confrontation of the silence and its hidden, underlying structure evoke in the wandering field that is created a kind of insistence of the necessity of this blanking for the self's manifestation in the face of void: a pattern in the arbitrary that perpetuates because it *is*. The question begets another question not in hope for clarity, but to construct: an eternal definitionless field amassing around what is not there. To try to define such space would only there negate it further, to bend it deeper there where it is not.

In the third unit of the four-part talk, Cage's text enters into its own sort of repetitive blanking in and out, circling its self-aware and therein hybrid empty center, repeating interweaving variations of small phrases, punched into the pattern of a frameless, blank collage: "More and more / we have the feeling / that I am getting / nowhere," he says, again and again. But also: "That is a pleasure / which will continue." The nothing moment, then, is fed into the self as the self itself, and it is a joyful being rather than some guidebooked idea we are forced to press against. The effect acts to rather defuse what could be immortal terror in the way when one is told they must *relax* when they clearly can't relax, unto a resignation to the futility of self, which once invoked, allows a kind of interior freedom, functionally useless but existing nowhere else but in the self—the same way that in resigning the control of ego

to the unconscious we are rested and forced against the things we otherwise might never wear: *the rolling boulder, the room's awakening, the memory of people we'd forgotten, or who exist only in the dreamholds of the head.* The sleepless mind allows at last, away from waking onslaught, some brainless shape to bloat inside of, blanking out against such daily sinking into the want of warmth and light, rubbed and rubbing around no center. One is left at last, without sharp signal, endlessly upon some nameless cusp evoking both strange pleasure in its presence and terror in its refusal to come on.

]

]

]

The longest I ever couldn't sleep at once was 129 hours, through the turning of the New Year into 1999. I was living in the ex–master bedroom of my childhood home, the same room, likely, where I'd been conceived twenty years prior. The house since then had grown—six new rooms added to its dimension in my preteens, boxing in more air around. My bedroom's only two windows faced a small work shed my father called "The Building"—for younger years I'd both feared The Building and somehow hoped to some day live inside it, in its small and gloaming light. Often, awake with nowhere else to look beyond my window, I would feel sure I'd seen someone there inside that other, parallel pale, watching from behind a glint of moonglow, there just as quickly gone.

This certain week inside that week I'd come down sick with mono. My face swelled and my body bubbled sore. Hard to drink or think

or move mostly, in which case most similarly afflicted should be sleeping, and yet I, inside my room, could not turn me off. My brain, as if in cycling against the medical commandment, *Get as much rest as you can*, insisted each hour to stay cycling, drawing days on. I saw clocks even when I closed my eyes, drummed with the slow pulsating idea that any second might be the one in which my self's sound might finally become silent, slip to nowhere, become gone. Instead I saw colors, prisms, tunnels, smudging; the room packed full of eyes; the light sometimes from TV alone at 4 AM like a long and grossly narrow hall. I lay on the bottom half of what once had been a bunk bed, a thing I'd begged for years ago for Christmas though there was no one there to share it with, as if in the night I split into two and needed both, terrified by the way the room around me, in those hours, seemed as well to bore new holes in the walls.

Also visible from the room, via its two other glassy surfaces, were (a) the kidney-bean-shaped swimming pool where as a young child I nearly drowned, my mother having turned one moment in the light to look at something elsewhere and turned back to find me having somehow flipped facedown, and where in later years I would spend whole days of whole long summers underwater trying to hold my breath so hard I could turn hard myself inside and be thereafter able to walk beneath the nothing, breathing, in my flesh, though I clearly never did; and (b) through the small slit of window just above my bathroom's toilet, with one small latch clasp holding it closed, a view that mostly for most years would be obscured by brush growth from the plants that grew beside the house, obstructing the backyard. Only from certain angles and by leaning could you get any bit of sky inside that frame, and, when the bushes had been trimmed back, the right side of our next-door neighbor's

house, where a very large man lived with his old mother—the two of them together inside that small, encrushed house for years with a lawn that grew up and over and would die. In that grass once I found a skateboard I rode until it made me fall and drew my blood out. I also found a black softball bat I would in some evenings hold against me when sounds inside the house and through the walls would stir, waiting for something to come out so I could crush it—something nameless—it never came.

For all those years and since then I've never seen an inch of the inside of the house of those nearest neighbors. I've seen only the mother and the man inside there come and go, mostly just the man, coming out to climb to stand inside the backyard and look at nothing, or once to get on the roof and fix the antenna to the TV. How in that time he's shirked the cells off of his body from at least 350 pounds down to near now around 220—a shrinking of self much the way I had, years before him, just next door—as if, in the years between, we'd shared a cyst, a giving-of into a void. How now, seeing him wobble from the garage door down the drive, I cannot help but imagine his home lined with that old meat, hung on the walls, a padding against light and outside sound there, he and his mother. Some days in his thin afternoons he comes out and stares through the fence at my sister's barking dog, staring hard and wordless into the dog as if to burst it from its center, to desist its barking sound.

Between these three exits from this bedroom there would be enough conduit-space therein that at any given hour in my night there could be something coming in or peering in into me without me knowing, and this does not include the vents, the phone lines, the eventual internet connection, the holes too small for me to

see at all. These openings inside my room, without sleep defense image, seemed to stretch over all the air. By the third day of staying awake panels of color began to appear over my bed and beyond my doorway, floating scrims of ghosting color that would dissipate as I moved toward them in my flesh. Other times the color would form dots or ovals on my vision which then would bloom to globes or sink away. Space became not a system of dimensions but a kind of substance one could mold, if in the whole exhaustion feeling too far sunk in to manipulate even my eyes—thus, a twofold kind of shifting: seeing more and knowing less.

Around the house inside these changing I trudged from room to room through disparate hours of the night, crying through the hallways asking anybody, god or whoever, just to shut me down, undo my time. Standing in the kitchen on the far side of the counter from my mother in a late light and her looking at me, speaking, as if from several hundred years away. Less than the words she spoke then, I remember the sound that surrounded all the air around me and between us, the slight shake of my frame inside my frame, and of the frame of house around me, and the air around that, layers quaking, full of night. Sometimes back inside my bedroom again hours later, as if time had not passed, I'd get the feeling that all the doors inside the house, all houses, had come open, and anything then was able to go out or come in. There comes, in the carving out, a sight—a slightly buttered color and sound that makes the old rooms, from sudden angles and in their constant whorled, unfurling periphery of, an occasional translucent texture, new.

This can be, in the excess of hours, and as days flip brutally slower along in the manner of a single, quick, enormous day, a pronounced prance, an unwinding. The hours might extend to form

new rooms hidden somewhere in the make of homes, deeper sofas, thicker books, wherein the earth, for all its air, seems as if extremely conscious of the presence of your *you*, as if returning, for all the ways you've walked and rubbed upon its surfaces, an objectless, surfaceless, hidden embrace. If anything, the slow down invites a silence, as if lying down while standing up. The brain taking the brain over. A raw relaxing. "In its early stages, insomnia is almost an oasis in which those who have to think or suffer darkly take refuge."[24] You begin to see yourself inside yourself—can almost see, as if from overhead, or in following your body down corridors, in halls, the way your shape reacts to what is set before it. You count the sounds that you give out—even if, at the same time, it becomes less possible to stop them, fix the slip of your control. The hours go on longer, but you milk less from them. There is sound. You might hear buttons getting pressed behind you, and yet, in turning, the air is there. An autopilot popping through the spine and frame meat that, in sudden heaving moments, comes back upon size—the moments others might, then, disappear into their sleep.

On the fourth day of full waking I saw inside my bedroom wall there appear the face of a small man. His forehead neon, bulged from the tan paint. His eyes empty in a gray way. His voice speaking to me in a language I sometimes still even now can hear: no words but in bloating, a kind of sound inside sound spreading out like an outdoor artificial light would in the mass sunlight of a day. This speech in my remembering, ten years later, sounds like nothing, though I can see the head, can feel the head still in my chest, and even feel the susurration of the sound waves pillowed through my chest in certain hours again awake too long in different light

24 Colette.

with longer bones—there is no word about the word at all except its speaking, saying nothing—a mode of color in woven tone.

For long hours in the colorless stretches I would stumble through the house or go on lying, cursing me and cursing god—both felt the same. My body moved still by my impulse but at the same time as if strung ahead by ghostly ropes, my brain aware and spinning but with someone else's speaking: heads inside of head. Just as there may seem shaken doors inside the landscapes, there become shaken doors with the flesh. A sudden urge to stand and move into the next room, the air there as if someone other had just left it, or is coming in. In the night there might be near the window the sound of speaking, or of doorknobs being turned. Notes to self appear in pockets, writings in the linings of the books. Or perhaps, as in my case, writing along the arms and hands—the body's tablet, ever-present—if coming out in syllabic strings impossible to parse from one brain to the other. These are truly separate brains—though brains encased within the same head, at some points overlapping, some remote. Someone not you pressing the buttons there between them, turning curtains, hanging new. Deletions suddenly appearing in texts you've written. From texts on shelves. As if living in a life full of deleted scenes, a disc cut from a room there buried deep—and at the same time not at all buried, but laid upon the light. New gaps then there appearing slowly between the uncovered stations. Time learns to pass not from A to B, but in a small series of loops. This hour might last a half of an hour, or a half of half, some fraction thereof and therein—the time expended, say, in sitting down behind the car's wheel to begin driving and noticing the new gaps appearing on the LCD—while this other hour, lying face up on the floor beside one's bed, the light overhead attached to some spinning ceiling fan, perhaps, light clearly disseminating from two spherical shapes hidden

underneath a glassy dome, might last twelve hours. Clicking off in reams of quiet rope, bunching up inside the body in weird weak points, sudden soring. *Where have I been all night?* This kind of time continuity distortion also appears in the way of dreaming—some sleep scenes come on embedded in the head seeming to go on for a whole life, trapped inside there as if no way out, as if this is where we've always been, whereas other nights the light inside will seem to burn only several minutes and yet we will wake up into a new room, very dry, a whole night and then some having slipped off in disturbed duration. Relativity, in this way, is old—it is not so much a question of experience and how one feels it as an actual variation on a theme, the blink modes breaking up, becoming arpeggiated, shifting between modes—the way a record might be blipped back and forth between speeds, slurring the voice sound there, pulling the notes, making a new song out of something other, the music burned into black synthetic circles, replicated planes.

Eventually, inside of troubled sleep, the sleeping and not sleeping begin to feel the same. There is a heat—a lack of heat—about the air that seems to vibrate just around you, for the pockets of the house where you are not. The constant thought of the current moment leads to the next moment, killing whole long loops in serial blanking from door to door to door. For all those hours spent horizontal, faking, trying, I don't seem to remember breath ever going in or coming out. Some time in the hold you might stand and look out the window at the other houses, still and silent, most extinguished, probably no other bodies moving, all seem asleep. The houses in these times seem cowering, curled down against the earth under a sky that does not blink. The black sky, where from inside cities there are rarely constellation objects but the strong ones, the arcs of trudging object bodies trolling data in an atmosphere

that smothers selves, where between these blips of passive wanting, most of the hours herein feel the same, feel not there or simply pausing, no time passed, no new song.

That year the New Year that year came and went in no mode—more awake and more asleep than ever both at once. I remember my girl-friend calling from a party as the date changed, surrounded by a screaming celebration, other cells, while against my face the phone hung on, a thick thing, like a face itself again with no mass, beyond my room, my body radiating heat in pillows, which when I lay down in sunk around me, mushing my sheets into moist curtains among which I'd lurch and flop. In some ways, the house around the un-sleeping body begins to become another house. Oftentimes, among the slurring, the mouth might not even open, confining in the sound: sound meant to be ejected into others remains inside the self, bang-ing in against the inner walls, perhaps in some soft spots causing dis-tortion, puffing out of limbs or in small pockets. Imagine living on the backside of the flat face of a clock. The air at times like something remained in the space pressed out of a very old or very thin balloon. The way an aching might arise from lying wrong or on unforgiving surface, the muscles and flesh bumps grow hidden bruises. The reac-tions slower. The nodding dulled off. Knobs on knobs. Touching doors to make them open and therein finding not even the handle will make them turn. Even these qualities are hazy in their defining, as the closer on your touch the less it seems to want to grab.

]

]

]

Among the spectrum of extended sleep deprivation, my own 129-hour bout is relatively unremarkable. Besides the countless unrecorded bouts occurring any evening in any home, there have been numerous well-documented bouts of people going quite further, if some simply to prove a point. In 1959, radio DJ Peter Tripp set a record by not sleeping for 201 hours, mostly confined inside a glass booth located in Times Square. A few days in Tripp became delirious and began to laugh maniacally at things that did not seem funny. He saw insects on the air, could not understand architecture, began to claim he was not himself, but someone else. Soon after the event, he is said to have suffered from a shift in personality: he lost his job, got involved in a payola scandal, went through four divorces, fried. Some claimed the experiment had forever changed his life. In 1964, seventeen-year-old high school student Randy Gardner upped the record to 264. The first seventy-two hours were reported rather calm. On day four Gardner believed he had turned into San Diego Chargers running back Paul Lowe and won the Rose Bowl. He became convinced a street sign was a person. Afterward, he claimed to find it easy to return to a normal sleep cycle. Later that same year Toimi Soini of Hamina, Finland, snatched the title at 276 hours, which held for thirteen years until 1977, when Maureen Weston, a British woman, took up residence in a rocking chair for 449 hours, during which she claimed to hallucinate but also claimed no long-term complications. In 1989, the Guinness World Records ceased tracking the phenomenon, for fear of potentially damaging effects.

Beyond these self-induced milestones—which seem exceptions as they are chosen actions, rather than activities of the choicelessly awake—it is hard to know what the truest length of sleeplessness could be—though several cases, however uncorroborated, appear

in which people claimed to have ceased to sleep at all. Al Herpin, who lived from 1862 to 1947, claimed never to have slept an hour of his life. His home contained no bed. He had a rocking chair he claimed to sit and "rest" in, reading, until dawn. In 2005, in the Ukraine, Fyodor Nesterchuk claimed to have not slept in more than twenty years. A series of doctors could not medicate him under or locate any cause. In the daytime he sells insurance. At night, he rereads the small number of books inside his house.[25] "I feel rather bad now," he said. "I am like a plant without water." In 2006, a Vietnamese farmer, Thai Ngoc, he'd gone on for even longer— more than thirty years, beginning with a fever he had in 1973.[26] He farms by day and hunts at night and sits out afterward under the stars. He claims to have learned to predict the weather. He's hired by local mourners to beat a drum to guard their houses at night while they nap.[27] He refuses to be tested, though news crews film him working four straight days in his rice fields without any sign of wear. "[My] biggest dream," he said, "is to have a dream."

In each of these cases, no medical data gives evidence unto the cause of the prolonged condition, though physicians speculate various theories, such as microsleeping or damage to specific areas of the brain. It is also generally accepted that because there is no perceived damage to the body—the men are happy—there should be no cause for concern. Even if their stories are stretches, lies, wormholes in an idea, they hold a resonance in being said, in taking up space in ways of speaking and thinking about bodies' mythology. Regardless of the doubt or conflicting visions, or constraints on

25 http://www.xenophilia.com/str_biol05.htm.

26 "My Kingdom for a Snooze," *Vietnam Investment Review*, October 30, 2006.

27 Thao, Vu Phuong.

these kinds of lore-made reachings, their ideas project an aura in the idea of what they are, likewise the backmasked slurs on records, cryptic codes of pyramids, rearranged books of certain bibles, the dialogue of crime-ripped rooms, drowned rooms, rooms where lives are ended and begun. In their imaginings, they are created. Speech renders in residue, one could argue, a thing alive: a mashed mask in network in the clear air, held night and day and day and night. In many ways, insomnia is as accumulation, borne out of a lack thereof—false polar magnets in nerve endings—a growing heat, a colder skin. More than the toss, what sticks inside the mind is the between-time, the waiting unto nothing, the texture of the air inside the house inside the house, like curtains sewn from spindles we could not see other hours. During my 129 hours, I would laugh through my whole head out of horror, to feel the shake of sound as it rushed out. I stood at some point for several hours stock still, mostly naked, in the long hall that divides our house, hung with pictures of me and my sister growing older, and the quilts my mother and her mother's mother made from cotton bolts using their hands. In thinking back, this whole block of black time seems dually curling and encubed: massed beside itself and in a long row that could be lifted upward by a hand, if only through the light and hours since then I could find a way to fit my arm into the right hole in this house now, any hour.

As the sleepless state increases in duration, some of that other light might begin crossing over, blending in. Things begin to function slower, more prolonged and spread so thin they both cover all and cover none. The brain feels thicker with itself in such a way that it can no longer read its own map for the new meat making on its frame. The insomniac is often found just as hyper-aroused during waking hours as at night, suggesting it is less a sleep-focused condi-

tional disorder, and more a kind of body, a way of sight—even if, in the crossover, the lack of resting makes the flesh more exhausted, harder to connect—a dual removal and instigation—a neutered state of the aware. Where there might begin to seem a third door in your apartment, the door is never really, palpably there, one's sleep's sublime logic cannot be fully entered, and therefore the magic of the dreaming becomes replaced by dead nodes, mirages of a whole other way: the furor instead eating at the memory, at clean awareness. The light in rooms might seem even more heavy, or in other ways not there at all. Speech or want for speech might grow more difficult, against you, a dreamworld's tongues becoming activated in the head but here awake coming out all wrong, a smear. Our rooms and people suddenly therein seeming at even further distance than they might be, with their own heads, and then suddenly much closer, amassed with veils of who they might have meant to be to you inside lost sleep. The house somehow more alive than it has ever been, but not at all here yours, and you inside such watching buried in you under all the you of you you aren't.

]

]

]

If this sounds romantic, or transcendent, it is not—or at least not mostly, for the true chronic, as the silent weight quickly begins to pile up. Motor skills are weaker, reactions deadened. There might be less will at all to move. Further damage comes in the form of stasis, including ruin of "cognitive flexibility, the ability to change strategy,

originality, and generation of unusual ideas."[28] It is less a chemical or neurological shift than an overall slurring, a mashing down of two very different kinds of world. Though it may seem, from a removed state, that the flood of dream brain into waking might allow blooming, instead it functions as extrication, like wearing the residue of one's self around the body as a costume or second skin. It can be difficult to feel at all pleased, to feel joy of any sort, beyond perhaps the long slow bowed notes of selves in separation, blank. Whereas at first the skin feels maybe steamy, at least looser, it begins to switch to something more like smoldering, tugged at from many angles—not synthetic, but not yours. Your features might seem deeper set into your face frame. You're wearing goggles. With this new mouth it is difficult to chew. Jesus Christ, the light is bright here. Is something burning? Where are all my socks? The walls and widths of rooms or doorways might seem to reach right out and bump against you, their dimensions variable, attempting bruise. In worst months, I have knocked my elbows and shoulders coming and going enough times to want to never move again. Trying to run comes off like underwater, your voice deeper, the ache of negotiating limbs—around the house in the night from room to room in lighting like a bug in search of flame seeing no flame, standing in the vowel-sounds coming out of lamp bulbs shading sections of the same wall waiting, waiting that one might come kicked open, in, or out, allow another kind of light in or out. The way the hands began to feel dusted as with chalk, or else chalk-outlined in walking around. The simultaneous hypersensitivity and dulled dimension of how touching anything leaving a film both of you on it and it on you, making, in mapmaking, a traced-out residue of where you've been, and perhaps, looking hard enough, in the right way, where you'll go.

28 Morin, 29.

One's thoughts in thoughts becoming seeming not one's own, but implicated, a stirring strung from out of incidental rooms. This depersonalization, in competition with the skin's seeming thickening, the tongue fat in the mouth, the headaches and multiplying ramifications of the same amounts of light—the sun, some days, as if a gift becoming opened, something shearing in the wake—this seeming other becoming stuffed down in the body with all that new weight, all that pressure, the gift-wrap entering the body through the open hours, the mouth and ears, each inch that much further from the ballroom that is a daily routine made of common pacing, average hours, for which, inside of, most don't even recognize the grandeur of the walls. The sum affectation here comes close if not culminates in something like what Brian Massumi calls *the body without an image*, "an accumulation of relative perspectives and the passages between them, an additive space of utter receptivity retaining and combining past movements, in intensity, extracted from their actual terms."[29] The body, entered upon by other, an awake veiling of consciousness by the unconsciousness, turning concrete, turning off, and yet in operation as an automaton, a puppet, a mime. "It is less a space in the empirical sense than a gap in space that is also a suspension of the normal unfolding of time."[30]

The entry point, then, of most locations becomes not the average daily machine of limbs and body but of projection through the head—often seeing one's future self forward in the making and yet still several feet behind, questioning the presence of the arm's meat as it moves up to take the apple or the keys, and yet in this removal of ease for daily making, there comes another kind of surrounding

29 Massumi, 57.
30 Ibid.

air. A shortened, conscious drift between those hours most days entered via the unconscious, herein spread among the light. The common becoming less common-seeming, a series of false fronts; the uncommon becoming appeared in the paint around a window or a car, or in the excess clicking that a lock makes, the slower moving of the tongue. From inside the self, inside another. Above ground underground. As often hours, in too much waking, the very ground beneath the feet might seem alive—as if nothing inside you will shut up, there must be something causing all that noise. All those buried people come before me. All that sound once channeled through this home, and still somewhere here lodged inside a temporary silence, anticipating sound.

]

]

]

What I cannot remember from my own 129-hour bout is what it felt like at last to black out. I cannot remember how at the end, at some point after such days, all that blearing rolled so heavy it had no other angle left but to become none, and through some weird, false door come open in our household, I at last fell: the seemingly unending mode breached in an instant, without struggle, as if my many selves inside at last had gone collapsed, and rolled over in the space of their pulsed absence to allow another in, a low ghost at once and always rising in the new void without struggle, in the face of its home's and our homes' many also unsleeping machines. The feeling of long-wanted resignation lost among the blur space of the click of the space of day again in ending of this instance—one moment on,

another out, with no warning in transition. While coming out of sleep can seem so jarring, a forced beginning to another opening of further day, going under wears the cloth of nowhere, upon which might be reflected skeins of images hid in one's folds.

By the time you pass out, hid in the bubble, the air of most any room has stretched so thin, become so familiar in its unfamiliarity, and vice versa, that the space is not quite at all a space, but some bit of cells remaindered after popping. It can be difficult to recall where the house and self end and begin. The sleep comes often like warm wax pulled to snapping—turned to two selves, neither aware of the other where it is. This does not mean there is a mend to the exhaustion—the broken sleep comes often shallow, paired as if right next to the old air—at once so black in needing caving, but caught inside the brain's grown-in difficulty of differentiating the waking blank from at last again being buried in the self. During my worst modes I can't recall much ever remembering my dreams—the dreaming seems instead to cover every inch of time awake among that black mode—as if at last the space between waking and sleeping has turned inverted, impossible to split and gummed with blurring. The collapsed memory stores zapped, its compressed time warped forth as if no longer recording—*nothing passing*—something always ever not quite there.

All nights in my space-memory seem to somehow lock together in this way—the space between where one is there and seeing and naming and knowing slid at last behind some grainless glass to instead watch the self as on TV—the flood inside the self there resigned in silence or in sleepnoise, waiting to again be pulled back out into what the day will be again where it had been before, if slightly older, another iteration. Looking back over the course of all

my time awake and waiting there inside me in the house, it's hard to tell one evening from the next, each stuffed up with all the meat of breathing and the screenlight and the media of outdoors coming in through windows and staring into boxes and pacing and lurching at nothing or spread out on surfaces in various desperate poses mimicking some image of the dead, waiting to be filled. Even when I'm sleeping well there comes an hour alone up late before the body moves toward the bed where the small awarenesses of coming soon to reenter that nowhere that the body holds stirs to spread inside the head—some shapeless want.

]

]

]

Among all that shapelessness, there are certain moments that emerge from in the lull—that seem to give context to the rotation of the nights around it, despite their equal utter perimeterless architecture—time aging also among time. Maybe my earliest memory of any all seems to initiate the space of all waking as mirror hall: I am standing in the kitchen of my house, before it was built onto; my mom in the bathroom running me a bath; outside it was dark and in the house was dark too beyond a dim glow in the kitchen where I was, though the light inside the bathroom there held so much bright, a light as white as neon milk, and Mom was in there sitting by the tub shape in the light's shell; the bathwater in the tub was running and she was stirring the body of it with her one hand, the other hand flat on her lap aimed toward and looking down through the short hall to where I was, and she was telling me to

come in to where she was with her but I couldn't hear her for some reason in the night, something surrounding in the air there, and in the space surrounding by the want to move and not moving the house around me seemed to grow, like the hallway seemed to keep getting longer, like I could never walk down the hall from where I was to where she was, though in the space of homes as a home is it was really then only like eight feet, and I could not move there, and I was crying, and in my mind the night goes on and on that way. Nights since then have seemed all to spread out from this instance, time before time could in me become counted like a wall—ending any day at the last instance of the day ended the day before this one, its friction with the night again tonight—*one imagines*—here soon to come.

Perhaps the other most heavy loomer in my age of night's work is the manner by which my years-long dream of the rolling boulder just above my bed finally came to end, which actually in how it sits upon my memory doesn't concern the dream itself at all—the dream one night simply disappeared, an abrupt blanking in its procession's long unfurling surface, never to return. Instead of the dream's end defining its ending—as at the time it ended I did not know it would be gone—*and maybe it is not actually gone yet—maybe each night I dream it still and can no longer recall*—what I remember most about the boulder's mental termination, these years later, is how upon waking from what became its final instance, another form had taken shape—a man inside a white car parked right there in the street outside my house. I could see him clearly from my bedroom from my bed there, newly woken, the house around me otherwise as if on pause. The man sat inside the car with engine on and did not move, his head straight on, looking forward, shrouded of features. For some time I could not either seem to move myself—I

remember how my head felt stuck against the glass where I'd moved up to press against it, my breath making a little fog around my sight—the form of the head and torso in the car showing no shudder. The light of night around us refused to change—no stir inside the house around me—my parents on their backs and breathing in their bed—all the still, inanimate machines. Hours, it seems, went by in this condition. Nothing. Through the frame of the glass the waiting house and me around my vision seemed to curl a bit around the sides, cleaving to the seeing of this moveless man there—where had he come from—what did he have inside him wanting—why. There is, in my remembrance of it, no sound or feeling. Time inside that night went on as if it had been this way all through all time into an image on my head imprinted.

At some point, in my waiting, I again nodded off. Like any other way I can't remember the transition—I was there at the window, then I was there again, time having passed again around me, though the boulder dream had not occurred—the first blank night in what seemed even longer than simple years. My mouth was dry. I could tell I'd slept only when I could see again the light outside the house had returned—one instant dark, the next in rising gloaming. The man no longer appeared there along the lawn, the street returned to same as always, giving confine to our yard's grass and the trees and wires overhead. The man was gone, and so, I realized over time, so was the boulder.

So many things inside that night that man could have done. Keys he could have used to come inside the house, or touch the windows, whisper into me. I would not have to know—my hours sleeping open, unto any kind of light—the patient, waiting error in communication between the self there and the brain. It seems

odd that years of the same dream would end with something name-less like this, something whose presence even in memory I can't put a hand to, but in my head the two events remain burned into one together, somehow crystalline, rendered in my head in perfect film—unlike most every other image in the long crud, yesterday gone underneath today's want for more passage, more called on. Whether or not this is at all how it happened, this is the way by which in memory a life is formed; one room butts against another, one branch of nothing splintered soft into the next, creating rungs, which then must be shuffled from one to the next like bloodflow inside each moment, both incidental and by form, something crept under the surface there meant to knit and wait and be, visible only when it's gone.

For many nights after I saw the man outside our house unmov-ing I waited up for him to reappear. He did not that night, nor the next night. Nor the next, then. Or again. And yet, upon the air there, where he'd been then, on the street there, there was instilled a silent charge—a layer to the air around the house and my own seeing that I could not explicate, or size—a layer that when passed through in my body in the light outside the house I rarely thought to think of, but only at the window, framed, felt distilled. Sometimes in late evenings or at the house alone I still look out that window to see if that man is still there—still right there outside the window right now, with this sentence still in my fingers, between my teeth . . . as just now I part this bedroom's bloodred curtains and, underneath, the translucent veil—a double layer against the seeing out or seeing in. Since then, the yard has grown in thicker, a bush with pink buds so high the stretch of street is hardly seen, beyond the fat tree now red with fall wet, its leaves molting red. The yard shifting around the house, changing

the house, masking the air. Today, for instance, I see no one, no man awaiting, no white car, no person I have never met or ever murmuring into me through the phone. Why not. Why am I sitting. What other hours.

Today inside the house I collect my legs and I stand up. I move here from the typing desk toward the doorway to other rooms—rooms I've lived in or around by now for years. I pass along the hallway hung with pictures of my sister and me varying in age—pictures of us, drawings we made (lines and words ejected from the flesh). The pictures of us watch me walk along the hallway with the carpet full of our dead hair. The carpet soft and without heat beneath my feet. I pass through another door into the kitchen, the room in which of all rooms I have put the most food inside my skin. I move toward the glass door I once ran head-on into as a child, running from nothing, the shape of impact shaking sound into my head—sound I feel still here in me, nowhere. Through the glass today, the light— the light of day in all directions, silent. Today is today again and I am here—I am in me, wherever I am.

Inside the light, I go ahead.

In the backyard, on the concrete, I find my father standing with the pool net looking up into the leafless tree in other years I liked to climb. Its limbs are splayed and skinny. Beneath it is the ground where the remainder of my first dog sits beneath mud buried in the clearing among some bush. The grass is not at all discolored where we chunked the mud out to make room for what remained of her body after being cremated, to dust. My father does not turn to look at me as I pass him. There seems a globe or glove around his head, a veil ejected from the form inside his mind that has eaten up his

modes of recognition—the bodies in this house here all around him often not his family he has known, but people passing by inside a strange hold in the hours; no longer sure of where the bed is, or the bathroom; his brain consumed with something ejecting spreading black over the interior terrain of his recognition, transforming the holds of the home around him in ways that no longer fit the keys—or is it the reverse—the keys malforming, fattening against the turngrain of the tumblers where for years he'd been and been—or both, or neither. He is here among us, in his body, though who he is in there has turned deformed, slim glimmerings of recognition or want or who he'd ever been coming on only briefly, in small passings, and even these diminishing among the night.

Today our yard contains no sound—the wind and light and animals as if on pause for some soft hour. No rising balloons. No other dogs. I hesitate for half a second, thinking to go back and verify my mother's presence inside the house there in whichever room she might be in—often staring into a machine working puzzles inside a box—to clear her mind and think of nothing beyond the click. Other hours she will sew, the thread and fabric forced together with her hands attached to her whole body, which created me as well.

I do not go back inside. I do not touch my father, ask him how his day has been, his brain inside him aging, losing cell meat of who and where his arms were in other days, hours he could transfer into me for safekeeping, so I'll remember for him. Most of these days I do not ask. For all the ways I feel failing as a person, this is the most palpable of all, and yet, nothing. My father's arms. The hair on his arms, and the hair not on his arms. The patches of the way his skin

has changed over all this time. Time we spent in different rooms, or in the same room. Hotels where both of us have slept. Hours we both have not slept. My mother. My sister somewhere else with her husband and her dogs, maybe sleeping or not sleeping. Every minute of every day is this. Surrounded by the yard where years I grew. The vortex of the body and the hours ill spent and the things said or never said. The ruin accumulating in soft pockets on the body and the mind, replacing fat with ways we went wrong—or worse, not even that—the fucked folds of every minute, like several thousand stairwells made of meat, all rising off from one point, crystallizing, lost—the inaction of action—the blank of acting, so as to be not blank—the blank even then, and even then. And yet. And yet. Even in this sentence, in this room of different light, I cannot stop myself from stopping myself. The man inside the white car, I know, today, is waiting, being for me, in the road. Outside my house—our house. Appearing.

Today I am awake.

I leave my father at the pool there, his arms inside his clothes, connected to those arms, his paling body, which seems to be expanding and imploding both at once. I walk across the concrete where I would lie for hours watching for something coming for me, from the center of this sky. Certain hours of certain days even having convinced myself I could see the balloon again floating in from somewhere, so far off, a dot set in the sky so deep yet I still could see it, another message-filled balloon. Sometimes the balloon would seem so near inside its small size it was a planet. Sometimes it would be the sky.

The man inside the car, I know, is out there.

]

]

]

I walk across this grass I cut for years wearing the same clothes, playing tapes of the same music repeating several hundred times, until I can hear them now inside me without hearing. The grass this year in such a dry heat becoming overrun with ants. How the last time I mowed the lawn, this past cold summer, I sucked up the antbeds directly with the mower and the blade. The beds becoming quick washes of brown powder. Spreading out in dry cloud on the light. How any second any section of any hour or block of air could become split to ribbons. Could become full of what you have or have not done again in vast recurrence, as in my father's dementia-eaten head. The hours malforming from his recognition. Every hour cut from hours never lived.

In the yard I go to the gate and push up the latch that divides the backyard from the front, moving my body through the gap inside the fence that divides our yard from several others, and from the rest of our near world. I pass through the gate, my dad not moving, air not moving. From the gate's mouth I can still not see the corner where I already know the man inside the car has parked. I move forward several feet up along the driveway past the cars we use to move through further air. My father having recently been resigned of his own car unto driving how for his brain has changed with loss of recognition, his failing eyesight and his memory and dementia, his unshaping motor skills. How now, in recent periods of new unleaving, I can see him sinking in to somewhere else, a

field of fragments of what had been once somewhere—scrambled frames. My father, into the smushed light of hours I have most felt being ejected from all dreams. The far-off glowlight of his nowhere becoming a true and seizing aspect of the house. His blood bottled in him, waiting. These days he sleeps more now than ever, as if drinking in the hours of that space becomes an exit—the only exit he has left.

From here I still cannot at all see the man, or his white car's shape, though I can hear him in my head. This man a minute from one evening of several hours of one day, and yet still so locked inside the face behind my face. This man, who has never slept, no hour, and will never—this man throughout all hours in my mind, alive.

Across from the corner where I expect any second to see the man's car, there is the patch of grass where one night I saw another man eject his blood—once waiting there to cross the street with my father and my sister in coming home from a football game at the high school we watched a man drive his car straight out into another car—as if he'd been pulled or insisted upon. The glass sprayed at our flesh. My father reaching back to shield my sister and me not only from the crush, but from the sound. The man coming some time later in that night, with us again inside, to knock on our front door and ask to use the phone. The blood he left on the receiver. The bloom of that glass still mostly all there on the air, any hour that I ask it, of light haunted not due to the dead, but our remainders. This corner, any hour, the scene of countless wrecks in endless heads, its plot of air alive with light and nothing, in plain daylight, night light, where. Speech, exercising, houses built and rebuilt, roads, destruction, shitting birds, inhale/exhale, laughter, asking, what might be buried in the leak, what was rained down

and rained up from and for us, what has come and comes again. This replication in a silence, lawns and lawns of homes and homes. How could I ever sleep here. How have we ever. Each inch's rooms on rooms on rooms.

Something flashes in my head here. An instant's closed eyes. A kind of gone. I think I hear my father saying something, then it slows down, then it's nothing. Not a voice.

When I look again inside my thinking to the corner nearer to me, slightly blinking, I see the man's white car parked again right there. Waiting idle, as it has been, all those nights and nights and nights. The hieroglyphic license numbers and chrome bumper gleaming in our afternoon. An engine purred under such silence.

Seeing, I stop, my blood going hardened in my hands. I had not really expected, even in projection. The windows of the car reflecting light in such dimension I can hardly see the hood—and yet I know the doors are not locked. I know when I walk up to the car and touch its metal, I know the doors will be unlocked. Even if not, I have a key still, somewhere. I know this man will let me in. In the light around the car my skin seems see-through. A glass bowl over my head and my home, over my father and my mother. I am standing on the drive. I am standing and am speaking, my mouth moving in my head's meat, in the light, though nothing comes out on the silence. No other cars or worms or birds. In some way I have been standing in this moment so long. This moment does not exist.

I see the white car's brake lights grow a glow—two blown red eyes on the ass-end. Out from the front, the high beams showing thickly on the already teeming day of light.

Briefly, in my pause, mouth still gaping, through the house's outer walls I hear my mother singing, the same songs she repeats in chain most every day—her voice just off from what the note is, vibrating in near-key. The note, as quickly, is diminished. The color of the house itself remains the same. The air around my head a helmet.

I approach the car.

]

]

]

The man inside the car is not my father but still the car smells like my father's truck: crushed cigars and wet and dirt and cracking foam.

The man inside the car is facing forward, at the windshield, with both hands gripping the wheel, and still I feel his burned eyes on me as I slide across the skin-toned seat in silence and I close and lock the door. Though from up close outside, the windows appeared opaque with clay mold, from inside out, the front façade of my parents' house is still apparent, holding still. The car's glass seems even larger from behind it, whole flat planes that show not an inch of the reflection of my head or chest and eyes.

The man inside the car appears obese in sudden places, oblong globes of flesh bulge off along his spine, at his right knee, near his kidneys. His clothes are white. His hair is gone. A small tattoo along the vein bulge in his left neck is the tattoo I meant to get last year—*I think this thought and feel it exiting my mind.*

We go. By going I mean the terrain outside the car begins to scroll around us, leaving, though this is the only signal that the car itself can move. It seems to sit silent with us in it—no control panel, no LCD—the man does not move his arms to steer.

All the ashtrays in the car are overflowing though now the car does not smell at all like smoke—liquid Downy, wet dog, bending metal—the smells shift immensely when I blink. The ash is also at my ankles, in my pockets, on my lap. The man's not smoking, but the air is, gentle fissures pouring through cracks in the upholstery from outside—as if the whole outside is burning underneath us, though through the glass the sky seems fine.

The seat feels deep and open all around me, yawning to fit my body in the dry cavern of its cloth. I relax, sit back. There is the man there beside me in the car. Though he is not my father, he has certain of my father's features: gone eyes, stern lips, white beard, the cheeks and forehead he gave me in our blood. He still has not at all moved his head—though he is breathing. There are pustules on his arms.

I open up my mouth to speak and instead hear a moist note—something toned from deep down in my lungs. It burns. My cheeks go saggy. I become wet around my crotch. The harder I make strain to eject words out, the more colored the air gets, shifting shitty. Stinking: piss, then weapons, lice, then a low light. Rubber libraries. Eons. Dice.

I can only sit still by not trying.

The man who is not my father speaks.

 – Do you remember

He stops. His voice is small and sandy, like something rubbed out from between two long human hairs. The main vein running at the globe-edge of his skull's frame stands out winking. His concentration comes from none. I open up my mouth again and he is speaking.

 – when you and Jason R. and Bradley R. and Samad A. made Darrell C. stand underneath the monkey bars in the mud-field behind East Valley Elementary and then took turns swinging down from both sides to kick his chest and stomach one after another until he turned bright white and could not breathe. You all talked him out of going to get help from the teacher by patting the cough out of his back and saying he was cool.

I see my pants are ripped a little. In the side mirror I can no longer see our house, inside of which the computer where I'd been typing is still typing. My mother in the next room asleep in her bed upside down.

That I could never get over coming back to that house, and likely never will.

By now we've passed the church on our same street I once believed was literally the house of god—god being my friend Adam's father, the minister who stood before us and spoke out or sung from books in words I did not understand. How I would not come when he appeared at our front doorstep to pick me up and take me home to play with his son, in their backyard with that magnolia tree that

seemed to touch the sky. How I hid inside a closet in no light and waited till he was gone. Then my mother took me over and that afternoon Adam and I discovered an elevator in his basement that went to nowhere, on and on.

Since then that church has doubled in its size.

The smell inside the car now is the same as the blood that was pouring out of Marcus S.'s nostrils without clear reason in the grass inside the night, during another Boy Scout meeting where everybody carried handkerchiefs and knives. The blood's glisten, his eye wet's glisten. I find it hard to breathe—and yet the creaming taste opens a door. The car starts moving faster.

– Hey,

I hear myself say. It's the only word I am allowed.

The word inside my mouth makes glow-oil. *I am working on a new balloon.*

– You are working on a new balloon,

the man continues, his hands so tight-gripped to the wheel his fingers seem about to break. I realize he is wearing thin gloves, revealed by how their skin color frays around his wrists. The gloves' color match the car's interior's color match the man's other skin, and mine. My skin is sticking to the all of it.

– but the problem is, you've already turned so old. Every day is faster than the last and you're still all pen to paper and all in small rooms hiding from the light. What do you think

sleep is? One third of any life. And still the bodies who talk about books don't want to hear what happened to you in there, call it ugly. Like every word you've ever said. Like every inch you've ever houred. This is the smallest car I've ever drove.

Driven, I start to say to him, correction—and my mouth is so full of my spit, I can't even snort or say no, pull over, who are you, there's no seat belts, where are we going, why does the radio not have dials, why does the seat belt feel like burning, what is that banging in the trunk. Suddenly I have all these questions, and from each of those three more, and from each of those a paragraph of wanting I've never written down and will die in me, I know, contained—even when the skin splits and my blood runs to leave the meat, these wrinkles will remain—these wrinkles will decay to sit upon the air the way all light does, a hard drive on the night, and yet still every day my first concern is all this typing—not any woman, not any walking in a pasture or a light. Every minute with anywhere and escalators and moss and doors ever, all directions all at once in every era, and yet the same room with the same splits in the same walls, healing and unhealing, asking . . .

I look down, see there is a button sticking up out of my shirt— from the center of my chest; it's always been there. Its head is gold and cannot see. I cannot move my arms to move my hands upon them to touch the button, to press the button in my chest, and I know that when I look away I will not see the button there again, ever or ever, or feel the wanting of it, the gold thrum, and it will be right there in my chest still all those hours, waiting all the same.

The man who is not my father lifts a hand off the steering wheel and moves to hold my face, to cup it like a massive taco and fix it forward, looking straight on, as he is, to what's ahead.

– That's not a button, it's a tumor. You are growing. Doesn't matter. You are growing inside too. The length of the human intestines are ten times longer than the length of the body. Each year 275,000 Britons disappear. In 30,000 years, Saturn's rings will have disseminated into blank. So what. So who. Listen, the reason you don't sleep is because you've never really been tired. Because there's nothing to name the thing you want. Well isn't that just so sad.

Through the front window of the car the yards of the houses in surrounding come on calm. This is a neighborhood and its outlying I've lived in or been around for thirty years now. Thirty years in counting down. There is the by-now half-overgrown driveway where the car full of screaming kids pulled over behind my friend Chu L. and I walking home from the comic-book store both with paper bags and the kid got out and ran and punched me walking in the face; how I walked stiff-armed straight forward not at all blinking, the warmth all spreading through my jaw.

There is the stretch of hill in the emptying where in the light off the tall lamp a van had parked and as we crossed some grass these two men came walking as if to cut us off, no one else anywhere around, the spot on the grass where I stopped and said we'd missed a house behind us and my friend said no we hadn't and I said yes we did I'm going back and the men were getting closer and my friend didn't get it and I grabbed his arm and we started up the hill again and the men walked faster and we ran, then later that night on television we saw how a few other kids had been abducted in our area by men inside a van.

Every stretch of these roads the organs for the map of every person passing in their way—the sleeping and unsleeping. A common night. Night in which you cannot see the sky inside its shifting, or hear the resin of it blanking in both ears like a kind of helmet that melts into what it wears (and it is the one that wears).

The smell in the car now is of new horse, a horse or horses being born—or both things at the same time, in every city, in every room in every city, in every cell of every room of every city . . .

- The only horse you ever rode on wouldn't even move. She just stopped and stood there in the mud. I should kick your ass out of this car. Stop talking. This is not a book about insomnia, because there is no such thing as insomnia. That's an idea they sold you, like new music and birthday money. Do you need to get out of the car?

My chest has swollen with liquid. It shows blue through my chest. The wet is warm. The seat rubs with me. I smell the burn behind my eyes.

The car, in moving, slows down to standstill outside a long field where massive towers carry telephone and power wires both ways for miles. The grass is high as a man's chest in places, of a crisp white, corn silk or a doll's hair.

The man reaches past me to open the car door, his flesh in my flesh, his head still headed straight and on. The door pops and I flood for it, my body growing out into the added air.

Far in the distance, the red roof of my parents' house billows brown

clouds—but I cannot see that from here. I cannot see them for the lip of sky hung hanging from the sky itself, where something on the light has opened up. A crust of birds or kites or helicopters moving in both the left and right peripheries, beyond the edges of my lids.

The smell I leave inside the car behind me is lavender and candy, crumpled paper, guns.

In the light outside my body stings. My flesh continues spreading out in each direction, blowing bubbles, wet or air inside of me creating room. The car idles beside me silent, waiting, while in the open light my skin makes more.

DEATH DRIVE

Fear of Body

On the earliest video images captured of me, via Betamax one Christmas, my body appears translucent. Where I am standing in the image you can still see the room behind me, as if I'm not at all really there, or am a temporary gloam over the more permanent structure that the house is. That house, by now, to me as a concrete place is gone, having been sold after my grandparents' passing, turned over to others to reoutfit with the hours of their lives. I will never go inside that house again—here it is upon the tape, in a day I do not remember but by seeing myself moving in the replicated room there. There too, the cells of my body, at age two or three, form a version of my body I could never find my way into again, and could not even as that image was burned into its pixels, even as I moved in the instant. And yet I am still in this same body, if grown larger, older, here today—I watch myself in the old space unaware of being watched. Therein, in the containment, I seem to contain a kind of false eternal life, a compilation of temporary

minutes constricted into data that inside the tape play on—me there, speaking, gleeful, shaking objects out of boxes, aging with age I have had now inside me for so long. The tape seems almost to mock the absence of my own version of the memory—what about my life the machine remembers that I do not. These kinds of videos and images exist now for most everybody in certain hours, spools of versions, days gone past.

In my own skull's box, too, beyond the camera's reach, there are films coiled, ones seen once and not again, some seeming not like days I've lived but like exposures burned in from a different kind of light. As thick and suddenly eruptive as recall can be—some moments so burned into the blood and definitive of self they seem always playing in there in learned silence, on and on—for each of any of these clearest hot spots, there must be hundreds of thousands of other instants crushed underneath—either because they seemed less remarkable than another upon occurrence, or simply because it is our nature, inundated, to let the mass of what has come and gone become dissolved into some kind of bulkhead over the hour, there but not there, accessed by accident and sometimes force of will— though so many of the instants that do roll up inside me even now seem somehow qualitatively, at the time of entry, unpronounced. More clearly than the specifics of most any of my birthdays, or the deaths of my relatives or my skinned knees, I remember things that should seem, in comparison, a sidebar, common. Better than being baptized or going to prom or my first ball games, I remember with some great degree of spatial semblance the year I saw a certain movie on TV—one I've never found again since whatever year—a film wherein a child sized like me then appeared asleep in front of another screen—until in the dark room through the glass, as he remains still, a horde of countless bulbous insects rush to fill the

floor, come to surge and writhe around his sleeping body in a clus-
tered mass encountered unaware—the insects then carry the child's
body off into the dark of the house surrounding, offscreen—gone
from me in vision except for where the sight is burned still in my
mind.

Another year, when I was three—*though this, unlike the movie, I
would not remember without having been told*—my mother found
me talking on the phone—connected through a wire to a stranger
speaking words into my head. Mom thought at first that I was play-
ing on in self-conversation until the nature of my speaking began
to shift, and it became clear someone was there. She took the phone
out of my hand and asked, "Who is this?" The person on the other
end hung up without further word. Our bill that month would
reveal I'd been on the line with whomever almost half an hour,
sharing wire, a digit string I'd dialed by fluke punching the keys.
Unlike the unread note inside the balloon caught in a tree years
later, I'd received a message, though one all buried, lurking here
inside me now.

What sounds that man laid into me, what language. His breath-
ing or commands; perhaps some code repeated over and over, pro-
phetic dictum. I have no memory of it at all. I know it occurred at
all because my mom remembers, and yet that residue still lingers,
or something like it—I feel I can't get the idea of the voice out of
my head. It feels as close inside me as any minute, in my body—not
a voice inside me, but its specter, by definition shapeless, and so in
concept capable of any shape.

This seeing, hearing, being, contained inside the self—boxes, film,
speech, image, air—must in gathering within me, even silent,

contain a voidspace—a terrain inaccessible but through an inversion or elaboration of a certain sketch of time held in chemical loops caked in my mind, their silent wheels working in orchestration with any other range of moment, forgotten and not forgotten, amassed dimensionless, a hidden blood. When I die, those spaces die within me, while the tapes outside me continue on, there with all the other relics of the things I've taken into me in translation via seeing, reading, thinking, wishing, what—each also to one day be discarded, sold or buried, burned, donated, inherited, thrown away, passed on to other bodies, for whatever, until those bodies too are gone.

]

]

]

To keep me calm or to recalm my internalizing terror in the fake light the house held to keep the night out, my mother read to me aloud. She read me books beside my bed about boys or men who, waking, moved—through forests to find fathers or ride on rivers; men who went because they could. Her voice gave a calm and even glove of warming, one like an endlessly played album I can in my head alone invoke: a soft pocket right there all through the veils of junk recorded on my brain's ends. With her there nearby, projecting softly aloud, the larger world felt far away—the crushing veils of silence in which the evil things could hide and approach suddenly filled with protection, an eye. She would stay there, predicting end points for our evening when she would need to leave me and always staying when I asked for further, more.

Despite her sound, the reading never made me go to sleep. Our time would end when she herself, among the reading, had grown tired in her own body, her voice perhaps having even changed in tenor, turning sore. Inside the silence after, my mom would leave me with the light on, my smaller self in fear needing the reading lamp to keep the room close, quiet. A light like fire that would invoke fear in those beginning their wanting in—it was not until later, maybe, that I realized the light is what would draw them, bring them wanting. So many years I camped inside the house among that glowing, exposed as new rock, my dumb awake glow spreading out around the house all hours in small unwinking, not even miles.

In later years, both my mother and I aging, changing bodies, I would record my own voice reading on cassettes that then could be replayed night by night in loops, the cogs inside the machine fitting into the two eyeholes in the tape's face, keys turning locks. Each night I would play the tape again, hearing my own voice in her image repeat those words pulled from some page, until over time, I learned the story from the inside, the phrases incanting from twin speakers unto late hours of no sleep, so that I could hear the words without them being said—cooked in my flesh. Those words in some way the seed of words sent out through my hands each day now, waking, repeating on and on beyond the shell, wormed in un-zapped fat, too deep, and reinforced in fresh reservoirs since then somewhere fed and fed hard in the days spent inert absorbing more.

I'm no longer sure what I was so afraid of in the nights by the age of these recordings. Fear then seemed a product of itself—as if I was afraid precisely because I did not know what to be afraid of, or of the silence of the air demanding something soon to come.

I can remember feeling crippled in the idea of drifting into the nothing of the space between the planets—no sound, no oxygen, no object but in incidental drift and fixed massive centers among the billioned grid of light defined by its absence for unindexed, countless miles—toward what but nothing—nameless. The black of that space lidded over, ever-present awakening, at windows—the sky at all times overhead. And yet, underneath this, I could not turn away from what seemed not even there. I was obsessed with space, the empty. I wanted near it. The plastic ream of neon stickers on the ceiling again replicating that same voidspace between lit spots overhead. I developed an obsession with becoming an astronaut despite, or in the wake of, the fear itself—eating space ice cream, watching and rewatching the movie *SpaceCamp*, wishing I was there inside the film, and yet never begging really to go to the camp itself—a spectator on the cusp of the machine.

In daylight, such recurring secret presences spread on playgrounds, whispered in the long white concrete halls of public school. Charles R., who ran headlong into the rumor of the Bell Witch, where he claimed to have chanted "Bell Witch, Bell Witch, Bell Witch, I hate you Bell Witch" into his bathroom mirror one night before bed, and then woken up with claw marks on his chest. And in that same grade, Corey C., who claimed his uncle had been decapitated by a flying Ouija board after trying to contact the center of the sun. The presence of our own Ouija board inside my house no doubt added to my internal terror, despite its hidden away station in my mother's sewing room between a table and the wall. What second flooding throttled through me some nights when I would find her using the surface as a lap desk for her sewing in front of the TV, the presence of Corey's language replicating in my body, draping, its presence still there even after she would return it to its hold. These

objects, verbal yet heavy, strobed into my skin. They woke me up and kept me waking: a fodder for a blue brain, already curling in overthought: as more than any other presence, after sickness, or in great pain, it is the self inside the self that keeps one up. I am a part of Charles R., and Charles is in me, and his witch breath, and his lungs—if he is alive somewhere, or ever—the words he's written down or felt against his head since the last time we stood in the same room. The hair that's fallen out of Corey. The light we shared through our TVs. This list remains unending, a short link in a rope that wraps around my head, coiling something out and something in.

With us in the house, behind the locked doors, we had machines: eyes of light and shapes that counted time and boxes covered with buttons one could press, things that stayed awake and in the same mode whether you would sit with it or would not. My family's first computer was the Apple IIGS model, sold to my parents for its supposed heightened graphics and clear sound, which at the time were something to behold. On this machine I began to worm into devices stored on discs, creations generated from long fields of text and ordered into strange displays, phrases coded into columns that when compiled might run a routine—I particularly liked writing variations on a program that would lock the computer until a password was entered, forcing the user to either know my command or press reset. I also drew up several text-based role-playing adventures that mostly went nowhere—I would give up before I got so far into the world they had a mass, thus leaving shells and shells of spaces scattered in code on discs ending in nothing, the blinking cursor awaiting my next command:]]]. These languages I arranged had at least two kinds of speaking to them—the language meant to deliver the machine its code, and the words that the user

would receive when the program ran, though I was the only one who ever played them—I had no one else to give them to. This duality of speaking—code arranged for some end purpose, arranged in networks of numbered make—would keep me up for hours in conversation both with the machine and with my future self, spooling up in discs that I still keep slid in black jackets in a closet of my parents' home, waiting for no one, alive, condemned.

Our printer with that same machine—some then-new dot matrix—gave off a rhythmic screeching with its work, as if it hurt to let the ink out, the paper spooling from its long slit mouth page by page. Many times the machines, in their transmission, would skew my sent-out data into glyphs. Somewhere in the wire between where on the screen I had typed my coded language in compulsion, the bytes of text would become disrupted. One page would spit out as eighty, all symbol and syntax, strings of characters in the speech of something else. These ejections would slur and spool out of the racket for hours, or as long as I would let the heads roll on, sixty, eighty pages, more. As with my keys before and *IT*, I would carry these pages into my room and sit with them for hours, combing the lines for hidden sound—secrets, maps, directions, code words, some human mumbling—or worse, something lost and terrifying to mesmerize me in the manner the horror book had. I sat up cross-legged well into the night scouring page after page with a glass and a highlighter, looking for something I could not name now or then, but still knowing fully it was in there, somewhere, if I could bring myself to find. Circling dots or loops or phrases in the error mass that might lead to incantation, a codelock. I believed in Borges before I'd read him: "There is no combination of characters one can make—*dncmrlchtdj*, for example—that the divine Library has not foreseen and that in one or more of its secret tongues does

not hide a terrible significance." Into the night, and another night and another night, becoming another long string of the unblinking, of the never cutting out, which therein began to form its own encroaching, muddled string of text and sound and image—the source of day itself in the image of some huge dot matrix printer over all things, spooling out of some enormous mouth somewhere far off and nowhere below the sky. Each night, when I had finished combing through the papers as much as I could manage, the ink transferred in abstract splotches against my hands, I would stack the paper in my closet, hidden from whoever else might think, as if the information had been meant for me and me alone, something designed to creep just at the cusp of me, knitted, waiting to be found, so that at any moment, if I closed my eyes, I might miss the instance of the thing at last that reveals the thing itself—the thing about me and the me in me there that I always wanted and never knew to name. What these words woke in me were different even from the words in books or movies, but something just above my head, a presence fed into the home cloaked in a shape that tempted its revealing, that kept me up nights longer in my wish for what it hid to come all in.

]

]

]

It wasn't long inside the longing silence of the house at night, alone up too late and hearing everything in nothing—the reading having ended, words remaining only words—that I began at bedtime to lie often with my head out in the hall. I'd set a makeshift bed up on the

floor between the doorframe of my bedroom so I could see down along the center of the house, into the living room where my parents stayed up most nights watching TV, my mother often also sewing, my father nodding off there in his chair. I could not even see my parents' bodies there directly, but could see that light, and hear the sounds, and know someone else was there, the sound of the television and their talking and eventually the movement from the room there to the bed. In this way I would stay awake for further hours, stretching my body, in paused want. The tension of that waiting, seeing, needing made nights longer in their unmonitored procession. I am not sure what I imagined my mother or father would do in the event a menace-presence—*mugger, phantom, giant*—did come into the house, but the anxiety suspended in that between— the borderlined anticipation of the terror and the presence of that most familiar other—nameless, frameless people coming in from somewhere, made aware in minor sound often blamed on aging houses—shift of beams, settling eaves—which often become carried over inside language, speaking, of a people—air inhaled by others at the same minute as I inhaled mine, or the way their bodies had their own space, their own anatomies, their organs inside.

Many people presume, often as a kind of torture logic, that in the night while they can't sleep, everyone else in the world is peaceful, calm, and at rest as if underwater, except for on the other side of the globe, where there is light, and those bodies we might run into in gas stations or late-night stores. Seeing bodies out of the house at night, among the streetlights or in the glow of moon or lamps of cars, can seem like checkpoints passed in video games, characters waiting to be invoked. Bodies at cash registers who check us out might seem like machines, always there, and for them to be elsewhere would surprise us, in the way a child is startled when

seeing a teacher outside of school. Though, of course, each of these persons is his own person, and has had the same shaped thoughts as you regarding you. "Each person is an experience for others," Lyn Hejinian wrote. "But many creatures have memory, maybe all do, otherwise nothing would happen. . . . And if there is an afterlife it is going to be damned crowded. . . . I probably wouldn't even be able to find my own father."[1] As, ultimately, no matter how near or comforted or spatially rewarding a person might be in their body at your body, there is a point at which the bridging must desist—the point at which here is where our space remains separate, no matter how close or clean or needed—each self surrounded only by that which holds them in their own.

At the center of my young self, opened with whirring, the state of my sleep stretched most nights so tight it formed a darker, ageless twin; any night could last forever and no time, an approximation of Zeno's paradoxes, such that "if everything when it occupies an equal space is at rest, and if that which is in locomotion is always in a now, the flying arrow is therefore motionless." In the house each night we grow older, each hour shorter in relative duration than the previous had been, an increasingly diminished fraction of our prior compiled years, though often seeming long and longer as they pass, for at an inverse rate of change of being their oncoming feels less new. Sleep is meant to punctuate this action, providing meter. A beginning and ending point to each subset method, named a day. Each body operating its own house within the house: limbs and skin around some center in a meaty, blood-stuffed dark—our self as a location, scrolled inside skin among the nights: as all time is night or night in relief, our body a hidden city aboveground.

1 *The Fatalist*, 26.

I learned as well to fight the fright the silent dark held by binge-eating breakfast cereal before bed. Crispix or Corn Flakes worked most often, though it was sometimes Shredded Mini-Wheats or Fruity Pebbles or Raisin Bran, depending on what there was enough of in the pantry and how many bowls it took. I could wolf through enough of a box to polish off a handle of 2-percent in half an hour, hunched at the kitchen table in yellow light, the backyard and pool through the glass doors behind me mostly masked with the reflection of the room and me there in it. The crunch of cold milk with increasingly soggy flakes, often topped off with a layer of honey, filled through my gut and stomach to my neck—as up to a perhaps embarrassing age of awareness I saw the body as an empty, unorganed vessel filled by whatever came into it from the outside, the phrase "I've had it up to here," issued from my mother in passing fury, serving a reminder of our hollow insides or perhaps a warning about how eventually, if stuffed over, we could burst. The caloric blanket of heavy eating in the evening somehow would calm me down as I seemed inside me to fill to closer fit the house, fattening clean out of whatever malfunction or displeasure had reared up throughout the day. The cereal, once chewed and digested, formed a slick runny mush coat down my insides, which would therein make me thicker, warmer, flooded free to drift off to whatever shape inside my skull a sleep would mend—not a muscle, but a growing curtain, making more flesh upon the flesh. The sound of rummage the stomach makes as it is being pressed hard against the walls inside the body performs a kind of music, the friction of your increasing sheets of skin, the food filling up the space where otherwise would have fed the silence of the terror.

This waking routine, faithfully repeated, made my young body grow large. Eating my way into exhaustion each night, if responsible for

snuggling my way into a healthy resting-cycle routine, also rolled me into an unhealthy rind of chub. Looking at the oval-shaped picture frame of my school shots from kindergarten up through high school is like looking at a time-lapse capture of a strange human balloon, one mostly always with a horrid bowl cut, cheeks with true define. In all the pictures, even the young ones, I have bags under my eyes, except in those where I am fattest. In all, I go along with the commanded smile. During the period from fourth grade, in which I looked mostly like any normal child, to tenth grade, the apex of my gaining, I went from weighing what I was supposed to for my framing, to many times the normal weight—filling out the selves stuffed fat inside me, swelling, gathering in mass upon the air. In ninth grade I weighed 260 pounds. There were several of me on me. I could hold my stomach with both hands—using my flesh flaps to speak in other voices, to roll around me as I moved. Certain days in certain shorts walking too long would make my skin chafe into rash in bright red patches, my self rubbing against my self as I waddled down the halls. Eating whole pizzas in one sitting. Ordering two twenty-packs of Chicken McNuggets and a large fry and Coke at the drive-thru. In food, comfort, I got larger. And I got larger, containing whatever I contained: sweat not sweated; cells not destroyed, but awakened; white fat foam. If nothing else, for now I was well rested, if thicker, wetter, growing grown.

What's off about my young concept of the food-induced sleep coma, I've discovered since, is that as the body thickens, with increasing BMI, the actual quality of sleep declines, trailing off in slow-wave rest and overall sleep duration, in which the truest rest rides, and growing more shallow, shorter, weak—"THE PREVALENCE OF OBESITY IN THE US HAS DOUBLED OVER THE PAST 3 DECADES. DURING THIS SAME

TIME PERIOD, SELF-REPORTED SLEEP DURATION has decreased."[2] Though it may have been easier to nod off in those caloric blankets, bloating, these teasing periods of patterns in which I'd help myself zone out from underneath my brain from there were only at the base of me increasing footholds for the sleep locks to worm their way in—a method that would only continue growing thicker with my body and the further influx of mental junk to feed into my brain—here as an American in America—a size wanting more size.

Still in my unknowing I felt my sleep inside my sleep begin to change—I began to dream in cycles of strange women. Bodies in small rooms that made me vibrate. Women with long fingers and no language, who could affix themselves warm to the inseam of my head. They would look at me in ways no one had looked at me. I began to find myself addicted to that hour. I began to send myself to bed earlier and earlier some evenings, full of feeding, and lie on the bed and wait for how the air would disappear around me—the shift of sleep oncoming in a quick cloak and unknowing, like a candle being snuffed; a wet sack over a large head, with no slither; the liquid underneath the skin.

After stumbling into my first orgasm one night while watching a bikini competition on TV, my dick for days looked deformed—changed, the flesh there made briefly crooked in its initiation rite. The hair there soon shook into growing, pushing stems of cells out of its center, messages sent from my second self. In my bedroom closet I kept a small tan lockbox my sister and I had once used for our imaginary club's treasury—pretend money held under lock and

2 Rao et al., 483.

key. Into the box I placed small totems of obsession, amassing day by day: at first simply clip-outs of the J.C. Penney's catalog where women posed in mostly safe lingerie, their nipples red dots showing through phrases of linen, posed in eternal ways. The early ecstasy of finding a new catalog had arrived inside the mail, with or without my mom's name on it, which I would pretend to be interested in for the collar shirts and coats to order. Taking the slick ream into my room in the name of Christmas listing, and locking the door there right behind. Into the box as well I placed a set of four postcards I bought in St. Augustine on family vacation, separating myself from my parents by pretending to want to go buy a book. The most definitive image of these was a topless woman blurred underneath an outdoor shower, the curve of her breasts alone enough to hold my head for hours in its 4" × 6" grip. I took and hid a Polaroid of Pamela Anderson at the contestants' front podium during her appearance on *Family Feud*, her shorts cut high up on her orange leg; red, breast-stuffed shirt and bleached hair against the gaudy colors of the show's set, the hokey male host waiting for her response. Back then I was still new enough inside my glue mind that I could pretend to call home from a friend's house and ask my mother to tape the day's episode of *Baywatch* and it did not seem obscene. Into the box I placed cassette tapes of sound I recorded off of the static-masked high-digit channels on TV. Black spools in clear plastic containing copied aural output from the scrambled women getting fucked. Their grunt and the skin brushing. The very specific sentences and cadence of their verbiage, which won't come out right on this page. Food or lipstick on their teeth. 3-D to 2-D to 1-D, played back on my white Walkman's headphones in my room or while mowing our front lawn. Into the box I placed several sheets of tracing paper, writ with images I copied methodically from my father's adult magazines—a small stack of *Penthouse*

and *Playboy* he kept in his closet underneath a stack of worn-in shirts. The image replicated on the paper in my still hand, listening through and through the house for someone sensing what I did. Later I would cut select pages out of certain issues—the woman in the orange bikini top showing her bottoms, the woman in red garters and sunglasses: *imprinted*—careful to leave no trace of where they or I had been.

These images, one after another, each I can still see inside my head. I can hear the sound of the women's grunting and the scripted sex speech spooling same as any birthday or Christmas— *more*. These pages the new spool from some strange, sex-rendered printer, one I could not fully gather in my mind. Poring over their glinting inches as if looking for a way to move into them, make them real. The code word. The key. The tunnel. Take that for what you will. These items in my room alone I would spread out before me on the carpet, in the light, in the same way I had before with my carefully kept comic books and ball cards—my indexed, unorganed, neurotic shrine, which in the night would be there, never-ending, a door of its own door. Some nights I would simply sit before the slick, deconstructed mural and look upon it, feel the gush move through my walls. Something about the blood inside me stirring—perhaps the true desired product of any obsessive act—could keep me up for hours into the night alive and blinking. A light left in the light left in the window in the night. As more years passed, and my partitioned understanding grew inside me, spreading out to overflow the walls of where I'd hid it (both intuitively, and in size), I began to allow small bits of paper radiation to spread into my bedroom walls, shifting the room's condition. I began by displaying, around the space where I would sleep each night, a small glossed magazine page of a bikinied woman with

large breasts. The image was not visible from most angles, blocked by a dresser in which my mother placed my folded clothes—unless you knew what you were looking for you wouldn't see it, 2" × 3". But the mere fact of the fleshy picture's presence into the open air without the hiding felt like bleeding into bright light. Even when I would leave the room I could hear the object of my hidden lust radiating in the walls left separate from my head, waiting for me, a declaration.

In the place of my previous decorations—album covers by Weird Al and Guns N' Roses and full-sized posters of Bo Jackson and Barry Bonds, *Uncanny X-Men* #265 and *Spawn* #1 tacked up carefully by their whiteboards—my aging idols—I made small replacements one by one, among the color, dotting bodies in corridors among the muddle. The flesh of my bedroom began to spread around me, leaking on my air like mold. Still a furtive, silent process, one into which at night I would enfold. The images I gathered came from grocery stores and bookshops, among what time of them I could squeeze out as my own. I was too young at twelve and thirteen to project myself in these locations without my mother, and so extricating from her for the collection was integral. I would hover near the "sports" section of the magazine aisle, after swimsuit issues and bodybuilding mags. Incidentally, my first glimpse of nude tits had been in a convenience store with my father, where a tattoo issue had women with bright nipples holding guns. I would move back and forth before the long racks, peering, seeing which magazines I could snatch when it seemed safe, and making sure no one could see me seeing; as for what they would then think of me, I feared. Sometimes I would pace and plot and gauge for half an hour, leading up to nothing as there never came the proper time. It was all about timing, about the small grooves of the public spheres around

my bulb. The fear inside me of both my hidden ideas, born in skin, and how they would be rendered in the event of meshing with other eyes inside the light—it was enough to make my blood ache. I imagined cameras at my head. Massive unseen bodies standing at my sides there, smelling the machinery of my head. At the proper times, though, when the urge overtook me, and through quick rummages of peeping, I'd find the proper page holding the best image of a skin woman I could find, and then, with my breath all solid in me, rip it from the book there on the stand. Quickly I would fold the women, being careful not to crease them across the breasts or thighs or face, put them deep into my pockets, and move from the racks with my head down, the silence of a hot furor settling all throughout and against me where the false skin touched my skin.

A few times I managed to convince myself to go further, buy whole magazines in small commitments, pacing near the register for up to an hour before approaching and involving myself in a transaction with whatever middle-aged attendant was on the job. During these modes I could hardly speak or blink or move my arms right. The unblank of such an ultimately benign—but so taboo to me, for its softly bruised air, the only—a draft unfolding in my barely teenaged flesh. Sometimes the shakes would get into me so deeply that even coming up to the moment of entering these stores with these intentions would make it hard to breathe. Certainly it was just as much the thrill and vice-light of the moments all preceding the moment of acquisition that got me going, the amalgam of furtive gestures and weird sweat. In any way, via obsession, these public fields could become warm, could close in and crush around me with their hum so loud it became more and more difficult to shut off.

As I gathered more fake flesh enmassed around me, my mind began to hollow to it, sink it. From tiny scraps no one would notice in the corner I moved to whole pages high or low centered on the wall, still the sprawl but much more out there. The room's air shuffled, balled. At the mall I would go to Spencer's and buy full-sized posters of Pamela Anderson (yes, again) in her panties, *Playboy* models cupping their chests. I would hang these behind the door at first, then in more places. The replications overtook the room. One Thanksgiving my aunt and uncle slept in my two bunk beds underneath my full-bloomed canopy of tits. All along there was no mention. My expulsed inner-light grew stronger. I turned the energy of the indirect exposure inside myself inversed, doubled it with further-packed air, remained silent through the day. The blue space above my pillow pockmarked with countless images, each with its own eyes, watching me through sleep, images that could be induced by focusing my mind and body into brainworlds where they were there upon me and I was given room into them to there release—inside a constantly ecstatic coma, at all hours alive, blurring beyond light the taste of night and day.

I began to find, too, in my attentions, that I could control the fabric of my sleep. By tuning my attentions in on the context of how and when I went to bed, the differences between the sleeping and waking states, as well as thinking hard about what I wanted to find when I'd be there, and holding it distinctly in my brain before and after, I could not only manipulate when and where and who and what I would see inside my sleeping, but also my own careering there among it. I knew nothing at all about the concept of lucid dreaming at the time, the various methods for turning these things on, but in the devices of my own controlling, my obsession, the dream realm allowed me an increasing reign over its glut, strung

along as if within Borges's hidden city Tlön, where one of many schools of thought "believes that while we are asleep here, we are awake somewhere else, so that everyone is two." My body's private body, rendered from its other light.

By manipulating sleep while waking, I could find myself involved in certain sleep-unique locales I found it difficult to extricate myself from as more time passed, as if by further practice I could fully eliminate the need for return to my body. I mean I did not often want to wake up: the rooms inside my sleep connected of a logic that when waking disappeared among the light. There were people and areas within the dreams that could be glimpsed at times outside the fold of sleeping, but not in such a way as what was in there, rammed with network. This was a world where trees did not age so much as glisten harder, and each room connected to all rooms, and the dead spoke with the living and the uncreated, though in communicating with one another we did not mention those old yards or our other bodies outside the fold. Mostly language was shared by eyes, not winking or complex gestures but a kind of texture in the light the way they worked here, of no ground, and the way the brain behind the lenses could speak without speaking. In this space there was a quite a bit of water—an ocean that from certain angles seemed to stretch on and on forever and had a depth into which a ball of light could descend until it was no longer clear or even there. Mostly we did not interact with these wet bodies as they seemed to suggest a whole other subregion to this region, and one that did not seem inviting. There was not time—as though time did not seem to count here in the normative way; the way it accrued was even faster than in the flesh. Weeks might go by in the duration required to lift an arm. I cannot account for the periods elapsed in this manner, as they did not appear in wrinkles on my body, at least on its outside.

When there were rooms in this room, they were often small ones, with other rooms inside them—here open to me, among day—unique spaces awakened in my assimilated nod-off. Some of the rooms might have small sleds of food inside them—fist-sized cream puffs, bags of fluid, apples made of obtuse color, sandwiches with meat for bread and bread for meat. I would not eat here, as to eat could nail you to the location eternally and without exit—had I the choice now again to choose to eat I might. Other doors would open into locations in my fleshlife, such as doors into apartments where I had not yet but would soon live. In one building I found a sofa and a turned-off TV and lay down beside it. This would be the house in which I later lived during the years I began repeating a certain recurring gibberish word, a practice I still haven't forced out of my body. In the room that day I could hear music that filled the house completely, like a water. It was the most perfect music I'd ever heard, or would hear—it was like eight records I had loved or would love one day played at the same time in perfect cohesion, as if they'd meant to be this. I went to the door and knocked with both my hands. A person answered the door there, someone I did not know at the time but would in later years. He was sweating and his whole of skin was flushed a bright red. He'd shaved his head—shaved it of hair I did not know then he had. "What is this music you are listening to?" I asked him. My voice was my voice. He looked me in the head with gleaming eyes. "*Goulange & God-father*," he said, and closed the door between us for those years.

In another room inside this region I followed a door that opened into the living room of an old friend. In the floor in this room I heard another music, a record I loved at the time. I could hear the music the same way it sounded in my body, though as I listened somewhere in the middle of the record the album hit a frame of air

it had never hit, and entered a composition that had always been hidden on the album, always right there, though no one had ever heard it. The sound of the song lifted my body off the floor and hung me floating while its presence filtered through my blood. All these years comprised and compiling in those sleeping hours during which I could eat my way around completely and explore. The fat cells of my body bringing full mass through me to keep me pinned and spinning down. In other rooms there were people I had known forever and yet would leave there when I left the space and began to forget how to find my way back to there again. Rooms containing objects and potential time therein buried. The dream journals I would write then in my memory, later to switch over to the computer, though in placing those words there I could not find the way to speak them—they instead became bruised replicas of nowhere, keys to nothing, phantoms of emotion enclosed behind nets and fences and locked with locks of all the time I have been gone, hereby dragged into the waking days as totems—relics of the other space threading all space.

The period of time I was able to access these regions of me in retrospect in human time was very small. I was a lazy lucid dreamer and did not string well. I mostly accidented my ways into seeing and still knowing. As in my fat body I began to hunger for some way out—to strip the cells off—I began to find the leaving closed many of those strumming doors. The motion to leave my fat flesh was in the idea of another person—an obsession rendered in and around a human air, which I believed I could open in the image of my dream people. A dream person, here in hand. I began to want to shift the fat bulb of my body into something someone could sometime want—an unhealthy impetus, to be sure, but also one that made me move. Or not move—as it was not in exercising that

I peeled off the bulk of pounds. Instead I forced my diet down to almost nothing—two hundred calories a day, which I held myself to above all things, no excuses, no parole. I ate salad and rice cakes, fake eggs, drank mostly water. My insides grinded through the night. Whereas most evenings before I could drift off in an overdose of carbohydrates, I now made my body eat itself. The sounds of the destruction would turn on and then turn off. It would come back often doubled, redoubled, exiting silence. The broil so hard all through my rungs I could hear it as if someone were speaking there inside me—the extra self I had encased. Seeing myself from there inside me, I could know it better. I worked to work it into forms. I worked to shift the cells I had in small ways—veins, shapes, muscles. A me inside me in slow emerge. This is my body. This is my body now. This is my body now now. In my flatting flesh I stuttered on. Days went on in this way. Weeks went. Weeks made of months. Months made of hours. Hours where the bugs were. Where my arms stretched longer than me. More of me disappeared, as did my control of the rooms that sleep hid.

In the three months between my tenth and eleventh grade years, I lost eighty-seven pounds. Down from flat 260 to 173, in slightly more than one full summer. My parents' friends began to ask my mother if I was anorexic—which, despite the lack of eating, I do not believe I was—as, in some way, I was still eating, though through the cells of me I'd kept around. Carving the body from my body. The other, in there. When I returned to school, the kids I'd spent ten years with so far mostly did not recognize my frame. There was something different about certain people's eyes. At the center of the oval of my school pictures, tuxedoed for my final year, my face is thinnest, glossy, forced grinned, a thin gloss of makeup covering over where the sleep ruin has reentered, or at least, in my

less-padded body, been allowed to surface, show its hold. At gas stations or theaters I would be ID'd and have my picture handed back toward me, fat inside the frame. "That's not you," they'd say. Their bodies seemed so far away.

Other times, inside the night in my new flesh, again not sleeping, I would find myself compelled to walk out from my house without my clothes. It began as a challenge to myself in the lowest throes of finding no exit outlet, sitting naked hours in the blue monitor glow. That first night I began by moving to open the front door fully naked, the night air moving in and around to encase my indoor skin. Onto the concrete with my bare feet on cold core into the light that permeated between my own door and the fenced-off yards on our far side, rows of windows each dark-clustered, sometimes opening into darkened rooms. That other air held an electric tension, so set off from the rooms and walls where I'd become encased. Stepping further out, onto the squared-off lawn, and then down into the street that shaped our lawn, the cold ground beneath my feet held some soft wriggle. The ground would even crunch. Each step further from my front door brought a second drum inside me. My naked body in the thrown glow for every inch would seem to reanimate alive—etched through with where I was not supposed to be in such condition—filling through me as if finally actually all awake, no longer bogged inside that halfway place of nothing where words would not come out except compressed. I began to find the further I could make it from my front door undressed the more my body hummed—as if entering some secret hallway, a machine the day disguised and opened unto me here and now only alone. I don't remember ever seeing any cars. No other people. Nothing but false light, the far-off growl of passing cars, my churning blood. Each foot seemed so far, each instant different.

And yet each way always ended just the same—with me back in my house, door locked behind me, my shape returned again in front of the machine full with the remainder of what I'd done—my sets of selves still there again spreading inside me through the small new space the night had made.

]

]

]

Behind my locked door, among the several curtained windows, I learned alone to further spread beyond the house. My own machine lodged in my desk space with its wires and its screen allowed to access servers housed in other houses. I entered hubs of bodies spreading 01010101000 under secret handles, obtuse names. I would dial the network numbers into these locations after hours in our long house, my parents in their room a few doors down. I would log into these systems, create an ID, troll through nowhere. There would be cryptic messages, scrolling false file cabinets of photographs—women nude and fucking, famous women or unnamed ones, women also somewhere perhaps logged in online in this same maze. The labyrinth of the BBS file systems could be confusing. You often had to know where within you wanted to go. Other servers seemed to house nothing—a greeting screen, a blinking cursor, a black background, waiting for some command. Growing nowhere on the air. This presence would become the prevalent cause of insomnia among all bodies—all day, all night, its waiting, need. I would tell the machine I was twenty, twenty-seven, sixty. I would say I was a male or a female. Any ID made by arbitrary buttons.

I was Richard, Logan, Bob. I was Marcy, Annette, Jo-jo. I had very many names, any of which could disappear or shift or be replaced. Locations across a globe of nowhere, all through late hours, replacing dreaming with compiled binary code. The language of these rooms sometimes seemed to act as extensions of the text the printer inside our house had ejected, again, again, again—in every house, then, too, that replicating sound, sound which when sent into sleeping bodies destructs the quality of their best sleep, even in leaving them unwaking, in no light. Some of the servers would require my own home's phone number for the entry; some would then require you to allow them to dial in, verifying your location in the blank night. In the house then in sudden spurts the phone would ring, the squawk of the modem speaking through the wire briefly, unto new, connected silence.

These hours in front of boxes in the thick throes. Feeling out the hours others in years before had learned through bodies or through waiting, herein expressed in digits fed into our house by the phone line, the diffuse glow upon my skin at all hours of the night. One learns not to see the clock there on the desktop. One learns to click in common ways, as if entering, through a browser, into a house of the familiar. More hours typed than hours spoken. Weaning off the social days of digging among mud in sandboxes and games invented, flooding into space where space was mine. Was (h)ours, in goofy rhizome, regardless of how blank, using the signifier board of signifier buttons for signifier characters that build up into signifier words, or fragments of signifier words, approximations of new breathing or sex sounds, signifier speech to express and/or induce arousal through the wires relayed betweens machines, creating hyperlink connections over long air to induce a state of ecstasy via things further signified, translated from the

machine to the meat brain in a causal stream of messages relayed in code, producing, perhaps, at least an increase of blood tone at one or both ends, perhaps orgasm, and for sure a surplus of zoning time, spent staring into light and pixels, hardly moving, while also at once likely absorbing further cells, further veiled information splurged into the brain cracks for cementing and manifestation of the mind into a state, where, after all, you are still sitting, silent, surrounded by your air of a conduit of body. Every hour looking for more holes and more ways in, where herein I would sit around and seethe with something that came from inside the machine, humming light. Suddenly, the palpable world seemed less and less to need to exist. The replicators varied. There were new screen names in the rooms. Such strange energy through the wires unto nowhere in a room alone, surrounded. New fields of text or doors of photos wobbling to the surface where I clicked and clicked. Words, in silence, rained. The machine asked me nothing, unless I asked it to ask me. I played games and banged at buttons. The sleep rooms for many masses became that much more partitioned, pre-reserved off, less distinguishable between day and night. My home held count of stuff, full hard drives and gone floppies and replicated CD-Rs in piles denoting further hours I will not remember, encoded in digits left to digitally, and eventually physically, decay.

Even in thinking and speaking all of this—in the *awareness*—I am no different here today—if anything, I'm worse—as now, the hysteria learned into me in my leanings through all these days, my inborn dependency for online realms remains so thick that often in temporary disconnection I cannot sit still. How now when the signal goes down, even for minutes, even just a particular wanted site taking its time loading in my cache—and it is always the site you need in hiding—*need*—each breath seems heavy, and my blood

will tingle and fill with slowly rising heat—very much in the same way not sleeping does, I'm sick to realize—or as if whole sections of my home have been blocked off, some precious objects locked in rooms abandoned—the nameless, endless sections, nowhere but in there—without idea of when or where it will come back, if this time in crashing the browser will be off forever and those reams of rooms forever crushed into code and fed and wanting on and on and into me, reminding every instant that I am not endless, really, in time or dimension—how I too am failing—and yet the endless unfurl of selves shaking me awake every night—the true center of that unsleeping being not that I truly have no clear horizon, have no center, but instead that the me inside my body is always immediately right there, my bulk of thoughts as blank as anybody's, stuck on e-mail, on repetition—human—dying—the very inches of me any instant all compounded, aging every instant no matter how I eat or breathe or move my head, no matter where I go in this long waking of the machines or the daylight, whether I ever sleep or not again.

Fear of Space

"Insomnia is not defined as a simple negation of the natural phenomenon of sleep," wrote Emmanuel Levinas. "Sleep is always on the verge of waking up; it communicates with wakefulness, all the while attempting to escape it." Insomnia, then, is also not simply a continuation of the self as Same, but the waking presence of the Other, "coring out" the self in conscious periods, the same way the Other works to core out the self inside of sleeping, while active defenses are down. There is a constant inner pressure of a presence there inside the self, pressed against another, outer pressure of what the self is not, beyond. Hegel refers to the Other as the alienation inherent between bodies, wherein "each consciousness pursues the death of the other," complicating the waking state as constant vying, wrangling, definition in contexts of spheres of light. For Sartre, the Other is "the indispensable mediator between myself and me," a feeling of shame erupted from the image of the

self as we "*appear* to the Other," forming an at once symbiotic and friction-making system open on all ends, in all lights. Lacan goes on to credit this infernal feedback system as the site of creation of language and speaking, a generative engine carried in our blank: "the unconscious is the discourse of the Other." For Levinas, this haunting of the surrounding selves within our own singular waking creates a spiritual location, something beyond the nexus of flesh and thinking. Insomnia does not demand, within the self, a form, and therefore "signifies the absolutely noncontained (or the *infinite*)." It invokes "a soul that is ceaselessly woken up in its state, its *state of soul.*" Thus, through being forced to reckon with such forces that would normally be absorbed in dream or memory-removed ways, insomnia brings the self to face the coring selves and worms of Other there inside it, awakening, in distemper, something otherwise beyond.

Not sleeping most often does not feel transcendent, however— whatever stretch of spiritual lucidity might come over is most often accompanied by shades of aphasia, oppression, frustration, anger, ache. In the sled of not sleeping, colors lose their color, take on other colors, acquire sound. Senses learn their other senses, somewhat, if in a way complex logics in a dream might seem everyday—the intuitions or received impressions of that hidden space once pulled back into the human light again suddenly seeming far gone, or disappeared. Objects, in extended waking, seem to possess objects. Light is angry, licking your head. Communication struggles with its machinations—the speech and beeping of people and machines both softer and louder at the same time, communication's multi-languages both more pulled open, brighter, and harder to hold in the mouth, invoke—*this is not my tongue.*

And yet, when charged with that idea of the other light, it is these selected spaces that can become the most terrifying when in certain lights they seem not quite what they were inside your mind—such as when being alone in a room you've lived in for years suddenly feels different when the light hits the walls a certain way or someone is knocking or there is sound inside the house you cannot name—or returning to a song, a place, a person you'd remembered fondly in such a way as how it'd shrouded in the mind, only to find it changed there, not yours, and even more malformed in presence in the image held in your idea of what it had once been. Fear drawn out of the familiar—instead of, say, a strange street—often feels that much more horrendous for it—*this is not the place I always thought it was.* The way these natured objects change (or do not change, but seem shifting inside, masked with faces you might mistake for home) in coalition with the self and its surrounding, developing a continual vortex of appropriation despite the appearance, on their outside, of permanence. Every moment up against every other moment that it is not, continually, forever—every moment never really held. The keyhole of the eye.

Meanwhile, in the body, when finally under, the effect of dreaming works in certain modes like experiencing any other kind of stress: heavy pressure on the chest, difficulty breathing, high blood pressure, a paralysis of limbs—and, in some, sleepwalking, tossing, chewing, automatism, gibberish—all mechanisms of simultaneous confinement and hyper-sound, unveiling repressed body. In some the terror might become apparent—aware of being trapped inside the self, and of being aware of being trapped, in certain angles, and of watching, from that body's hold, as the trapping is going on—a meta-state much like that, perhaps, in claustro- and agoraphobias, or, on the other hand, the lure of

autoerotic asphyxiation, smothering, and other, of a doom—of an overwhelming form impending—an approaching—other sound—new balloons. The body remains in throes desperate to communicate with the world around it, even while buried, caught between two states, fully in neither.

Between states, the body floats between the states of self—always bodied in the palpable present, but piloted with a mechanism that must coexist, and in the shift operate inside of methods that send signals between the versions—flares sent through skin. In his quasi-novel *The Age of Wire and String*, Ben Marcus defines the mode of snoring[3] as another sleep-speech mannerism, ejected from bodies making more, or "language disturbance caused by acciden-tal sleeping, in which a person speaks in compressed syllables and bulleted syntax, often stacking several words over one another in a distemporal deliverance of a sentence." Marcus offers, of the nature of these disfigured words, a direct translation: "Pull me out, they say, the water has risen to the base of my neck."[4] Here the sleeping self, who will likely not remember or only remember portions of what has happened in conscious absence, can only communicate to the environment of human speaking in what seem malformed utterances, learned in life by most to drown out or disregard. The language of the self inside the self, spoken into an operant human receiver, is essentially gibberish, conducting only in its wake irrita-tion in response to what Marcus interprets a gesture of pure fear, a metaphysical transmission of the self's anticipation of its own death held inside it, obliterated between fields.

3 In 1993, the Guinness World Record holder for loudest snorer clocked in at 93 decibels, the same volume as a belt sander, and more than half that of a rocket launch.

4 *The Age of Wire and String*, 8.

In Kabbalah, such speaking might be considered employed in answering a *dream question*, asked of angelic escorts in the ascent of the soul: answers hidden in this product of the blank space, a furtive message. "The early medieval master Hai Gaon notes a method for attaining a dream question involving fasting, purification, and meditation on a text. Based on comments by Abraham ibn Ezra and others, scholar Moshe Idel has identified this text with Exodus 14:19–21, each verse of which contains 72 consonants alluding to a mystical series of Hebrew letters said to represent the true name of God."[5] God here, in gibberish to humans, exists among a nameless language strung in chains among a life, held in the image of the bodies of those in repose of their will. The pronouncement, perhaps not surprisingly, is similar to that anticipated in the occult, such as in Aleister Crowley's rite of Eroto-Comatose Lucidity, from 1924:

> Finally the Candidate will sink into a sleep of utter exhaustion, resembling coma, and it is now that delicacy and skill must be exquisite. . . . The attendants will watch with assiduity for signs of waking; and the moment these occur, all stimulation must cease instantly, and the Candidate be allowed to fall again into sleep; but no sooner has this happened than the former practice is resumed. This alteration is to continue indefinitely until the Candidate is in a state which is neither sleep nor waking, and in which his Spirit, set free by perfect exhaustion of the body, and yet prevented from entering the City of Sleep, communes with the Most High and the Most Holy Lord God of its being, maker of heaven and earth.[6]

5 http://en.wikipedia.org/wiki/Dream_question.

6 http://hermetic.com/crowley.

The gate, from both ends in these instances, invokes the higher state of self available in which the self ceases to control, can be manipulated into seeing, at last, what had been at all times just right there—a vessel in which the self serves its own reflection—a space inside the self that extends beyond the self. Through this window, and by bringing it into the day via an insomniac state, one might find oneself in the fold of somewhere else—at last, perhaps, invoking access to those keyless, faceless rooms hidden in any day. Somewhere between want of everything and pleasure of nothing.

Or one might simply go crazy. The line between the real and unreal here grows thin. Automated in sleeplocked manner, by law an active sleeping person might no longer be responsible for his or her acts. Law has historically protected those found in unknowing operation of their bodies while committing capital offenses. Simon Fraser, of Glasgow, had recurring dreams of a monster that entered his home in his unconscious. One evening he dreamed that a white creature came up through his floor, and he beat it to death against the wood. He woke and found he'd smothered his infant son. He was acquitted, under the condition that he would thenceforth sleep only in rooms alone with the door locked.[7] In 1987, Kenneth Parks, a twenty-three-year-old father, testified to having had no consciousness, to having been fully asleep, while he drove twenty-three kilometers to his in-laws' home and murdered his mother-in-law by stabbing. Parks's extremely unusual EEG readings, coupled with lack of obvious motive, and his testimony of knowing nothing between going to bed and arriving at a police station saying, "I think I have killed some people . . . my hands," in sum led to his acquittal. In Manchester, England, in 2005, a man,

7 http://en.wikipedia.org/wiki/Homicidal_somnambulism.

Lowe, beat his father to death via a series of attacks in three unique locations of the father's home, on different floors and on the front walk of the house, resulting in ninety different physical injuries to the body. Both were very drunk, and had gone to sleep in different rooms. Though the spread-out and repeating nature of the assault was found not consistent with usual sleep-violence behaviors, the court acquitted him of all charges.[8]

Several instances involving the acquittal of pending rape charges provide the same reasoning as in the cases of homicide: that the sleeping men did not realize they were raping, that they could, inside their sleep, perform daily acts without knowing when or where or against whom.[9] These behaviors are almost across the board the result of "provocation or close proximity" in regard to the victims, true for 100 percent of acts caused by confused arousal (like sleepwalking, but not leaving the bed), and for 40 to 90 percent of those caused by actual sleepwalking (which is defined as the second an unconscious person's foot touches the floor, and can range from "slow wandering" to running.[10] Triggers in the cases of these incidences include sounds outside the body "such as snores or internal events such as apneas, hypopneas, or leg movements," some of the most common complaints of wrecked sleep, which again recall Marcus's distress signals from the self inside the self.

Violence against one's own self, often by accident and resulting from dumbed motor skills, is also not uncommon, and can be manifested by "tripping over objects, falling down stairs, cutting

8 Pressman, 1041.

9 http://en.wikipedia.org/wiki/Sleep_sex#cite_note-3.

10 Pressman, 1039–41.

oneself with a knife, or burning one's hand while sleep eating," the flesh stretched to the point of ripping. Though the average rate of success of a suicide by overdose in the United States is only 1.8 percent,[11] those involving Nembutal, a former active agent in sleeping pills, have been reported as 100 percent successful throughout 840 documented cases when coupled with antiemetic drugs.[12] In some, the self-destructive sleep behaviors might become so complex they result in involuntary snuffing, such as in 2010 when thirty-five-year-old conceptual designer Tobias Wong hanged himself while sleeping, the last in a series of strange unconscious behaviors that included holding business meetings, selling things on eBay, designing costumes for his cats, and mistaking his lover for a murderer. Another frequent parasomniac, Michael Cox, hanged himself inside sleep in 2001 after watching *Schindler's List* before he went to bed.[13] Others have jumped from windows, walked into traffic, mishandled guns, dealt damage by bumping into walls hard with the head. Though some have tried to debunk the common advice that you should not wake sleepwalkers in the midst of their procession, countless studies have shown that those shifted dramatically from the sleep-state action to the waking light are violent and negative, confused particularly in the sudden shift of self inside of self to self in direct contact with the other, crossfed with hidden terror, a translation of the night. Even in sleep, then, we are someone, waiting. We are full of our blood, and we have hands. Reality becomes then a silent question of where do the many of me in me and the kinds of air around us overlap; where might time and place inside the body be negated, turned otherwise alive.

11 Stone, 230.

12 http://www.tagesspiegel.de/weltspiegel/Sterbehilfe-Dignitas-Minelli;art1117,2502357.

13 http://www.telegraph.co.uk/science/7960448/Death-that-stalks-the-sleepwalker.html.

]

]

]

The French surrealist writer René Daumal died at thirty-six in 1944. Up to the day he died, he was working on a book. The book remains unfinished, left open in the fifth of a projected seven chapters. The book, titled *Mount Analogue: A Novel of Symbolically Authentic Non-Euclidean Adventures in Mountain Climbing*, concerns the reckoning of a mountain concealed on the earth, a mountain whose *"summit must be inaccessible, but its base accessible,"* and which traverses the *"path uniting Heaven and Earth."* The mountain is, as well, subject to certain rules. It "must be able to exist *in any region* on the surface of the globe," hidden, for the most part, "not only to ships, airplanes or other vehicles, but even to the eye." The mountain might exist *"in the middle of this table"* without our having the slightest inkling." The texture of the opening to this mountain remains invisible to everyday eyes by a *curvature of space*, in the same way that stars remain visible from certain positions even when they have become hidden in eclipse. The space around Mount Analogue continues as if it does not exist, manipulated by the context of the curvature, the deflection of light. "To find a way to reach the island," writes Daumal, "we must assume on principle, as we have always done, the possibility and even the *necessity* of doing so. . . . At *a certain moment* and *a certain place*, *certain people* (those who know how and wish to do so) can enter."

The novel, after defining this event of voidspace, follows a small crew of eight people who set out in a ship called *Impossible* to locate

this opening unto the mountain. By deduction, waiting, and repetition, they are able to open, in the sea, a fold of air unto the place, locating in our other air, in fact, the presence of the glyph. They find, upon the mountain's base, a small society whose currency is based on *peradam*, a crystal of such density "the unaccustomed eye hardly perceives it," a blanket of secret money, in the face of all things, buried, awaiting he who would dig, or look, or want—money not as object of replication or signifier, but as the product of the search, some small reflection of the self projected from the self. *Mount Analogue*, the novel, ends therein in mid-sentence, at a comma, just as the expedition begins to ascend upon the mount—the narrative sucked into the white space of its ending, transported from the page into the blank. Daumal had been working on the sentence the day tuberculosis took him out, snuffing his mind inside his body, as if the text had stopped him, or better, as if the novel continued on into himself. As if he, in his body, had come unto a hole.

Around such a hole, the potential world looms in every object. Any surface could be turned into a door, unfolded by some focused mode of self activated to locate the space between the spaces—buttons, windows, a vibration—all of which at all points wait watching, surrounding the self's center, a potential to be invoked. Their presences, whether unveiled or left to stay hidden, demand psychic attention to the self stuffed within self—a simultaneous creation and erasure in each moment that passes as common days do, bypassing both destruction and invention in every step, in world moored upon world. In sleep one might brush against these spaces, if reflected in the other kind of Other windows half-open or half-closed, hid in the head; while awake, the hummed, negating sound that comes off the massive walls of color of a painting or a field of text or a wall or photograph or speck might seem to be speaking;

any inch waiting to open, to become invoked, or likewise, to fold in and disappear. The signal-slur of increasing sleeplessness in which the senses begin to mix and fold into deforming might be seen as a matching folding of the vision, opening unto the air laid on the air. Between these dual-made states exists the self—each of us at all times all surrounded by both the forward going and the approach of death; the space of present breathing and the air beyond. Each object is defined by its potential, its connection to each other, "the transitions as well as the ruptures . . . and even the fact that one world disappears in favour of another," creating an over-opening and mega-mapped structure of limitless hallways, doorways, and weird light, where "there is always something else implicated which remains to be explicated or developed. . . . Everything happens as though *the Other integrated the individuating factors and pre-individual singularities within the limits of objects and subjects*."[14] These moments, ideas, surrounding, buried—endless vertices and incidental collaborations of the self against the self—suggest small doors or contexts for direction set in all things, to whatever length they can be approached in youth of mind—a sleepless light that feeds its own sleeplessness in approaching, or in complex waking. The location of *the mountain*—or whatever form of transcendent location the self might crave—*eternally nameless*—remains on the middle of a common table, or inside the bedroom closet, or in the slur of space unseen behind the head—a connective tissue gener-ated and generating, buttons blistered on the several bodies inside the self contained and uncontained. To find the mountain is not even the goal here, really—it is the space surrounding, the want developed in the flesh that changes the flesh of self from a mirror to a conductor—a body among bodies meshed into a web into a mas-

14 *Difference and Repetition*, 281–82.

sive body of media and memory and hours, the breadth and mass of which we will never see from where we're standing—though we can breathe it—we can permeate the void.

]

]

]

"All people's pictures," wrote Clarice Lispector in 1963, "are portraits of the Mona Lisa."[15] That same year, Andy Warhol produced *Thirty Are Better Than One*, a work that portrays thirty Mona Lisas photocopied, black-and-white and errored, like a hive—the thirty ghosts of versions of us watching, of one body, collaged via machine. The effect from afar of the many utterances of the classic painting build en masse toward a blank field, a flattened void—the many heads together, instead of gathering one's glown aura from the rest, form a kind of wall. "I wanted to paint nothing," said Warhol. "I was looking for something that was the essence of nothing." His nothing, like Lispector's, comes from the folding of an image, blurring the space between where the individual body ends, and where all the others begin. Or vice versa. It, like any instant, seems to both confine itself and permeate the space around it, like a brain searching in itself for where it is, hiding from death. The void surrounds and stays unseen.

Lispector and Warhol, respectively, died aged fifty-six and fifty-eight, in beds that were not theirs. The message of their passing

15 *The Passion According to G.H.*, 19.

spread through mouths through wires and into more machines, leaving, past the body, only their image, word, and name—their forms aggregated as flesh into soil and water—their beings each as an idea humped as icons in the sprawl. Pictures of them now, like anybody no longer living's pictures, seem to contain a horde of hidden self behind their eyes—locked windows to terrain never again creating or destroying, sleeping or waking—like the Mona Lisa they look and look into the viewer never blinking, always still there when the one alive still turns away.

In his eight-hour film *Sleep*, made the same year as *Thirty Are Better Than One*, Warhol exhibits a cut-up series of looped reels of his sometime lover John Giorno, transformed, as Warhol aimed, into a "star" while all unconscious, his body speaking in the absence of its controller. Warhol repurposed this human body in the same manner he had the commercial object, the copywritten. In the ribcage-rising-falling silence, rummaging over the landscape of the man, the camera remains poised, oddly electric in its capture of what many would call as close to *nothing* as you could ask for in a film: an automatism; a conscious kind of light, even asleep. "It just starts, you know," Warhol said of the film, "like when people call up and say 'What time does the movie start?' you can just say 'Any time.'"[16] Using film to mimic and thus extend the images and shapes that pass by in most instances unrecorded, to herein possess and subject them to be replayed in confined time, seems to model the brain keeping the body stuck awake, and thereby tortured in what it cannot have, and also must continue having, the absorption of thoughts and air, even when one no longer wants to, shaping time's passage with an artificial frame.

16 Goldsmith, 44.

The result of such extended waking, and in the film, the long, re-peating shots, is a surplus of time where time itself degrades in value, life in diminishing return, toward death, and in the wake of death a slowly tapering hallway wherein the space between death and life itself, and waking states and artificial measures, seems deforming, making copies of an act held not quite right. "Seeing everybody so up all the time made me think that sleep was becom-ing pretty obsolete," Warhol predicted, "so I decided I'd better quickly do a movie of a person sleeping."[17] The underlying pro-jection herein being that with such repeating mass and endless feeding, one day there might become among our minds a state in which we can no longer differentiate between sleeping and waking, between the doppelgänger and that from which it has been cast. The film *Sleep* itself, now almost fifty years in the past, in retro-viewing seems already somehow alien, controlled—even at times blurry, more like moonscapes or mannequins than something ours. It seems to suggest that the nature of our sleep itself each night is shifting right beneath us without notice, each day becoming some-thing else, more ruined and malformed, alien even from this body spread in silence not so long ago, on screen. "I don't know where the artificial stops and the real starts," said Warhol.[18]

Even in the most benign of objects, in days fleshing, there are map notes toward potential holes between the extant and the perceived. There is a bigger body made up of the bodies, hulking in night of light and light of night, and which, when strung together, might open wide enough to enter, as in its affect of seeming sleeping with-out sleeping, insomnia might begin to wear around you as a house

17 Warhol and Hackett, 33.
18 Goldsmith, 93.

inside the house—a second, sheltered skin above the skin you're in and beneath the ceiling or the sky, both holding out and holding in. In this way all houses could be the same house, connected in all the films and all the books, all of one air: the hotel in *The Shining*, in which no characters are pictured sleeping, whose walls and carpets lead the visitor through and through them, among the residue of who has been inside them all those years; the ballet school in *Suspiria*, where two students realize the instructors leave at night not by walking to the left, where the doors make exits, but to the right, heading deeper on into the house—a discovery which, after making an aural mental map of the building by counting footsteps, one girl is murdered in a room full of white wire, and the other, center figure (after pouring the sleep-inducing food she's being fed into the toilet) finds not only a confluence of witches, but a door into the mouth of hell.

In these films, the fictional locations serving as settings must be channeled by actual locations, in human light. Some rooms are constructed out of soundstage walls and boxes—defined space designated for years of shape-shifting architectures, innards, and air, as well as the bodies brought into them, representing other bodies, and their posited languages supplied by someone else, played out often in replication with minor variation in pursuit of uncovering the scene to be replicated in another way, on film. This history of our creation has gone on as long as all our lives in one queue, and each day appended to in clicking, filming, named. In each, there is the brainspace and sleep lost over the anticipation of the next—the filmmaker's years and years of manipulating mirrors and other bodies, toward the credits, in want of approaching further toward the one; the years of study of the painter, to get one stroke right, to perhaps, throughout a life, render one length and width that distinctly

helps awake the thrall; something unnameable, unspoken in the fixture of a curious node inside a whitened room; holy spaces; unholy spaces; a mesh of the internal mind with the external, as with ghost sightings, ESP, séance behavior, black lights, pyramids, mob violence, installation art, computer glitches, online forums, out-of-body experience, comic books, dream interpretation, conductivity, and so on; of the common ground between these: a continuum of unheard sound—a sleeping of no sleeping, or sleeping outside sleeping, or eating outside eating, a silent floor. And among the flood of it, again, the errors: the queue of holes in continuity and imperfect rendering of form, the errors and the overlap of bodies, wrecked brain matter, hours, aligning into further wake, *as it is in the human that the door must be found, and for which the door exists.* A game of days. A calm embracing of no nowhere in some somewhere. A lick of houses, walking, light. "Out of the totality of the images, out of a metamorphosis of elements," wrote Antonin Artaud, "an anorganic language develops which enters our consciousness by osmosis and needs no translation into words." Words, false models, stacked in albums, lined in faces, clinging hard to time to make time beyond go beyond time, which as it continues, must continue to deform the shape of the face in its wake, to keep it hidden, as the flesh and word and photo replication-body grows, fed by the living in restless output to amass around the dead.

Further filmic settings absorb their aura from translated air in unique human space, such as the weird-light-surrounded entity of *Poltergeist*—beyond its legendary death curse, based in the knowledge that four cast members died within six years of the release. The film was shot in Simi Valley, California, on a Roxbury Street, which was lined with new homes, surrounded by undeveloped land. The houses had no lawns. Location scouts, under the guise of mak-

ing a B-movie, offered residents free landscaping for their homes in exchange for allowing their premises to appear on film. In certain shots, one can see that the first house on the street—an eerie copy of the home of the film's central Freeling family, and a house that was unoccupied at the time—has no landscaping, unlike the others. Production wires can be seen running from the lamps of the Freelings' home. These are small details, burps in the contained air, that again here in context echo in the waking space to some other light—something rattled in the film stock—minor errors connecting from dot to dot the camera accidents and light poles and shadows, stutters—a fabric made of glitch. There is Descartes' reminder, also, that waking up from a dream can be a part of the dream as well, and thus the discontinuity of waking, and distrust of rationale—never knowing where the body has been really, or where it is going, or the words. When *The Shining* was translated to be dubbed for foreign broadcast, certain language became changed. The iconic phrase *All work and no play makes Jack a dull boy* became "No matter how early you get up, you can't make the sun rise any sooner" (Spanish), "The morning has gold in its mouth" (Italian), "What you have is worth much more than what you'll have" (French), further iterations on the words crammed into the words already there, the words that inside the film, never change, despite how they are read—each a layer placed into the text inside the image regardless of one's awareness of it, as the thing itself goes on—the film existing copied in countless surrounding houses, like the Bible, strewing flesh of media between unseen doors. "A photograph is a secret about a secret," said Diane Arbus, who later killed herself by slitting her wrists and eating pills. "The more it tells you the less you know."

Twelve years after *Poltergeist*'s release, the Freelings' doppelgänger

house drew extensive damage in an earthquake; the garage ripped out of the ground, the driveway cracked, and surrounding walls collapsed. In the Google Maps view of the *Poltergeist* home (4267 Roxbury), the houses there now look like pyramids, overgrown shapes. Above the house, in the middle of so many massive houses, sits what appears to be a field of yellow sand—a blank space with odd lumps set in it, mounds. *The browser will not allow the street view to touch down.* All of these houses have a beginning point (their construction) and an end (their eventual dismantling), though the air they contain remains unique space. Bought and sold, hammered and burned, whatever building or hotel or nowhere becomes brought to stand around it, in walls and windows, tunnels, doorways—where—those specific nodes, short of eternal obliteration by some black hole explosion or angry god, will go on—*within the hole where the earth was.* They will be the meat they are from A to B and B to A, again, again, despite whichever kind of board or nail or glass pane, whoever makes the space their lair—their code names caught for now in glyphs and numbers, our makeshift location signifier, GPS (of latitude, and longitude, and altitude, and precise time) (of space, control, and user). In real estate, *stigmatized properties*—those altered in air by occurrences or aura-making such as the *Poltergeist* estate—must in some cases have their status disclosed to potential buyers; this can include both *physical* and *emotional* components, for which guidelines vary in negotiation between state lines, though there is so much that could never fit into a contract, could never be teased out of the frame.

"No dreamer ever remains indifferent for long to a picture of a house," wrote Gaston Bachelard—as in every house is every person, structures like the body in the light, and hiding from each other underneath the houseflesh other bodies, so much nowhere.

The wanting wells throughout the hours of the day, the structure of one's home, and within that, one's body, remaining under constant fuselage of other's seeing, wanting, passing in the blank, even, as they see, in driving past the rows of homes in going for groceries, the peripheries projecting, combing through mental mud. Such is the wont of accidental witchcraft. Such is unconscious absorption, radiation, charm, which Bachelard eventually confronts via the body, among sleep: "The repose of sleep refreshes only the body. It rarely sets the soul at rest. The repose of the night does not belong to us. It is not the possession of our being. Sleep opens within us an inn for phantoms. In the morning we must sweep out the shadows." Those who do not sleep, then, for longer and longer periods, in some informal affront against the dark, forced against the will to reckon with that which would have us be silent, open, in want of exit of the self. This residual, complex motion appealing to the body at such levels that it becomes difficult to speak or walk, shutting down in the face of such looming, of the space around the body beating body. "You don't try to photograph the reality," Jack Nicholson said, quoting Kubrick, in an interview years after the director died inside his sleep, "you try to photograph the photograph of the reality," and somewhere in this, the replication forming its own version of the same—to want and want at and never enter.

Of course there are the countless houses in countless films, their innards reel-to-reel with captured air—homes in the backgrounds, homes in horizons, rooms in videotapes and snuff tapes and webcams—houses replicating their long walls around the air for every minute, on and on into the year; even when the house itself is torn down, its confines set in some way where we will breathe. "There is no trajectory on the screen that does not correspond to its double

in reality,"[19] and likewise, the double to its next double, on and on. All of these homes and houses must then be somehow connected in their ongoing, the flesh of one home reappeared in a third—the pattern on the floor from the poet's bedroom in *Orpheus*—where death comes to stand over him in the night—is licked with the same pattern as the hallways in the apartment building of *Eraserhead*—both rooms with portals held within them that lead into the realm of death. Tunnels. Time effacement. Negotiating motion for replication in all time, pulled open in small places by the body, as a tool. "The film plays my parts for me," the actor performing the title role of Orpheus, Jean Marais, is said to have said, as if in performance he had realized he was not the self himself, but was merely walking in the form of what the film, among all film, wished him to be.

"Some houses may have been moved," writes Ben Marcus, "and may have contained the ancestors of other shelter tribes, others might have resisted sleep migration and collapsed." Here not only are the sites of all the houses linked, but sites of prior demolition, evacuation, a whir of coordinates in which the self some years might hide. Marcus goes on: "Archaeologists divide the time of this culture into the house maker and the house destroyer periods; in the latter period, participants turned increasingly to nonuseful and abstract houses, eventually constructing the penetrating gevorts box, of which one thousand wooden units were made during the Texas-Ohio sleep collaboration, 1987. Gevortsing has subsequently become known as any act, intention, or technique that uses negative house imagery during the dream experience as a device to instruct inhabitants to sleep-kill or otherwise destroy themselves, their

19 Douchet, 126.

walls, windows, doors, or roofs upon waking, until a chosen version of the culture has been sufficiently driven from their home." At last, in Marcus's projected future, in an act of revolt against some seeming ever-present oppressor (which is so ever-present as to infect our dreams, to take on forms they cannot read, but must assume are there), humans at last lash back against the air of other bodies and years accrued around them—via such things as photographs, films, codes, flesh, language, machines—they become aware of where they've been (surrounded) and realize their own bodies as unconsciously possessed by what they remember and do not remember, own and do not own—their sleeping minds invoke their expected waking into a want to claim the house for what it should be—ours—no longer plagued with culture's malfunctional gloss.

The revolt, though, rather than against some figurehead of history or politics, must be here against the self—to dismantle not the product of the place and aim of being, but the site of it: the body and the home, eater and container of all air. These people, in Marcus's programmatic language, read less like actual humans (narrative characters) and more like relics, photographs of selves of us in rooms we already do not remember—though the blood of such want and supplication are all over our (the reader's) hands: we in the many shifting nightly versions of ourselves inside of sleep each day, upon waking, seem in the same way so far apart, like we'd been acting, or summoned into a game—this gevortsing is all the actions we've been taking without taking, wearing ourselves down in every instance by the doing and not doing, no matter to what extent we feel we have or have not failed—our eternal want for the thing we cannot have, to be the place we cannot be, to stay alive though we will die, to live in one house with all our love forever

and to be alone, to sing in silence, to be free the way we feel when we're asleep.

One could list these shapes of spaces on and on forever—these rooms which operate in texture like some vacated space located only forever there inside the film, though seeming connectable to your own light, as if through a tunnel hidden behind a certain panel of your home. Proust well reflects this weirding schism between the hidden self and the framing bodies in his *Swann's Way*: "But even though I knew I was not in any of the houses of which in my ignorance upon waking had instantly, if not presented me with the distinct picture, at least made me believe the presence possible, my memory had been stirred; generally I would not try to go back to sleep right away; I would spend the greater part of the night remembering our life. . . ." Our life, yes: sleep does contain a life. Our memory serves as a series of mirrors, as would a home's hold, the walls of the houses in flux therein around them—the one stable section those returning surfaces that spit the self back at the self—the self thereby split somewhere in there at some centerless center, again refracted. The night's soft settle in our eaves, bursting in its reflection, and yet clung to in the blank. Each contains an affect that stays upon you, in the body, however traced or disregarded—and in the space made there resides, continues to exist both part and parcel, however morphed by memory and time. Inside each home, its rooms. Inside each room, the objects. Inside the objects, open doors, leading silent into something uninvited, often ever never named, at once always under infiltration, and somehow daily known as home, a thing we mark by simply breathing in, and more directly, in waking and trying and being, by marking with our ideas, however brief, however continuously disrupted by any inch of any instant every hour, all around.

]

]

]

In my own house, today, alone, my bed stands surrounded on its longest side by a bookshelf of the same length. The books' spines watch me sleeping or not sleeping. On top of the shelf the newer, as yet unread books stack higher up. These books, most of which I've opened, looked up, forgotten, hold their ideas in no light, awaiting, pressed unto one another, no bleeding in—though, if they did, I would never know. The face-to-face and page-to-page in silence. The watching. The contents dumped, misunderstood, and lost in ribboned measures in my head. A mess. Sometimes in the night when I cannot find any semblance of me or what the roar is I will sit up and take a book down from the shelf. Once asleep, I have been told, in inverse method, I eject a different language on my tongue, a language rummaged from some other, culled up from somewhere buried or inherited or woken. The further problem of sleep speaking being that often there is no one there to hear it and you are speaking into the alone, this aurally induced dimension coming out of you without your having heard, except for in the folds of you where you often will not find you. What percentage of experience comes stuck in slits of self that will never appear unto you, or never again be replayed. The gibberish recorded out of all the nights I've spoken there unknowing perhaps an anagram for what I was sup- posed to be, or directions to a spot where right now I should be standing to receive the next note in the chain. What derailments in not knowing. What language has been witnessed coming out of me in other silence reported mostly as syllables undone, or often

laughing hard or making dialects, words sent into the bodies germinated only in rooms I will not enter again.

Some nights inside my worst not sleeping I will move to stand before my bookshelves and just look. Spines line the bodies, labeled titles in symbols—names of other humans, names of this—the lifetimes of images and hours clocked into each and every inch of texts in words again, again used like words are used to be words. Shit. The doors in all those books—doors described and thereby somehow woken not in the book as place but in the head. My house is stuffed with crowds of other people, and not even those just ghostly (passed), or through wires (electronic monikers), but right beside my body (paper, paste) and my head (ideas, sounds) at every hour (never asleep, never alive), while I sleep (yeah), while I walk around or eat (I feel the most asleep when I am eating), all watching and not-watching (who is there), silent and loud enough to seem like burning (*I am in here* being smushed). All those words on all that white—and all that white around those words, as if to drown them.

Parallel to where my head goes when I lie down each night on the bedside table is Wittgenstein's *Tractatus*, a thing I've worked at so many nights and hardly found a way to parse more than a few pages—instead the pleasure of it comes on in the comb of slow ascending digits, each reaching a little higher with its logic each time before I lose inside the rub the sense of grade. This point at which I lose me and touch the perceived nothing of the paper is the point at which I really begin to love the book: I love its code, its mouth I know I'll never fully, even really partly, understand. I love how it seems to want me to be gone—its face decimating my intuition and my will and still existing—a bomb that ticks and ticks inside no gore.

In the shelf space in mirror image there's a cleanish copy of Djuna Barnes's *Nightwood*, which says: "Sleep demands of us a guilty immunity. There is not one of us who, given an eternal incognito, a thumbprint nowhere set against our souls, would not commit rape, murder and all abominations." In any body, a similar potential terror. In any house, in any bed, and, among light, stuffed into certain unknown moments, blanking out in midst of the tally of our skull meat and our eyes: "It has been experimentally shown that persons engaged in a monotonous, repetitive task tend to lapse into sleep between each response and to awake at the time of the response. This cyclic alternation between sleeping and waking may occur even when the rate of response is three seconds or less. This suggests that the schizophrenic features of light sleep could occur in persons who were walking about and appeared to be awake. . . ."[20] Some would go so far in this belief to describe other worlds laid over our world—the poltergeist realm, dream architectures. All our shared air as a house—all shared language, image, as a framework for some other image, over time and in the body, in all ways, and unseen. Becoming wanting of it. Attenuating. What has and has not been removed. The way an image caught inside the sleep mind can affect the body in the wake, even if only in trace: the same way a light or unheard words might snake and furor in the mind. There on the eighth page of Cortázar's *Cronopios and Famas*: "In a small town in Scotland they sell books with one blank page hidden someplace in the volume. If the reader opens to that page and it's three o'clock in the afternoon, he dies." The last two pages in the book, and in so many of these books—blank and waiting. Any time. And the offscreen territory of these spaces, looming in the margins, in the blank between the breath blanking each word from the other,

20 Gove, 787.

and there within the syllables themselves, the hole contained in-
side the *o*, the dot and body of the *i*—these, surrounding our sur-
rounding surroundings. These, in which other languages might fit,
other ink, the out-of-field acknowledged in some nod of pen or
sound-created syllabic collision, in the contained and uncontained.
Doorways, in their waiting, in translation. "Transparent tigers . . .
towers of blood." Every house so huge.

One cube across from Cortázar, Italo Calvino's *If on a winter's
night a traveler*, beginning and ending in repetition, the narratives
lost, erased, cut short, despite instructions for their handling, ar-
ranged in rupture around some hidden center.[21] On the back side
of the same shelf, David Markson's *This Is Not a Novel*, a catalog of
artists' lives, condensed to certain sayings, actions taken, configu-
rations in single lines, therein together forming an index, a hive
of lives.[22] Catty-corner to Markson, Ronald Sukenick's *The Endless
Short Story* made endless not by actually never ending, or even ex-
hibiting the novel as continuous in loop (à la Joyce), but rather by
referring to the book within itself, contextless, as if a node meant
to be found hidden there in its meat, the paper text not the thing
itself, but a conditional suggestion, a roadmap to some hole. "This
is THE ENDLESS SHORT STORY. It doesn't matter where you
start. You must have faith."[23] Nearly spine to spine with Sukenick,

21 " 'Reading,' he says, 'is always this: there is a thing that is there, a thing made of writ-
ing, a solid, material object, which cannot be changed, and through this thing we measure
ourselves against something else that belongs to the immaterial, invisible world, because it can
only be thought, imagined, or because it was once and is no longer, past, lost, unattainable,
in the land of the dead. . . .'" 72.

22 "Italo Calvino died of a cerebral hemorrhage," 29.

23 Within this book, another book created in reference, *Prunebomb*, "a book that explains
everything . . . but it hasn't yet been written actually it is being written right now but it will

Infinite Jest: within which, a footnote containing outlines of all those unmade films, again, or those made and lost films, or films that exist by mere suggestion, films buried, waiting, asking, on. Those films' creator, within the book, James O. Incandenza, who therein "demapped" himself, ending his brain, as would his own creator. This filmography in some way comprises the ultimate text-based correlation to the out-of-field—mass in mass, embedded—though in the case of *Infinite Jest*, it is this footnote that most objectively defines the object of the book itself—the object for which the book is named, Incandenza's final film, the last film in the footnote's massive, branching archive.

The tone of the blood of David Wallace on the day he first heard inside him those two words, that title of that object, sent in him— to be repeated and repeated on thereafter, upon air. The air or food he ate, the incidental sound he absorbed between the typing, any seeing. His hands.

Today.

On the opposite side of the bookshelf from *Infinite Jest*, the frayed ends of its white pages facing toward the book I've just replaced, sits the *Collected Fictions* of Borges, literally itself the meat of several books within one book. Within the book *Fictions* appears, again, the text "The Library of Babel," which among its paper walls contains another set of walls, these provided with compartments for "sleeping, upright" (as in, perhaps, in waking form); a

never be finished it is being written by you and me and everybody and it includes almost everything . . . what it does not include is what interests me as soon as I discover what it does not include I include it then it doesn't interest me anymore."

mirror that many men use an excuse to suggest "that the Library is not infinite";[24] light "insufficient, and unceasing"; all in consideration of the perfect replication of book housing, conceivably within *a sphere whose exact center is any hexagon and whose circumference is unattainable.* According to the text, each of the five walls holds five bookshelves, each shelf thirty-two books, each book 420 pages, each page forty lines, each line "approximately eighty black letters," therein made up of "identical elements: the space, the period, the comma, and the twenty-two letters of the alphabet," of which, regardless, "*there are no two identical books,*" and therefore the Library contains "all possible combinations of the twenty-two orthographic symbols . . . all that is able to be expressed, in every language." The resulting Library, like a brain, is therefore "unimaginably vast but not infinite," "unlimited but periodic," a place "where after untold centuries . . . the same values are repeated in the same disorder . . . which, repeated, becomes order: the Order," containing not only the histories of cultures come and gone, mythologies, archaeologies, but also, and in much greater proportion, a mountain of surrounding gibberish. Among these books, the text continues, there must be a perfect book, "the cipher and perfect compendium *of all other books,*" which has been looked upon by some librarian, therein a *god.* The search for him is proposed via "regression: To locate book A, first consult book B, first consult book C, and so on, to infinity. . . ." In infernal, likely futile pursuit of that book, the narrator says, "Let heaven exist, though my own place be in hell. Let me be tortured and battered and annihilated, but let there be one instant, one creature, wherein thy enormous Library may find its justification."

24 "I prefer," writes Borges, "to dream that burnished surfaces are a figuration and promise of the infinite. . . ."

What is a justification but an end. What is a recurring thought but some senseless, timeless parsing of the nothing eating at the skull under the skull, the brain's flesh writing its language on the insides, a novel never read. "The temporality of the body . . . can be understood as the double, in the actual, of the event, whose reality as pure interval of transformation is virtual, on the order of potential, more energetic than bodily, incorporeal. Or, its attachment to empirical time can be understood as the durational equivalent of the edge of the hole in empirical space into which the eyes of movement-vision disappear, in which case it would be the rim of the virtual at the crossroads of the actual."[25] Through sleep, the leaving doors becoming open, sending rooms onto themselves. The open field map of the open field becoming closed to this room as room, open to somewhere else—as in the way one could complete the puzzles set into the time-narrative of a video game without looking, with the screen turned silent or fully off, if one knew which buttons to push when. A life in timing, coagulated, code. Where are you now. The bends off any hallway passed over silent, still, unseen: the nonexistent building, a construct of no air.

]

]

]

Somewhere in between these hours of seeing and sleeping, a kind of connective tissue of the self in silence must awake. The mind via the body is open and absorbing, fed in air by something both architected and removed, responded to by cells continuously reorganizing, newly

25 Massumi, 60.

birthed and newly dead. Again, Deleuze: "We take snapshots, as it were, of the passing reality, and, these are characteristic of the reality, we have only to string them on a becoming abstract, uniform and invisible, situated at the back of the apparatus of knowledge. Perception, intellection, language, so proceed in general. Whether we would think becoming, or express it, or even perceive it, we hardly do anything else than set going a kind of cinematograph inside us."[26] Scenes on film provide a waking replication of the same meat of space traversed in dreaming and in being forced too long awake, through which the self goes through conscious modes in a kind of mushy impotence, captured in a realm that can't be manipulated, altered, awoken. Like mobile environments—the boxed-in confines of an airplane or a car, a house transported on a truck bed, a body—films carry their air with them, manipulating the continuity of air by forcing displacement, even if concrete coordinates defining that air (as with GPS) remain the same.

This media-enabled mapmaking grows even deeper in what ends up not pictured, what is always just there at the edge of the camera, offscreen. Referred to by Deleuze as the *out-of-field*, this space erupts from the constant awareness that around the seen there is a larger set, and around that a larger set, and so on. This space-expanding replication goes so far out that no matter what is in the picture, there is more beyond it, giving definition to the space of the seen self. This space gains traction the further the field of the shot is limited, making the power of its surroundings that much more other, much confined. Much like the state of continual expectation of the other discussed by Levinas in the inconstant state of sleep, the confines of the confining enrich the immediate minute,

26 *Cinema 1*, 2.

the open node, with a kind of ever-looming sphere of power—something transcending the contained. "The more the image is spatially closed, even reduced to two dimensions, the greater is its capacity to *open itself* on to a fourth dimension which is time, and on to a fifth which is Spirit."[27] With Deleuze, the contained image and definition of the other lurking always there around it both defines the other in its absence and the absence in the context of that absence and its impending presence. It thereby allows the image to move from mere contained time and space (image) into mental image (transferred time, no time, nowhere, blank as 'white on white which is impossible to film'). Each object, image, instant, then, becomes hyper-loaded, awake inside a body it can't shape.

Thinking of dreaming as film, then, colors the insomniac state as an entry to the out-of-field, in waking exit of the mind. Sewed off. Seamed in. Constantly in hover and undefined. An uncentered excavation, which in some objects might seem obvious, predictable by context, and yet still is never there. The set of a person's home in a soap opera, for example, may promise, in its making, that to pull away would reveal more of the house to be like ours, simple, predicted rooms, with mirrors, tables, chairs, and bodies. Or furthermore, the context in which we know the shot is set. That we might know in pulling back we see the cameras, the operators, the undeveloped sections of the warehouse which, in a conceived space, contains the to-be-filmed, and yet there is forever in the looming that unanswered unconscious question. The thing itself becomes dismantled and reassembled every instant by what it isn't—and it goes on. Some of the out-of-field may be the organs of the body that have been removed or otherwise destroyed, placed concretely out-of-field of the continuum,

27 Ibid, 17.

and yet in some way, by creation, somewhere in there, having been: the reels of film created and then burned; the image in the image covered over, blocked out; what had been upon the field there days or years before, or would be entering the field when the field is no longer watched; what sections cut from all the films and all the books in want of their cleanest shape, in the same way there are those who amputate their own limbs thinking that flesh connected to them is not *theirs*—some other body on their body, woven into the image of their skin, feeling more themselves in that removal, in that erasure.

The older I get, each time I lie down to go to sleep again, the more it is in resignation from this unending going and its implicated human end—that somewhere, in us, as beings, there must be a wall we cannot breach—a wall that in extant idea gives us reason to keep going in search of it, forever—in search of our own end—if appended by the idea that there too is a further out-of-field—that the space we circle in these hours gives only glimpses, mirrors, and beyond there is something without what. And in the circling, the furor—our endless wanting—all these bodies. The more you want, the more you want. The more you want *it*, the more *it* is, all around you, grown out in your hair and teeth.

Here, again today, are words. All day, inside my waking, this fucking infernal typing, racket, click-clack, for which I ignore time I could have given to my father, to my mom, to H., to anyone, to light, to air. *Click clack click clack clacky*, the most common reason these days I do not sleep. The words shit out inside me, in a spooling, coming out into this box—this white box that will grow large as you allow it, until the memory of the machine becomes overstuffed. Tonight is small. Tonight is everywhere at once, and every image, fat as fuck, bricking my blood.

Fear of Self

Somewhere in this sprawl of hours is my father, and the destruction of his aging brain. Dad, now seventy-three, has been diagnosed with acute dementia. In the dementia, as it opened, he began to forget how to get to places he had been many times before outside our home. He would find himself driving deep into the country in his small car, with a cell phone he could often not remember how to use. I find the meatloaf in the cabinets with the clean dishes. Bowls of cereal wrapped under foil in the freezer. Many days he cannot answer any question. His eyes deep in his head—in the image of someone who has not at all been sleeping—though now sleeps more than he ever has. His usual bedtime of 10 PM drawn back to eight then seven. The other day he went to bed at four in the afternoon. My mother stopping him in the hallway, asking him to come sit with her, it's not that time yet. "I know what I am supposed to do," he said.

Recent nights now, among the long sleeping, my dad might not recognize the bed. Suddenly the room is not the room he's slept in all these hours—my parents having been married more than forty years. He often does not remember the marrying, or what her name is. He talks of going back to the home where he grew up, a farm that since has been sold, the house dismantled. *The house, though, still there on that air. The same roads leading to it, as a tunnel. The years he spent there, bodied as a boy.* The negative house, in its destruction. The *sleep-kill* in the flesh. I honestly can't say, as I write this sentence, that my father will be here by the time I finish with this manuscript, *another book*. When I say here, I mean in body, as he is already often gone inside the mind, except in moments, in slow glowing. More hours there seems not anyone there in those wet eyes—or worse, the someone once there trapped under many layers, some force within him repeating in reverse. The skin around his skull. The hair. How he will often, in the midst of worst forgetting, put his head down in his hands.

Sometimes standing in the same room with my father now when he looks at nothing and sees nothing and responds to my speaking to him with more gone, I feel as if I have been awake for many years all in one moment and there is nowhere else to go. But I do go. I leave the room, because honestly, I am frightened. And yet at night now I've been sleeping better than I ever have. The present terror, perhaps, of certain kinds, forms a kind of other hands, enough to at certain presences hold you under water, even further down, more than the blank rooms overflowing, again, the houses and those years.

In the afternoons my father walks around the house holding keys that do not fit the car he is no longer allowed to drive. His dementia, which he does not believe in, and his recent glaucoma eye condition,

which he does not believe in, have at last overcome his ability to re-
spond in traffic, to find his way home. We have had to take his Cor-
vette from him, hide the keys to all cars, as in his frustrated anger he
will try to fit into the ignition anything that glints. His waking hours
a series of nervous limbs and huffing, a spiral loop of thick obsession
over the idea of when he will again be allowed to drive. That he will
not, that his eyes aren't legally okay now, brings furious terror to his
skin—the breath and blood underneath his face skin welling as on
days when I was adolescent and would test his nerves by saying stu-
pid things. "I'm blind! I'm blind!" he shrieks into the house during
day hours, throwing his hands up, in mockery of our concerns. His
recent new glasses in their fabric-lined case, which he carries around
the house as evidence, in his mind, that he is a prisoner in here, sur-
rounded, though it is less his eyes and more the fact he often does
not recognize where he is, that even my mother seems a stranger,
that he speaks of his passed parents as if they are waiting for him
in an old house that does not exist. We can't bring up these things
to him directly—try explaining a mirage to the air upon which it is
formed. Instead, we hold ourselves around him in the air as best we
can, try to lead him back in patient speaking to the body of today,
paring down the drift with knots of logic—"This is your home."
"There is no one in the glass." "I am your son."—though you can
see the drift of the machine inside him wavering between actual air
and his phantasms. Sometimes when he thinks we are not watching
he gathers the keys that fit the storage closet, the doors to under-
neath the house, going back and forth from where the cars are as if
this time these other, tiny keys might fit, much in the way I would
wander with the plastic key sets tight in my hands waiting for the
day they would find the moving thing that they unlocked. Wishing
I could take the childish sense of calm about them that I had then
and touch my father's forehead with it, let him rest. It has been the

fastest longest year I can remember, bumping in old rooms where a suddenly descending veil of awful air crawls at the walls.

From the pharmacotherapy manual I borrowed from a friend's mom to study sleep medications, there are further sections on stages of cognitive decline, which in their clinically emotional language read like the last year or two of Dad's waking life, often not too far-flung from an extreme state of the sleepless, despite his now sleeping more than ever, day to day:

> Stage 4 (Late confusion) Patient can no longer manage finances or homemaking activities. Difficulty remembering recent events. Begins to withdraw from difficult tasks and to give up hobbies. May deny memory problems.

My mother at the kitchen table certain afternoons with the reams of foreign paper spread around her, wearing reading glasses over the checkbook, the way I remember Dad had always done. The way the eyes change behind the glasses, larger, dimensioned outward toward nowhere.

> Stage 5 (Early dementia) Patient can no longer survive without assistance. Frequently disoriented with regard to time (date, year, season). Difficulty selecting clothing. Recall for events is severely impaired; may forget some details of past life (e.g., school attended or occupation). Functioning may fluctuate from day to day. Patient generally denies problem. May be suspicious or tearful. Loses ability to drive safely.

The cereal bowl covered in cellophane inside the crisper drawer this time. The closet. The blue bowl of cranberry juice left on the coun-

ter. The way my father will return to the same common roles over and over, eating more than ever, sleeping more than ever, showers at 3 PM, glassed in inside how he cannot remember exactly what he's already done.

And just beneath this, what is to come:

Stage 6 (Middle dementia) Patients need assistance with activities of daily living (e.g., bathing, dressing and toileting). Patients experience difficulty interpreting their surroundings; may forget names of family and caregivers; forget most details of past life; have difficulty counting backward from 10. Agitation, paranoia, and delusion are common.

And then:

Stage 7 (Late dementia) Patient loses ability to speak (may only grunt or scream), walk, and feed self. Incontinent of urine and feces. Consciousness reduced to stupor or coma.

The average period of onset herein being eight years. His mind inside him ending before the body, dragging the body behind it, in revolt. How of all the doctors my father's seen in the past months, their most common observation is what great shape his flesh is in— how were it not for his gradually destructing synapses, he would seem so young for his age. If it were not for those holes.

That at first I'd begun to type these stages out for how their shift bumped against the strange glass of prolonged waking, and in the recitation finding my fingers stuck hard to the keys. Knowing only slightly, sidelong, how perhaps that shifting seems, as insomnia

does, like being locked out of a large, comfortable house and into a mirrored room where air is heavier, under oil. Standing at that old familiar window seeing people passing, with each revolution seeming less and less like anyone we know. The tunnels of terror-walking growing tighter, warmer, leaner to the face, approaching a shapeless, shaking destination that seems further off the nearer it becomes. As if I could parse that, here, in my soft body. As if any inch of his descending, glazing mind could here be gleaned. My hours spent seated low in front of this machinic glow box typing these words out instead of standing with him, standing in the light of his remembrance while it remains.

Here I am not asking, not saying, moving past, for how these hours, new to him, for me repeat. That how, in my father's blanking and often disoriented, disturbed flesh, in his forgetting, confusing ways he'd walked inside of so long now every day—how underneath that, in the moment, in the sheer bulk of his frustration, the bulge of his tongue pressed in fury behind his bottom lip, same as mine in the same spot—how in the deliberate way he chews, in all his pacing, staring, seeing, I see him still right there—caught or clogged inside a self of other self, a fully breathing body mask—how underneath that, at its center, beyond the fluttered veils, and no matter how gone—he is there. And in him I still see him, however tattered, however pulled apart in his own form. The food he eats and eats, in his forgetting of what he's already put inside him, building the body's rooms. Obsessed with how the house is empty. The hours seated, still. The two pairs of jeans he folded over his arm in the mind he'd be leaving to live inside "the homeplace," his parents' house, that phantom body, still packed inside there with his in-stances of bodies of the living and the dead, though even when he sees them in the human air arrived to visit, he doesn't recognize

they're there. It seems profane to mention the way for years my father said and said again he'd rather get turned off than be out of his control. How in his saying that, then, it seemed a joke almost, like some unmade day that would, could, never come.

The days continue coming anyway, regardless of how long off they are. Regardless of all these rooms hidden online or on film or in air, how many hours we could spit into machines. My father in the afternoons still watching NASCAR, younger men behind the wheels of cars he can no longer drive. Earlier this day it crushed me in my body to watch him stand before the TV with his coat on and keys still in hand as the race emcee shouted "Gentlemen, start your engines!" and my father's arms did not move. The race being the Daytona 500, where my father would go each year with his brothers to watch the cars do circles live, and with them together eat and drink. The circling. Days coming. Night.

"Where is everybody?" my father asks most times I see him, in the strings of days, coming from rooms alone into rooms where there I am—as if in days before the rooms would teem with people who have since then become disappeared. Seeing the thinning returning to my sleeping recently now after long periods of better evenings seems, since my taking notice of it, to have reinforced its gait, as the last few days now in particular I've been up still when the sun rose, still thinking the same things. Seems like it'd been forever since that flopping grouse wound and unwound me, flopping unmeasured patterns on the bed—and yet familiar, like a room inside the house I'd been in a billion times until I'd forgotten it was right there on the air. The copying cycle returning cleanly as if it had never been gone. The familiar, but never less disruptive seize, that same blank awaking its unawaking in my brain.

With my head folded in the lip groove of the pillow, the contents of the skull seem heavy, warm. As if a fat field buzzing there between the skin, a bug light waiting to give zap. *I do not want to think this thought, and so it thinks me, harder.* Not that I could tell you better now, because of this, anything about it. Close up, the string seems even shorter. The knot of thoughts that eat the hours mostly circling that small series of ideas, which in removal seem a flat blur. Eight hours passed flat on the back, feeling like twenty hours minute to minute, but like two or three in retrograde. The longest, fastest night. The residual refrain: Please stop thinking. Please, this is the end now. I will silence myself and lie still. The clock will no longer continue rolling. When I stand up, I will feel real. Among the day here in the house with the forgetting man the blank spots stretching larger for each time I instigate them, and in the making. All the hands at all the buttons. All the brains. I write the paragraph and then delete it. I open and close files, staring at words. I can feel something stirring in me, in there, wanting out, and yet the doors at best revolve—pumping in and at themselves in want of wanting. Eating. Refreshing faster, faster, for more new. All those finite people in any image, cells in some black fabric, spreading, under night, dismantling the self in other aura, awake but not awake.

Most days, my father, recognizing mostly nothing, walks around the house for hours without pause. I have seen him walk in dark along the hall to the room where he has slept for years and years here, stand inside it staring, come back out. I have tried to ask him to come into a room where I am in here typing and stop and speak to me. When I ask, he asks me to take him back home. He says this is not his home, here—the house he's lived in forty years. He says, "I've been around here all day and I'm ready to go now."

He does not recognize the backyard or the bedroom. The lights in the hall are often off. In his sleep in the chair before the TV he talks to no one, often laughing, speaking a language of somewhere far off and rolled. Shut in a dark of heavy nothing, a film made of no light.

Tonight inside the house I'm in nothing will stop. The air seems not air at all, made for our breathing, but empty space; the telephones inside the rooms and all the rooms of houses here surrounding about to ring; the bodies through the window sometimes passing and when not passing always about to be again, any of them someone who might turn and walk toward the window, press their face against the glass, see me seeing them, and say a word.

My father as a younger man. My father in the hours of the day he and my mother made me—what he ate, heard, what he said, what doors opened or songs sung. As in how after a first private showing to a small group of people, Kubrick cut thirty minutes out of the film. As in the people, minutes, in any body's mind there buried, fit into a gray made flesh. As in along the hall the hand-sewn quilts hang parallel on the wall's far side to, in many rooms, books in bookcases full of words, words rendered and waiting, never to be opened into light again, unless.

Tonight the night is still the night. The crush of no noise at all for right now that seems to permeate the air. The latch on the thin window. Bodies passing on the other side.

The skin that freed itself in friction from the arm of Borges as he walked from room to room on the day he first bumped upon the thought of a space containing all possible books.

Last night, abutting this one, predating whatever else, maybe, perhaps I grab a random book by its spine among the many lining my loft with its high ceilings, out of some drift where any book is any book. Perhaps I read from the page to where it opened up: "There are things you can think about," the book says, or said, is saying, "where if you follow your thoughts in, no one will ever be able to get you out."[28]

]

]

]

Suddenly, inside my typing, my father is standing right behind me at the door—as if he could hear inside the pattern of the keys his name, his shape, symbols marking down what he is doing in this house that he has cut out of his work, his mind.

"What you doin', mister?" he says to me in a pinched, strange voice, his imitation of an older man than even him. He hasn't lost his sense of humor. He's wearing his windbreaker, Easter yellow. One of several hats he rotates in and out over the bald part of his head I can't ever remember seeing not rubbed bare.

"Just typing," I say, turning from the words. "What's up?"

Without answer he moves from the door on down the hall, into the bedroom where my mom is probably just now lying down in the same spot she has most every night since I was seven. A few minutes

28 Sparling, 133.

later, he walks back past. He turns the light on at the far end of the hallway, the longest room in our whole house. I hear him walk into the far end again and then it's silent. The light is on.

I save this file.

I stand up again inside the house. I walk along the hall where the light goes on along the long room and stops and ends at the next room, the kitchen, sandwiched between the primary front and back entry and exit doors. In the room beyond the kitchen I can see the muted glue of textures of the next space thrown out from the TV, and beyond that, another door into a space filled up with darkness, the last room on this end of the house, its mouth.

I don't see my father in this makeshift tunnel, and there still isn't any sound.

Coming on into the kitchen the large panes of glass that comprise the door and windows reflect the room I'm in back at itself, the light inside not also outside, flattened. I see me stand there in the shift of glass, making two people. I can see through me, again. Certain low-lit shapes sit in the yard under another, softer, further off illumination, blockaded at certain angles. I cannot see the sky for all the night. The front door is locked or it is unlocked. I don't know, from here, who's touched what, what could come in through the night in search toward this glow.

I stand inside the doubled room—inside and outside the house both—my father in neither—his body where. His mind as all those doors sleep has held hidden, some sealing off under their cells or as the years curl further in, the spool of sleep.

In the kitchen I move toward my reflection facing me, spreading my arms out flat, four of them, on the air. I move closer to the glass. I become larger, shifting the texture of the light.

From closer up I can see forming, among the concrete and the yard, different shades of dark and tunnel where the air is. I move to press my flesh against the pane. It is a cold surface, soft but ungiving, demanding exit only under being broken. At the median of the two rooms in one image, I press my head against the plane and close my eyes. My teeth inside my head form a ream of girders. My cheeks in knots of round. This silent house. This night around the evening, not electronic. This pressing presses back at me with questioned pressure, some soft unbending, a translucent sense-thin skull. As if at any moment it might open, fold me through it. And I want it to.

I do.

]

]

]

Outside the night is warmer than it had seemed felt through the glass. Over the pool's water, a thin skin, caused in the stillness of the pool's disuse, the sky doubled from overhead in reflection on the scrim. Another mirror. From outside, looking back, the inside of the house seems so clear—bright as if with no air, in a vacuum, sealed—a place I've never been—as if I'm only in here in this instant. Through the house's eyes back in I still can't find my father moving. Nothing but the light and my split body, still pressed

against the glass from the inside. These rooms humped up to one another. These rooms where—where what—here tonight confabulated in crystalline arrangement, hidden—no air shaking—all evenings in this evening placed on pause.

I walk along the yard between the fence into the next yard, also confined by the street where in other years I fell and left behind bits of my skin, paving its paved face with other layers of my body, for its surface, and spilling onto it in blood, a consecration of that hour and the beginning of new heal; the wires hanging from the house's roof's lip and strung along to poles stabbed in the ground, feeding off into the other neighboring houses and on down the streets among their artificial light; the yard of grass I've cut pushing machines upon it in rhythmic patterns over and over again, year in and out, and yet the mud beneath it never failing to keep sending new cells to be cut and cut again, slowing only for the freezing air of seasonal night; the music I pumped into my body over and over in that circling, loud enough to mask the noise of the machine, not loud enough to mask my own thoughts underneath it hovered, in the input, in sight; the years my younger father set part of the yard on fire piling leaves and branches into a mounded divot, burning those excess folds off into nowhere, into the air, for which we breathed—all that sound I can't remember, all those words he spoke into my head; the trees that used to fill the yard all mostly cut down, so that in the light and night there is much more space to see of other homes, the open windows in the night air blank of the bodies surely somewhere there inside them, asleep or awake; the year the bird fell out of the sky in some negation of its sense of self and landed stomach-up upon the yard, the light of sky that afternoon as Dad and I squatted together there above it, the sky behind us, the blank behind that, no oxygen, no sound.

The yard tonight, white, dying, brittle—my father no longer able to spend long afternoons with seed and blade, pruning the yard up to be a thing he took a pride in, an outfit for the house. The sky tonight, there is no moon—no definition in the low code of its abstruse, slate gray ceiling, flat and unending until the point along its stretch it disappears behind the lip of my perspective—clipped under by the curving of the earth unto the forms of buildings and the trees.

Underneath this what, just like my father, the nameless man's car tonight does not appear—he where here inside my life I've sensed always approaching—no face, no frame—and always just ahead, unshaping time. In the car's place, tied to a massive bolt, clung with protrusions, nodules, gold, as if torn from the center of a lock or from the engine of a car, there is strung another wire—this one thinner, *blacker*, than those strung between the houses, chewed up and kinked like pubic hair. The wire follows up from its endpoint where the ground is, leading off into atmosphere, into the nowhere of the night. Between my two longest fingers' pads the wire remains silent—its shape off, minute in one dimension, endless in the other, as far as I can tell, lurching upward, outward on. I feel a slowing urge to yank the wire down and hard from where it runs off, suspended above the street as far as I can see, and yet I do not. I hold it firmly.

I walk forward with the wire in my hand. I lead my way along the wire in low light. It doesn't matter what the wire is. Along the lip of street heading due south, among new grass the state has recently installed, to cover over pipe and mud, through which the rainwater will go gushing nights that something overhead throws it down, some eternal wet in slow recycle, cells once inside of others, where

and when. Over the sidewalk where I have run so many nights to burn my cells off, feeding my own sweat back into the unending mouth of what is breathed. The wire leads me on between the flat faces of the two long neighboring buildings where for seven years I went to school—the one building on the left, behind which I once watched a kid get clocked along the jaw with brass knuckles while a horde of us all watched, the grass field where I was so fat I could not finish the mile for all that hulking and the terror of my veins, those rooms gummed each new year with new bodies, unreflective in the night; and the one building on the right where I grew thinner, the trophy cases full of photos with trapped versions of people, many of whom likely still live within a nearby range. The glass of neither building winks. The parking lot of the grid on my left is full of at least a dozen empty buses, parked at parallels, where from the distance I see oblong shades of bodies, held still in the aisles, no eyes.

I follow the wire between the schools on both sides. I can see the wire's glint extending further on ahead, down the slow grade to the creek bed which certain nights would swell so high it covered up the bridge. That night, in the downpour, we came to stand there at the lap and watch the cars scream through at different speeds, until the small dark red one flipped, gunning its wheels. Metal on metal in that evening, glass popping out half under water, blood mixing with the mud rain, silent now, again—all this air in endless charging, eaten up with what had been seen, while tonight—no one.

I hear my me inside me think—shitting out each word of this in its iteration, scrolling on a wire from my cerebrum through my sternum and meat of heart, to catch tangled in the thin rungs of my fingers and wrapped around my testes, filling space with

tumor-noise. Behind my head the moon grows glowing so hot and fast I have to close my lids to keep from burning, and then and there under my lids I hear the moon blink with me—*burning out*—so that there at once in my unseeing the air around the earth also cannot see—the fields and houses and the hours cloaked with nothing around my nothing, a darkness deeper than no mind in mirror cloak—a darkness time could not erase in new directions—ageless black unleaving. I swallow and hear shapes. I rub my finger and my thumb together and feel the words between them screech, wanting out into the dark where they could hide from paper and from thinking—to slip into no light and never be remade—all my words ever only wanting in this in me—to go nowhere.

When I look again, the night is fine. It is as any night—the time between when I had looked and not looked, in the dark, threaded with the street bulbs and our glow, the moon returned to screw above anybody, all reflection—an eye without a lens or head.

Beyond the creek, and past a further field and hill paved of its grass, along a long rip of mud where once a manmade lake had lain, its liquid so dark in the passing there is even no reflection of what stands above it, overhead, among a neighborhood I've watched rot and repair through my thirty years, the wire leads up to a house—a house, as white as typing paper, lit just with two bulbs on either side of its one door, the curtains in the window of a color dark enough to appear beyond opaque. A house, I realize in standing three feet from it, the wire wet from sweat inside my hand, that has stood across the street from where I grew up all those hours, all that time—though I do not now know how, in all my walking, I have returned here to stand before it, and there beside it, before mine, where here the light is different, and the yard is knee-high,

and the brick is colored like the scratch mark in my knee, but it is still the house I have spent the most of all my hours there inside of, come full circle, lost in accidental circuits of the feed, in the folding of the map. Through their bedroom window, I see my mother and my father standing shoulder to shoulder with their eyes closed in their heads. *There he is.*

This other house's door is locked. The bolt makes a clicking sound inside itself when I flub at it. The wire strung into the night. My own old home is closed off also—the knob spins in my hand.

I turn around. These two houses stand facing one another by a margin wide enough for me to move between, pushed together in my presence to obliterate the yards—covering up the space of years where I had moved and stood and swam and read and talked and looked at sky. The brick of both just at my front and back, breathing my breathing, dragging at the hairs pinned in my pores pinned in my skin pinned on my flesh. The walls seem from here to go on so far—I cannot see any end. Along the length I waddle on between the houses dragging, the night above me doing slur; lines pulled out of lines where the sheath of dark screams friction between perspectives, like sliding off of something just behind it, tipping lids. The farther I can fall along the way between the houses without blinking the gap gets bigger, though there seems nothing there behind the fold—the sky behind the sky the same color as the sky in its same hour, as if any hour splayed, the night peeling in constant burn of layer all through the days in mirrored time like skin goes purred. Nights barfing nights and into day again to barf the day again to night in cycles thinning out the space between us and whatever way on out there, the air rained with that matter, thickening the earth in matching rhythm of the rising of the dead.

I walk along the wall and skin my skin becoming bunched until, on the newer one, appears: another door—a hole into the house again I'd never seen there. This door is smaller than me, chest-sized, with a peephole that sees inside. The rim around the door is sealed, healing as with bruised flesh to cake the door into the body of the house. Through the hole I see the light arranged kaleidoscopic, in neon rainbow, camouflage, snowing in slow screech—the hours of the house wrapped up in hours turned to mush and wearing time upon its time at last no longer there translucent but neon, gummy—then, with my eye's ridge screwed harder down against the metal eyelet, the colors become a wall—become a hall, a subtle tunnel, raining length from where I am into some center of the home—become a stairwell headed up inside the house unto a layer set above it, though the house always had been a ranch. On the stairs, packed in chorus, a stream of people, naked, shaved-headed, waiting in a line, their spines and flesh packets so crammed together in the low light it is hard to see where one begins and another stops. They look like me, my dad, my mother, all at once—faces buried in faces, as would earth. They look like anybody. If I let my eyes go goggled enough, it is all one flesh—it is all air, all the house just this one room.

In the room, for one blinked instant, the man is standing—the same man from the car, the same him with the voice I feel that came into me through the phone, same who wrote the words inside the balloon, him having hid same most years somewhere in the middle of my books—here he is there, arms loose, posture lilted slightly backward, as being pulled to stand erect. His body changes as I see it—there's my body at age nine, there is me at eighteen, me at fifty—there is not me there, but anyone, the skin of his face cold with a glow. In the instant that our eyes meet he is unblink-

ing. There is a sound. I cannot see—not into the house, my lashes itching. My eyes roll in my head. I step back in the outer, darkened light—*ouch!*—step away—bang my head and back against the house still there behind me, crushing pressure down in spiral through my cerebrum. My own house, this version, wound in the wire, shows no matching hole—its flat expanse continues on warm to the touch—deformed.

I try to look again at where the hole had been to see again into the house into the man again though the hole no longer appears there: against the wall instead my face is itching, sticky. Through the wall I can hear my parents shouting something at me, or each other, or at anyone at all. Something in me nudging where the hole was, a bubble traveling along my bloodlines down through my organs and my spray; the hole eating holes into me, popping pockets, eating up what had been there. The wire pulls, as would guitar cords and piano wires—as would lengths making a fence—as would a pumpkin's innards, growing riper unto mush. It pulls at me to go on against the house in the contained air, of a no light. Beneath me caves eating miles beneath the earth. Shafts no bigger than an eyehole on a pyramid that open into chambers, rooms designed in profile of where they've not been filled, in the past appearance of a succumbing to the death. The hole an elevator up my spine cord, for one second, shivering as would a length of skin too closely shaved. I can hear my father's brain—hear it shrieking where inside itself it feels itself parting from itself in cellfields and lurched in want for where the other parts of him outside of him exist, held in me in what I've seen of him that he now no longer will remember—where the hole inside me eats in me the same—days unfurling out of days there fed from his slow death, like anybody's, massing at my lids, flushing my weight with all my hidden orbs of absorbed

pounds—the fat around me always in me and around me despite where I had tried to burn it off.

In where overhead by now the sky is going lighter, light as paper, bumped with garble barf-out from old machines, I continue on around the house in round. The houses need against me. They squirm. The brick brushes out by length in turning wooden, turning metal, then to mesh. The mesh remains opaque—though in the web of slits each inch makes, something yawns—the hours of the house the night devours. The hours of the night against the house, inside it, wanting out where I'd lain open and become it and not remembered—will not even now in having seen or read or written—the residue of captured speech and thinking absorbed into the ground under the house with sour loam—infiltrating the foundation, boring more holes where the soil would beg to be filled in—with more bodies full of bodies in the brains degrading and the images caught burned.

Upon the slanting soil the house begins to shift. From the flat smushed face of the new widths of the old house my father's outline becomes pressed through. His shoulders, chin, and sternum. The lips beneath the surface moving, saying words I cannot hear. The bulge grows hair out from it, hair that whitens, curls to mold like what had grown up inside our home's beds' sacs. In my head, the text my father speaks becomes new veins, abrasions, tracing bridges between skin that will also make me old. That time will ask for. That he will ask for. That will eat years. That are already in me buried.

There on the wall of the house across from my father's bulged impression—*I can hear it, I do not look*—there is the body of the

other man. Two holes, where eyes are, go down deeply into a kind of light I cannot see. From the holes, a gentle smoking. Choirs. The houses leaning, trying to fold their frames back into one. Into one house, like all houses. The houses around the houses leaning too, smushing in around the aisles and wires to meld to nothing. To be nothing, cream the space to zero. Years of bathing. *I must leave here.* My arms around my arms make knots—clogging up with motion I have not made. *I must leave here, now, now.* In my body I go on. I go on in snaking along between the houses, in their slow purring where the folding has already made a mess out of the air, blurring the sky above the house into a circuit board, a prism—how in the blank between the houses it is no music, but lack of motion, some stillness so still that it seems between the edges of my skin to strobe. A still so still it is the absence of all action, a space in which there's never been a thought—no flood of snow or sickness, no need.

The gap and faces of the facing walls go on as long as I go on— making me that much more wanting of the end oncoming, though by now I can't even see where back the way I came—the whir from where all this walking started—no beginning. Walls in both directions, on both sides, a paralleling sound. I hear me ask outside me where I'm going, what to want for, aimed at no one, and yet I get an answer—the blistering of my soft eye—patches of colors squirming in the shape of what had been seen—cloud bumps—screaming grog. A fluid rushes backward from where the lids are, blinking, back in warm gunk up my sinuses into my skull. I slosh around in that some minutes, bumping back and fro between the two surfaces, hearing guns. It feels familiar: *this has happened to me in a book.* My hands somewhere beside me. My chest. In spotty blinking, I catch glimpses of the stretch. The sky above it giving colors,

sort of learning how to laugh. A word is written up there some-where—many words, disfigured, in a language canopy—I cannot find my name. I strum still forward, seeing backward and before me both at once, as if walking through a loosely wired house of mirrors—the lights tipping in and out—more laughing—or in the ways at night I'd walk from room to room, flicking the switches, not wanting to fill my head with too much light, but not also want-ing to run into the shapes the darkened rooms make. The persons in the thrall. You somewhere on this graft's edge, colored of the eyes. This sentence to be closed between these pages and let to hide forever in a dark inside your room, perhaps. Or to be transported, closed in no light, to another. To be burned, made into a still more temporary light.

I cannot hear you breathe. I am talking all the way out loud, my mouth's meat fixing syllables with words my body wants to say, in the history of how I've learned, and yet the sound is undynamic. I hear it instead in my blood. Corkscrewing sound erupting glitch-marks in the organs I have been told that I need. The organs, some or one and then all of which, will one day fail. Or have failed, in their failing, passed down and down. The wall of the house I grew up inside of by now is so far from where we started I can't remember where we've been, but in the diminution of my vision I can hear better, through the brick. I hear the voice I've learned I used to have by watching versions of me caught on tape, talking out loud, in the way I've been out here trying, saying words I said once then back then. Words which in their exit of my head have left somewhere behind them. Through the house's hulk the words seem pleading, rendering the flattened face with little veins, mazes in tiny tunnels on the outdoors, a massive human skin, where facing this the wall of the new house combined the house is made of glass now, an opaque

glass that clears in splotches where I breathe, my blinking becoming calm, slowing off until my lids seem to no longer want to lift at all without a burning. Through the lids I can see into this house now whole—see the whole house in one prism, sound packed into sound, packed into light and aging, crystallized. Through a hole the house did not know it had in it forever—I can smell the hole extending back through all its time—through the hole into the second house there I can see into all the houses where the house has always been. I can see, though it does burn me, though it hits upon my eye, hits me blankly, each inch at once, each inch asking me rubbed out, rubbed into the mush of coming color that the night makes replacing the prior pixels, a flood around my eyes.

Inside the house there all around me here at all angles growing I see:

A WOMAN STANDING AT AN OVEN, PUTTING GREASE ONTO HER HANDS, HER BELLY HUGE

SEVEN DOGS CROWDED AROUND AN OBSCURE POINT ON A LAWN MADE OF ALL LAWNS

WATER FALLING IN REVERSE, DESTROYING COLOR

A CLOUD OF BLACK SMOKE CURLING THROUGH A FLOWER GARDEN

SEVEN GUNS, AIMED AT A HEAD WITH ITS FACE MISSING

BABIES, RASPING

THE LARGEST BIRTHDAY CAKE ANYONE HAS EVER MADE, BUT ALL TRANSLUCENT

Someone now is tapping on my shoulder, but I'm stuck there, the wet inside me turning around.

I see . . .

NUMBERS BARKING AT ONE ANOTHER ON FIELDS OF PAPER

TWO PHOTOGRAPHS OF WHITE ON WHITE

AN EXTREMELY FAMOUS OLDER PERSON WITH FACIAL FEATURES POURING PUTTY IN ALL DIRECTIONS IN THE COLOR OF THE SKY

BLUE MILK IN A WHITE URN ON A SOUNDSTAGE SUSURRATING

A POCKETWATCH MADE OF ASH

TIME IN SPINDLES OF GRAY SUNSHINE SHITTING FROM THE FACE OF THE POCKETWATCH GROWN LARGE AS A WHOLE MALL AND WRAPPED IN LEAGUES AROUND MY BODY AND ALL BODIES

A GUMMY HALLWAY AND THE MAN STANDING INSIDE IT WITH HIS EYES CLOSED AND MOUTH SO WIDE, NO TEETH

OVAL PRISMS IN A BEDROOM GLEAMING LIKE A MOON
DOES

YOUR FACE

Under each image I cannot stand up. I feel my legs farting under-
neath me, sinking into soil—into where the ground beneath us has
bent gone, cut open with the holes eaten up all through it, yawning
today for all the meat the ground could ever want—the bodies fill-
ing in around us, houses around us, fuzzy.

I see . . .

ME, WITH MY SKIN BACKWARD

ME, WITHOUT MY SKIN, THE SPAN REPLACED WITH
BEES

YOU INSIDE A WARDROBE, TURNED TO CLOTHING TO
BE WORN BY SOMEONE YOUNG IN YEARS UNWRITTEN

MIRRORS SHATTERING IN EVERY HOUSE

A SNARE DRUM MADE OF SAND

A MUSIC FROM SAME SNARE DRUM, CLAWING AT THE
SKY, MAKING HOLES WHERE LIGHT COMES RAINING,
WHERE SOMEONE SAYS . . .

NO LIGHT

MOUNTAINS WHERE THE SOUND IS, RUMMAGING INTO A HOLE, A HOLE AROUND WHICH THE NO LIGHT IS ORGANIZING, SUCKING SMOKE OUT OF THE LAND, SUCKING THE CELLS INSIDE MY HEAD BACK TO A SMALL POINT THROUGH WHICH, WITHIN THE HOUSE, I FEEL A GREAT RELEASE, A LITTLE POCKET OF EXPLOSION, A RISING NIGHTTIME UNDER THE LAND, INTO . . .

A CHILD

A CHILD FOLDING INTO ITSELF INTO A CHILD AGAIN, INSIDE A CHILD AGAIN

A CHILD INSIDE A CHILD, INTO A CHILD INSIDE A CHILD AGAIN INSIDE A CHILD AGAIN, REPEATING

INTO NOTHING

There I am looking all at none. The skin of the image in an instant gathered into one syllable, one frame, containing all prior images and what to come—a frame unglitched in its focus, put on pause—every instant all at once. I hear no bells—there is no sound or surface there beyond me, the me of no house or hole beyond my rind in itching freeze, a copied conduit of rooms in rooms and no one standing there inside them but spreading out from one point into a map of homes where homes had been before the homes here, a crushed museum: space removed of what it had contained—the living room where I would roll, perched on the carpet with the TV, repeating its speech—*I can no longer remember what came in or out*; the kitchen where, the blood dripped the day my sister bumped

open her head, spilling soft onto the tiles and years later I'd be paid in cents to scrape an error waxy lining off each square—*but what beyond that, any hours that had surrounded these two small things clogged in years around an instant's spine*; the hallway, longest of all rooms, and with the most bright light in the whole house—*nothing seems to have ever gone on here beyond the walking back and forth, the passage from space to space for something always elsewhere*; the bedroom where the bed is, where from the ceiling the boulder rolled, and where I notice now there for the first time, mirrors of both sides—one making the long face of the closet, one, wider, in the bathroom, just across—a wide conduit between them over where, in those nights, I would be—*no memory beyond the memory of doing nothing to preserve the instant in its passing, the passing acting as the instant in itself.*

Where in the house here, here I am in here—here in here standing right beside me in the glow, the room around the room around the room so washed in silence I can't bring myself to look beyond where each of these words go on ticking along inside the white—the white of white—another body—some skin shape seated in the light—a body like my body had been when it was in here—still here—made of me. I am parallel to my own body, fleshy mirror. I raise my arm to touch my arm—all of me there just before me, spread like paper— when I touch me, the room collapses in the light—the light collapses inside the room inside the light there underneath us into soil—the soil beneath us filling in around us in the house again beneath the house, packing in the holes with all our murmur.

HOW TO RELAX

drugged to sleep by repetition of the diurnal
round, the monotonous sorrow of the finite,

within I am awake

Frank Bidart, "The Third Hour of the Night"

God of Nothing

Days are what and what are days. Where. Days go on beyond the
want. In silent corridors they go on building—a what around the
what-space that sits with silence and does exactly what it is—which
is just nothing—and therein must go on beyond however you
might think you'd make it stop. Without sleep the aggregate aggre-
gates its aggregating aggregations into something at once speeding
up and slowing down—beating unseen walls over to find behind

them more walls, darker, flatter—spaceless secrets—and so then what then—*there you are.*

"Almost all suicides, about ninety percent, say, are due to insomnia," says E. M. Cioran. "I can't prove that, but I'm convinced." If nothing else, being awake too long surely could be seen as motivation for the mind state of the want for spilling one's own blood, like a machine becoming overheated from extended usage, too many frictioning hours in too much light—gunk gathered on the gunk—the way skin changes over time in pictures, always worked upon instant to instant, any of them at once no longer yours, but given up unto something nameless.

Any night there is all night. Every hour seems to pass as if it were no hour, each instant ending as it begins, in mirror of all that came before. This slip can seem both timeless, in its oncoming, and destructive, looking backward, the ground beneath your body being eaten up. We keep busy often simply to seem still moving, covering up the sound of turning under, nodding out when at last exhausted, or when there seems nowhere else to go—or everywhere to go and no specific impetus, or how when there it appears in many ways like where we'd been—the internal urge for some destruction in the face of nothing turning inward, and again reflected. "A person who commits suicide," writes Christian Gailly, "has only one idea in mind, to kill you." You, the you that I am, the I that you are: selves reflecting selves and in recitation, forever leading on. The clog of worlds erupting into stigma and murder, even further manifested in the mad. Of being spun and spinning, of pushing along, each of us, through doors—a waking unto black light, unto holes our longest times can hold to, trace.

The ruin of not sleeping properly or at all has proven to result in damage, unto death. Bodies sleeping "less than four hours per night are three times more likely to die within the next six years."[1] The cause is related not only to the decrease in population and activity of white blood cells, but also to a decline in the body's ability to convert sugar into energy, resulting in an increasing ream of fat. Physical and mental response times are lowered, creative impulses diminished, performance ability waned down to states of near disuse. In an extremely rare condition known as fatal familial insomnia, found in only fifty families ever, the intensity of the sleeplessness gradually increases over four stages in a period of six to eighteen months, during which the sufferers experience burgeoning panic and paranoia among their whole household, leading to rapid weight loss, dementia, a final state of unresponsive muteness and, eventually, their end.

In general, the way we sleep is definitive not only of the general biological function of our bulk of bodies, but also of our species in the context of physiological evolution. Humans have by far the most clearly defined monophasic sleep pattern; meaning that we sleep all in one period and operate awake all in one period, subject to variation. Our sleep sets us apart. Chimpanzees operate under a more biphasic structure, with nightly ten-hour periods punctuated with many minor awakenings, and a five-hour nap during the day. Non-primate behavior tends toward a polyphasic cycle, with some species regularly varying between sleeping and waking as many as twelve times in a twenty-four-hour period. Giraffes sleep less than most any other animal, between ten minutes and two hours a day. More anomalously, baby dolphins and killer whales often do not

1 http://serendip.brynmawr.edu/exchange/node/1690.

sleep for up to thirty days after becoming born. Elephants embody another schedule of duality in that they sleep standing up through their NREM periods, and then lie down when REM hits—as if the dreaming were both the real rest and the weight. Ducks are able to split their mind into fields of sleeping and work them in shifts—one half awake to preserve the body against predators, while the other half regenerates in rest.

It is theorized, then, out of all of this, that the shift from polyphasic to monophasic sleeping might have been an important difference between Neanderthals and modern humans. Interesting, too, in light of the fact that the disruption of the monophasic cycle, the locking out, often causes in its host body a return to baser physical behaviors—beyond simple glitches in motor skills, memory, and communication, sleep deprivation can cause frustration so intense it leads to psychotic and violent behavior, and its sufferers are more prone to becoming belligerent and exercise threats.[2] More directly, it can cause conditions such as "tension headaches, gastrointestinal problems, nonspecific aches and pains, and allergies."[3] Problem-solving skills can degrade, too, resulting in primitive "cram the object into the shape" strategies, as if the echo-pattern of the sleeping exhibits a return to the prior, cave-cramped mind.

Felix Kersten, a confidant of Heinrich Himmler, writes of Adolf Hitler: "An incurable disease was destroying Hitler: his judgment was affected, his critical faculties were unbalanced. The headaches, the insomnia, the weakness of the muscles, the trembling of the hands, the fumbling with words, the convulsions, the paralysis of

2 Kellerman, 120–121.

3 Morin, 13.

the limbs would increase relentlessly. The ecstatic illusions, the megalomania would have no check." And so too, with Stalin: "He began to suffer from insomnia, and his shortened arm bothered him periodically"[4]—such sleeplessness in some way leaking up the veins of the tyrant's murderous malformed appendage in the image of *Twin Peaks*'s backwards-speaking dwarf, the Man from Another Place, who murmurs into a mirror, "I am the arm," some kind of ruptured anatomy, an itching language, spilling forth in the way as would the fear, again, of the intruder, on and on—Stalin's brain fraught, creeping in the holes of holes of too much waking, as Lenin's did, as did those of Napoleon, Kafka, John Wayne Gacy, Van Gogh, Michael Jackson, leagues of the inevitable awake, their bodies tied together in their hyper-folding black-lodged knowledge of the carnal shape of night.

]

]

]

Of the millions today dealing with various strands of insomnia, it is estimated that fewer than half seek treatment. This figure is similar to that of those with disturbed mental health: "57% reported a belief that poor sleep would resolve on its own and/or one should be able to manage insomnia independently, 38% indicated that there was a lack of awareness of available treatment options, 31% noted a perception of treatment as ineffective or unattractive, 17% referred to a stigma surrounding insomnia, and 11%

4 Brackman, 175.

endorsed personal constraints regarding treatment-seeking."[5] The major problem with sleep treatment, it seems, is that the problem for each person is so diffuse; what works for one causes for another only more frustration, deeper shrieking; there's no guaranteed off button until you're dead. This doesn't stop at least some of us, in certain desperations, from trying most anything anybody might suggest.

"Just relax," people who have never had extended sleep trouble themselves have said to me in more instances than I could name. "Stop thinking, lay there, and relax." This is, of course, easier said than done for some people, and in truth the further encouragement of such an aimless, nothing-named instruction often causes only further clouding, making worm. The more one cannot do the thing so easily offered by someone else as an easy fix, the more confounded the condition itself becomes. The solution, then, is part of the problem—the key hidden somewhere in the context of that lock—the lengths to which one might go in search of some effective combination ranging from the common sense to the extreme.

Early attempts at sleep solutions begin with what some then considered magick, a cryptic manner of appeal. A popular British medical journal from 1880 notes the success of bloodletting in those held awake by some mounting pressure in the head: "Case III: Mr. H., aged 47, foreman in a corn-mill, stout, full habit, suffered for three years from headache and oppression of the brain. He had been treated without permanent benefit by several medical men; none had bled him. On August 10th, 1879, the patient

5 Vincent and Lewycky, 807.

came to me and complained of pain across the top of his head, like a *boring* between the skull and the brain; also fullness [*sic*] and oppression; also feeling to stagger when walking, like a person drunk; also sleeplessness. For five weeks I tried the effect of various drugs, with but little benefit. Leeches to the head gave a little relief. On September 18th, I bled the patient to sixteen ounces; and, before the operation was finished, the headache was cured, and the following night the patient slept better than he had for several months."[6] By 1909 the same journal praises the use of electricity on flesh: "High-frequency currents, when administered carefully by a qualified medical man, induce a sleep that is pleasant in character and has no evil consequences. Further, not only is sleep produced, but the patient derives general benefit from the influence of high-frequency currents. There is a feeling of well-being and of exhilaration produced, which is permanent in character." On the same page as the shock-praise, the article disparages the use of drugs as a solution: "Their results are not permanent; and they are frequently a source of danger to the *moral* of the patient. Further, while they promote sleep, they usually occasion unpleasant sensations on the day following the administration of the drug."[7]

Other sources in this era expound on the home-based use of experimental chemicals and herbs, and in the same breath acknowledge the nature of the substances as "likely to do as much injury in the one case as in the other. He would be working on his own body, and hence much more to his disadvantage than if he were endeavoring to compute the orbits of comets or the periods of

6 Brown, 14.
7 Ibid.

the rotation of the moons of Jupiter."[8] Herein the author, an ex–"medical officer of the army," deferentially conjectures[9] upon the benefits of, among others, sulphonal ("In proper doses, it produces sound and refreshing sleep, but it requires from two to four hours to act . . . intense cardiac weakness, stupor, and even convulsions have been induced by its use"), chloralamid ("As soon as the people get hold of it we shall surely have an experience of its effects very different from that which we now possess"), and chloral ("The sleep produced by choral is natural in almost every respect . . . a large quantity acts as a poison to the heart, paralyzing this organ and therefore causing death"). Here again, the door to death, in parallel halls: side by side in absent light—which, for some, in jest or measure, might become, in worse lights, a cure itself. In his introduction to an episode of *Alfred Hitchcock Presents* in 1956, Hitchcock announces he's just "come into possession" of a cure. "It comes in capsule form," he says, arranging a row of five bullets nose-up on his desk. "For best results, they must be taken internally." Studies linking sleeplessness to self-murder in this way have found those too long awake as much as 2.6 times more likely to turn to forever wanting out.[10]

By the 1960s, experimentation with hypnotic suggestion rises to popularity with regular reports of strong results, particularly as an alternative where sleep medicine had failed—*in repetition image, in*

8 Hammond, 21–22.

9 "I am writing," Hammond says, "simply to give him information in regard to an exceedingly interesting and important subject, a mere smattering, as it were, and not sufficient, even if he were possessed of a medical education, to enable him to use any one of the substances brought to his notice."

10 http://sleepdisorders.about.com/b/2009/04/09/insomnia-doubles-the-risk-of-suicide.htm.

coagulation of the mind's wanting to be confined. As well, muscle re-
laxation training, systematic desensitization to aggravating stimuli,
classical conditioning via metronome and other triggers, biofeed-
back, electrosleep (induction of low electric current into the resting
body), placebo attribution (pills that have simply been suggested to
cause calm), and even correcting a sleeper's expectations (relieving
stress by devaluing routine) have all been studied and marked as
potentially beneficial methods of therapy, despite their connota-
tions.[11] Other studies suggest that results come only from cures
intentionally paradoxical—i.e., telling patients that the sleepless-
ness is a side effect of their trying, and therefore, to nod off, simply
try not to—whereas straightforward, analytical methods further
the problem or have no effect—i.e., having patients focus on and
identify the thoughts that keep them up, thereby subverting the
brain by turning it against its own weight, instead of crawling fur-
ther in.[12]

]

]

]

Particularly in our current realm of increasing self-diagnosis and
online problem solving, the menu of ways to learn to sleep could
stuff a head. Online, each question often comes with fifty answers,
and further questions often veer out of each of these. Our infor-
mation has its own information, which begets information. Inside

11 Montgomery, Perkin, and Wise, 94–98.
12 Strong, 193.

the shells, if not by nature, we must find a way to sleep, to learn to override the signal with our own nowhere. Googling *sleep* as of today returns 1.42 trillion results. Googling *cure insomnia* cuts the set down to just under two million. Often the resulting copy for these vendors seems written by someone hypnotized or already deep asleep themselves:

> The interesting thing about sleeping pills is the placebo effect. . . . Sometimes when I can't sleep, I put myself into a state of trance, and imagine that I am taking a sleeping pill. I am usually asleep in a few minutes. Even though my conscious mind knows that this was not real, my subconscious mind does not know and this is the important part. THE SUBCONSCIOUS MIND DOES NOT KNOW THE DIFFERENCE BETWEEN A REAL AND AN IMAGINED EVENT.[13]

Other sites offer webcopy spellspeak, mistyped modern babble relics of the home remedy, likely generated by a head behind a desk to make a couple bucks, or out of boredom. Try actively accommodating this:

> Wrap handfuls of uncooked oats and dried camomile flowers, and a pinch of mandrake in a square of cheesecloth and filter a hot bath through it. Light some Egyptian kyphi incense and bathe while deeply breathing the aromas. In bed, envisage yourself in a field of camomile. . . . Think of lying down in the fragrant daisies, lulled to sleep by their fresh, sweet smell. Beneath the ground, the underworld; and above, in the blue sky, Witches and rainbow-hued elementals fly by on unimaginable missions.

13 http://www.wendi.com/html/insomnia1.html (SomnuLucent four-cd set, $117).

You lie drowsing in the fragrant flowers, following one of the passers-by, then another, tracing their patterns in the ether and following to the tunnel leading to the deep blue yonder.[14]

Or:

> For a full-blown case of insomnia, put a head of lettuce into a blender and reduce it to a liquid. Gently rub this on your forehead and temples for a few minutes before going to bed. If you still can't sleep, liquefy another head of lettuce the next night, but drink it this time.[15]

As sorry as these are, you can believe there are those who've tried it—as in the grips of the shit you might believe in any idea as a potential out, or on a long night concede the doubt on the off chance it might somehow do the job.

What becomes even more confounding in the online forums of these methods is the constant sales pitch sunk into the jargon—if not simply the jargon in and of itself, being a commodity of canned language and expected soundtrack. In the margins of the search results, Google offers columns of paid ads: "Waking up at 2AM?, Highly Effective. 100% Guarantee, Get the Rest You Deserve, Phone Hypnosis or Online (Only $50.00 until Nov. 30th receive custom CD or MP3)." Here are endless options, copies of copies. While you are looking here, see also here. Listen when I'm talking. Know this. Eat this. Over here. Even would-be film clips and audio installments of the actual hypnosis bookend their sleep-made

14 Kala Trobe, "Anti-Insomnia Spell," http://www.workingwitch.com/spells/sleep1.html.
15 http://www.spells4free.com/Article/spell-for-sleep/220.

message with more dot-com blurbing and copy talk. Today a You-Tube video titled "Hypnosis for sleep and relaxation"[16] comes with not only the inlaid ads of the corporate sponsor YouTube (again owned by Google), but also the semi-opaque overlays that now adorn the bottom of any video you watch (they can be can be x-ed out if you click them, though be careful not to click the ad itself), as well as further comment ads the video's creators have inserted to supplement with extra information the text ads that make up the introduction to the video itself, an elucidation of the elucidation, all set up before you get to the meat that's supposed to help you go to sleep. Beyond all of that, on the same page, is the video's description message, which contains more URLs and jargons, in addition to codes you can use to share the page, and below that, links to other videos by the same creator and those of a like interest (this particular clip goes to a whole palette of videos with words like relaxation, meditation, sleep now, hypnosis, hypnosis, hypnosis, on and on). The YouTube ads even have little placards beneath them—"Advertisement," in small gray font—in case you somehow didn't realize, and really need to know. And there beneath the label of the ad, another ad.

These days we never are alone. My father, in his old age, not computer savvy, watches NASCAR, the ad-laden machines circling and circling a flattened hole. For others, there is baseball—men throwing spheres and running; genre novels—caricatures of caricatures; yardwork—the fringe and silent growths of architecture—a strand within a strand of endless strands. A sleeping or waking spinning while standing still, or unseen stairwells, numbers counting none. Even in the light of homes there are these boxes and the wires and

16 http://www.youtube.com/watch?v=x1QxSlwc4Ow.

the doors. We diagnose ourselves. We know ourselves and others through the pictures and the language and the sound. As of this minute, DomainTools.com estimates there are 112,606,155 active websites. There are 373,749,730 names of shells of sites once active, now *deleted*. In the past twenty-four hours alone there have been 74,463 new created and 84,167 deleted, and 82,045 already-existing sites transferred to new owners. A constant creation, recreation, decreation, destroyed. The space for expansion approaches endless, with no current maximum cap on the potential number of characters in a newly registered URL. Some browsers may not be able to parse the string (in 2006, Microsoft stated its max was 2,083, though Firefox would carry up to 65,536 characters), making the site difficult to access, but as far as privatizing the space, all gates are open—an unlimited field of nowhere directives, in no land.

Any name, too, is subject to variation, sub-indexing. So you can't have insomnia.com (though, as with other sites, you can have all other kinds of info about who owns it, including their name, address, telephone number, and e-mail, by which means you might conduct a deal), but the potential registrar isn't by any stretch ready to let you give up then and there. Instead of insomnia.com, DomainTools.com suggests the following privately owned but up-for-purchase URLs (as of November 6, 2009):

SevereInsomnia.com, $588.00

NewInsomnia.com, $1,410.00

TotalInsomnia.com, $1,688.00

InsomniaZone.com, $1,050.00

InsomniaGames.com, $708.00

InsomniaCoffee.com, $1,588.00

Beyond these already begotten name tags, there are the endless reams of potential doppelgängers, poised to slink out of the void for somewhere around $9.99. The registrar's suggestions in lieu of insomnia.com spill on for pages, each yours quickly, at a click, though by any instant also perhaps sucked up by another buyer, the eLandscape changing, becoming tamed:

FREETURMOIL.COM
BIGTURMOIL.COM
TURMOILLIVE.COM
EASYTURMOIL.COM
TURMOILONLINE.COM
NEWRESTLESSNESS.COM
TURMOILSTORE.COM
HOTTURMOIL.COM
MYRESTLESSNESS.COM
TURMOILPRO.COM
TURMOILFORYOU.COM
TURMOIL4YOU.COM
TURMOIL4U.COM
TURMOIL2U.COM
BESTAGITATION.COM
HOTWAKEFULNESS.COM
WAKEFULNESSPRO.COM
WAKEFULNESSFORYOU.COM
WAKEFULNESS4YOU.COM
WAKEFULNESS4U.COM
WAKEFULNESS2U.COM
YOURSLEEPLESSNESS.COM
NEWSLEEPLESSNESS.COM
MYSLEEPLESSNESS.COM

BESTSLEEPLESSNESS.COM
FREESLEEPLESSNESS.COM
BIGSLEEPLESSNESS.COM
SLEEPLESSNESSLIVE.COM
EASYSLEEPLESSNESS.COM
SLEEPLESSNESSONLINE.COM
SLEEPLESSNESSSTORE.COM
HOTSLEEPLESSNESS.COM
SLEEPLESSNESSPRO.COM
TURMOIL4YOU.INFO
TURMOIL2U.INFO
TURMOILFORYOU.INFO
TURMOIL4U.INFO
SLEEPLESSNESS4U.COM
SLEEPLESSNESSFORYOU.COM
SLEEPLESSNESS2U.COM
SLEEPLESSNESS4YOU.COM
BESTAGITATION.INFO
YOURINSOMNIALIVE.COM
YOURINSOMNIAONLINE.COM
YOURINSOMNIASTORE.COM
YOURINSOMNIAPRO.COM
YOURINSOMNIA2U.COM
YOURINSOMNIA4YOU.COM

YOURINSOMNIAFORYOU.COM SLEEPLESSNESSONLINE.INFO
YOURINSOMNIA4U.COM SLEEPLESSNESSSTORE.INFO
NEWINSOMNIALIVE.COM HOTSLEEPLESSNESS.INFO
NEWINSOMNIAONLINE.COM SLEEPLESSNESSPRO.INFO
MYINSOMNIALIVE.COM SLEEPLESSNESS2U.INFO
NEWINSOMNIASTORE.COM SLEEPLESSNESSFORYOU.INFO
MYINSOMNIAONLINE.COM SLEEPLESSNESS4U.INFO
HOTWAKEFULNESS.INFO SLEEPLESSNESS4YOU.INFO
WAKEFULNESSPRO.INFO YOURINSOMNIALIVE.INFO
WAKEFULNESSFORYOU.INFO YOURINSOMNIAONLINE.INFO
WAKEFULNESS2U.INFO YOURINSOMNIASTORE.INFO
WAKEFULNESS4YOU.INFO YOURINSOMNIAPRO.INFO
WAKEFULNESS4U.INFO YOURINSOMNIAFORYOU.INFO
YOURSLEEPLESSNESS.INFO YOURINSOMNIA4U.INFO
NEWSLEEPLESSNESS.INFO YOURINSOMNIA4YOU.INFO
MYSLEEPLESSNESS.INFO YOURINSOMNIA2U.INFO
BESTSLEEPLESSNESS.INFO NEWINSOMNIALIVE.INFO
FREESLEEPLESSNESS.INFO NEWINSOMNIAONLINE.INFO
BIGSLEEPLESSNESS.INFO MYINSOMNIALIVE.INFO
SLEEPLESSNESSLIVE.INFO NEWINSOMNIASTORE.INFO
EASYSLEEPLESSNESS.INFO MYINSOMNIAONLINE.INFO

Any one of these suffix- and prefix-affixed strings is potentially yours, a waiting doorway into somewhere to be developed or resold, or otherwise resigned to the middle ground of registration. Some of these may once have perhaps been bought and built by others and then abandoned, in the shape of houses haunted by what was and now is not. The skeletons of these once-entered and since-abandoned electronic rooms still abound here, archived, if not in brain meat or old caches, until somehow those archives crash or are erased, by some furious weather or magnetism, some

god act. So much of nothing these days ever is deleted—copies of copies, zombified. What is spoken from any platform might appear in mirror sites at anonymous addresses without permission, culling text simply to feed search engines, traffic, endless spool: a silent congress, a morphing backlog, electronic window, every hour in your home. Spam folders stacked full of language piling up without an eye, sent by machines to millions of accidental or magnetized addresses, sometimes sucking actual unique messages into its vortex, claiming presence in the blank. The result here, with such influx, is that there's so much being made you'll never see—throes of constant building and recycling—an endless tunnel, corridors upon corridors of code. Many of these sites, too, are aimed at particular persons, in subsets of language. What will be missed. How does one choose. Soon it is the flux itself that is the identity, perused as unconsciously as one passes ads and grows old.

]

]

]

"The more our daily life appears standardised, stereotyped and subject to an accelerated reproduction of objects of consumption," writes Deleuze, "the more art must be injected into it in order to extract from it that little difference which plays simultaneously between other levels of repetition, and even in order to make the two extremes resonate—namely, the habitual series of consumption and

the instinctual series of destruction and death."[17] Expression in the age under computers and endless replication continues to further and further incorporate the inorganic spread into its flesh, turning in on itself as would more and more mirrors, a reflective and variating outer shell—there are more nodes alive now than at any other minute in history, no matter when you read this sentence, no matter how long this book survives, until there comes some Other [pause] Meditation. And yet the light is on inside us, drinking. The light sees, eats, absorbs all. It "connects the tableau of cruelty with that of stupidity, and discovers underneath consumption a schizophrenic clattering of the jaws, and underneath the most ignoble destructions of war, still more processes of consumption."[18] And, grown out from this light, the outer scrim grows thicker, both holding out and holding in, silent in meditation, ever-present. So much is about an often unconscious but continuously updating manipulation of the existent, finding new doors hid in large maps, milking the error up into replication and recreation. There is virus, hacking, glitch. Within each of these, the thread continues spreading, knocking out new doors inside itself to keep up with the coming fold.

"You have to get people very quickly," says JODI, an award winning duo of video game mod artists Joan Heemskerk and Dirk Paesmans, specializing in video game mod and web browser crashing art. "You need to give them a karate punch in the neck as soon as possible. And then—of course—they don't get to the details, and the site will just sit there for the next five years or ten years, or maybe 100 years. And maybe their children will have the time

17 *Difference and Repetition*, 293.
18 Ibid, 365.

to explore the details . . . [(laughs)]."[19] JODI's work, like forced waking, and silence musics, spurts in manipulation of the error in a creation. Their piece *My Desktop OS X 10.4.7* (2007)[20] is simply a zoomed-in view of a user negotiating a Macintosh OS X desktop screen at rapid pace, scrolling and clicking and blipping back and forth through various folders, programs, access points; copying and pasting glyphs of command text; causing the system's error sounds and movement usage tones while a synth-dictation voice spells out each move in collaged glitch. The result, while at first startlingly commonplace in appearance for the ubiquity of the computer screen as realm of art (and after all, we are probably viewing this video on our own desktop, a screen inside a screen), becomes quickly claustrophobic and manic in its process, made more so particularly because of its very banality and any day, everyday, but supermagnified terror sound.

The very fact of much of JODI's work being indistinguishable but from certain stretched moments of daily integrated electronic experience is what makes it, as an entity, so effective—like the strange light of certain scenes in *Inland Empire*, there and not there, like ours but slightly off. JODI's modded scenes of popular games like *Wolfenstein 3D* and *Duke Nukem II* catch the user's avatars in glitch boxes made of colored space that interrupts the body and the air—sheets of architecture folding into limbs and breathing space around the user's only tool inside the codeworld—while the errored sound of the game inside the game goes on. Another project, simply titled *OSS*, comes on a CD-ROM, which when inserted

19 Tilman Baumgärtel, "'We Love Your Computer': The Aesthetics of Crashing Browsers," *Telepolis*, October 6, 1997, http://www.heise.de/tp/r4/artikel/6/6187/1.html.

20 Also available in the video archives at Ubu.com. More at their website JODI.org.

in the user's computer immediately overwrites the desktop with a pyramid of 317 files. The effect, unlike the string of viruses and spam popular throughout the '90s, is not to cause dysfunction, but to "manipulate the surface of your system. An interface is a translation of code and your understanding is what you believe and that's all there is to a computer, it's a language."[21]

The effect is not destruction, but reordering, renegotiation of the content and interaction with our *other household*, the electronic rooms where we store not only our digital identity information (credit cards, numeric values, browser cookies, even background wallpaper and design), but also the more abstract or self-negotiated tokens (Word files, pictures, image of self). The computer, in some way, has become the most direct avatar of the user—show me your desktop and I can likely glean a dozen things about you, from sense of order to priority to interests and ideas. A computer is, in some sick but honest way, a child—an amputated mirror of the self we interact with via buttons, cameras, microphones, and light. This is not the case for all bodies, surely, as some can hide out, but it is more the case than at any point before, and perhaps more so than we'd like to imagine. Even JODI talking about the overlay interface of *OSS* seems like some handbook to a waking: "There is no About or Read.me file, just this grid of folders. It is a stress situation, some people try to deal with it, others want to get the CD out as fast as possible but then realize there is no CD icon and it gets even worse."[22]

21 "Interview with Jodi," Rhizome, May 19, 2001, http://rhizome.org/discuss/view/29955/#2550.
22 Ibid.

Brian Eno explores this sort of self-mesmerizing concept even more demonstrably in his sound and video project *77 Million Paintings*, which combines an enormous database of randomly combined generations of color, light, and tone to create an aural chamber. The work is composed actually of only 296 works that in collage and juxtaposition, along with the layers of sound, develop a field that seems to the viewer (and the creator) to be ever-shifting, but is actually mathematically rather small: a mistakenly finite infinitude. According to Eno, one would have to watch the program for 450 years to see a repeat. This confined but massive rubric, he says, drums power from a reversal of "the supposition that you can always hear something again. We're so used to recordings. The last 120 years of human history have been this tiny little blip . . . where suddenly we could have identical experiences again and again."[23] In this way *77 Million Paintings* models an insomnia enslaved, the endless spooling busy brain of a sleepless meat at night, parsing and reparsing the same terrain into new glyphs. As though in the head the parsing ramifications and wrinkles rooms seem to go on and on in all ways therein forever, ultimately the branching and unbranching all leads back to the same center, the brain space occupying a negligible 2 percent of any human's weight.

Though it has always been this way—translucent rhizomes and complex histories set on any air, and the brain endlessly wanting and not succeeding in defining itself within—the package of the junk from which we might select our elements grows only larger, and more readily awaiting, and more there. The internet itself becomes another realm of endless hive meat over the always waking 24/7/365 bright-lit gorge. Not only are we now dealing with the

23 Interview with Eno for BBC, http://www.youtube.com/watch?v=_06fTFFMoi0.

hours of our experience and seeing, the residues of every person's person hung like unseen curtains over every inch where we inhale, there is also now a second, electronic looming, rooms buried and married to all rooms, a silence seeping of some nothing, renaming names inside our sleep, or at least gone. Toggling between the Google SafeSearch feature's levels of access—two modes adaptable by any user, with a third offering "moderate" coverage between the two—quickly reveals the onslaught of fuck and feces connectable to most any search. Google *mother* and in the first page of image results (at the time of this writing) you get a picture of a nude dude ramming his cock into a young girl's face while another, older woman lies back on the bed to watch. This next to a picture of somebody's grandmother with a thank-god-someone-still-loves-me face, holding flowers and wearing pearls. Though we no longer need to remember all the information we once had to store inside our heads in order to make it useful, the definitions we might gather in the same name are all gyrating.

From enough distance overhead everything appears the same. The way on Google Maps the cursor's tiny outstretched hand clenches the earth before you drag—the leaning diamond-shaped eye hidden over each and every one of our houses, capturing that air in database-made air. The weird looming patches of gray blank space over new area as the browser waits to load. Google-mapping "hell" actually tenders a result: "We don't have imagery at this zoom level for this region." A search for "heaven" returns 2,894 locations. Photographs of photographs, to be zoomed in on or out from, made into directions, toured, printed out.

For all the hours held inside us, and the vertices of potential other ways those hours could have been spent—a splitting unto infinite

splitting—there are also all the doors and paths held over us, on our exterior. Watching. Waiting. When. For what. That there could never be an answer becomes as well the innards of the question— the bloodlight of the word itself. Because you wouldn't want to know. Because you could not. Because, given the answer, the light inverts. Becomes a no light. And then these houses—folding on a fold. "I can't jack off without history peering in," writes Johannes Göransson.[24] And too, the air and walls and endless doors—and the out-of-doors. The excess breathing, the history of any dot, or any word around where it's been placed.[25] Here where after erasing the word "mother" in the search bar and instead typing the address of the house where this sentence is being written into Google search leads me to hover over the terrained image of the house, inside of which, one might imagine, I could also be sitting, in my underwear, glowed on by this screen. According to the current map, there are three cars parked outside my house. Two of colors I don't recognize. Another waiting in the street. This moment frozen in representation of the place wherein which my body matured, grew older, large. *Who said you could have that? The roof over what is mine. Why doesn't Google see inside the house, forever? Google Attic. Google Mind.* Enmapped: a rash of trees like enormous broccoli grown over a section of our roof. Whole sections where trees cover the screen from end to end entirely—a huge crudded maze of green. Other cars on other streets unmoving as if we all went still

24 *Dear Ra.*

25 Göransson, on his becoming: "Or when I was about 10 I was hospitalized for this or that reason and I refused to eat the hospital food (as I refused to eat most food at this age, I was a spindly wreck of a boy) and on my way to an X-ray session I passed out in the corridor and had to be carried to the room. This is how I invented erotics. Later when I was operated on and was anesthetized, I had this vision where doctors in doctor clothes wearing gas masks were smashing computer screens with sledgehammers. It was beautiful." (via email)

at once. What people hidden in this picture, beneath these roofs or blending in. What, unknowing, is contained—like the Magic Eye paintings sold in most every mall, which I've never been able to make work. *Look again*. Out of this chaos might emerge a landscape. Within this skin there is a seam. A watching without a blinking. A kind of map of sleep that does not sleep.

Down the street here in this rendition of the miles around where I grew up there is the church where I was baptized, where later the troop leader of my Boy Scout group showed me his stab wound to prove how I should listen. Staring at the church's image here again today from this false overhead, I can't help but want to move further there into—to crease the page of screen and enter. I zoom until its face is wholly splotch: pixels larger than their data. The window tonight is not cold. The light inside the house against the night again makes it difficult to see anything but me. I see my face there, as if through the window looking in, as if waiting for me to open the glass and allow entry. My eyes. The size of the church since then has at least doubled—the way all modern churches seem to, eating $$$$—you can read its new countenance from the street, the pervading hulk of it that much larger, longer, as if it's adhered to the air it once only inhabited, in surround.

Further down along the browser, dragging, from the church there is the driveway where a nine-year-old girl once threatened me with a hammer. The house where during third-grade afternoons we imagined war with sticks, and concrete in the backyard of a kid I helped learn English from his Portuguese—he who since then, right after high school, drowned in his parents' bathtub in Brazil with a girl. The cul-de-sac where some kid I'd never seen before and would never see again showed me the origami woman he'd

folded into being, complete with vagina lips cut and pasted out of a dirty magazine—such moments somehow rendered in my no-where, made of other people, less of me. Every hour of this caught inside here unremembered but by my temporary brain—a brain that can't even catalog all of that it holds or has hid.

It seems I've hardly grown since all of when. Perhaps my mind has. Perhaps, in confabulation of the distances the world once held, and the amount it seems to hold now, packed full, the air indeed has been pushed in, the same way time as we get older seems to go faster despite its eternal measure, with each new second held that much slighter in contrast to the bulk of all the years. If time and space are not enough to fit my incidental reconnaissance to the Google Maps image I've so recently drawn up to write of herein, this night I will go running off into it in nothing but the rhythm of my breath and the sloppy smacking of my feet upon the pavement, perhaps in some pattern of repetition over where I've run before, the misted night above me abstruse with such glow and the hung bulbs here making the sky by now resemble one large silent box, of a silence I can't help but think of as an image, of dimension, screaming silence, white on white in other air, which from under-neath and right there seems as if somewhere above me it must come at any minute to sudden end, a day contained, a thing photograph-able from some distance, a thing contained. If I am asleep or awake right now, I can't remember, and it hardly seems to matter.

]

]

]

Today while trolling through various web results for deeper sleep cures, I find a man in a video titled "All Hypnosis Is Self Hypnosis"[26] who offers to hypnotize me right now—through the machine, via recording. Underneath his up-close, centered, smiling head is the URL of his hypnosis vendor site, along with a message beneath it telling me to visit the site and relax even more. The Google-supplied ad over the message under his ad under his head says "Learn to Hypnotize Anyone," and then it changes yet again. The man tells me to close my eyes. "Because there is nothing for you to see," he says. He's staring. I press pause and stare back into the pixilated lidded whites of his small head. The ads around him go on blinking. While he's on pause, I get new e-mail—I see it appear as a number annotated in another open browser tab, and when I click over to read, as I now must, by impulse, I find a new automated message sent from Facebook, letting me know someone has commented on my latest status update: a Ben Marcus quote that appears also earlier in this book. The message says the comment says: *I like that sentence, too.* I delete the e-mail. I refresh the page and see nothing else. The paused video on the YouTube tab sits behind the fold of this tab waiting. In total I have six tabs on my browser open: Gmail with all the not yet archived but already read mail compiled;[27] Facebook home with all the updates of the 894 friends I supposedly have;[28] a Wikipedia page on the Ziggurat of Ur, which I can't remember why I have open;[29] a long essay on the rhizomatic riddle of Stanley Kubrick's *Eyes Wide Shut* a friend sent out on Twitter,[30] for which I'd closed Twitter to have room

26 http://www.youtube.com/watch?v=jE7m_4Fch14.

27 http://www.gmail.com.

28 http://www.facebook.com.

29 http://en.wikipedia.org/wiki/Great_Ziggurat_of_Ur.

30 http://wrongwaywizard.blogspot.com/2008/10/bore-me-again-o-wrong-way-

to fit all the tabs comfortably on one screen and still be able to see when new e-mail arrived; one of countless pages today selling hypnosis CDs;[31] and the video of the man—each of them in some way selling something, information however hidden[32]—and each waiting in their own silence, folded, to be again brought to front or dismissed.

Before going back to the video again, I open a new tab on my browser and load iGoogle, which holds my Google Reader, tracking the hundreds of RSS feeds that get continually updated and tracked and fed into me through the day. I see a friend has shared a link to an article on Gizmodo.com that claims how each year each American consumes 34 gigabytes of data (including internet, TV, radio, and reading), accumulating in a national sum of 3.6 zettabytes per year (a zettabyte is one billion trillion bytes, the article explains).[33] Within this, per day, there are slightly more than one hundred thousand processed words, through movies, music, books, and TV, though the internet speech dominates them all.

At the far end of the house I hear, in my gaping, someone opening a door. Seconds later, my cell phone vibrates in my pocket, tickling the thigh flesh, radiating cells. Without taking out the handset, I press the button that makes the vibration stop, sending whoever is in there on the far end to a recording of my voice asking him or her to leave me a recording of his or her voice.

wizard.html.

31 http://www.wendi.com/html/insomnia1.html.

32 Any of the said links too, perhaps by the time of being read wherever, having turned up dead, leading instead to error fields or flats of white.

33 http://gizmodo.com/5422324/each-american-consumes-34gb-of-data-a-day.

I go back to the video of the hypnotist and I press play. The man is again speaking, as if he'd never paused at all. His head is gloamed white and slurred with purple. He has eyes that sometimes roar, but held confined in this clunky, bitmapped image. A music comes on around him—the same blank synth spread through all the other hypno-wanting videos and mp3s and websites with embedded sound. He begins to speak into me, saying the same things all the others have, asking again that I relax, that I go deeper on into my softing, that I forget the whole rest of my whole life, my future, my glow of nowhere, that I turn on my unconscious mind, "because our unconscious minds know all of the things we have experienced in the past . . . all of the information from our past . . . perfectly acceptable for you in every way . . . and in a moment you might have a new idea. . . ." The words do what they want coming at my head. I'm kind of glazing over, but not, I think, in the way he means— I'm fucking bored, but no more tired than I had been, or groggy, or wide open—at least I think.

The man ends the video then almost as quickly as he'd begun, with his website information repeated for the cause, followed by a slow fade to a whole black, but for the same URL writ on the screen, replication within replication, waiting for the next viewer in the queue to wake it up, open it on. I close the tab and go back to my e-mail, where there is nothing new, even when I hit refresh.

The sum message of this video and others like it is: You are comfortable. You are safe. You should slowly breathe in and out. There are many adverbs. You cannot hear the speaker breathe him- or herself. "Relax," they say. "Relax." The only thing we seem to need to know is *it's okay*. "That's right," they say. "Thaaat's right." The lilt of the voice like some secret broadcast over America, in slow

uncombing. "Everything is just okay. No matter what happens, you will be calm and you will feel better than you have ever felt before." Many programs like to suggest you floating up into or with clouds out of your bed. You might be encouraged to see yourself in the bed soft below you, the room familiar. You exit your body and your home. You might be transported into the sky or, if you like, a beach. "Even if you do not fall asleep during this," many mention, "you will feel more rested and relaxed as a result." The product, then, we may imagine, might not necessarily be something immediate to feel, but instead a product that will open in us without warning. Many of the meta-commentary-type allusions that pepper the dream-speak are concerned with allaying any fears that you can err here, affirming there is no intended massive goal. The direction, they insist, is yours. Wherever you want to go, you can go there. Any choice you make is the right choice. Your imagination belongs to you. "So relaxed," they say. "So comfortable," as if the words themselves in transition to you then must immediately become true. Somehow even the most horridly produced versions of these videos on YouTube often have more than one hundred thousand views, with comment testimonials from users proclaiming the product's virility. And of course, beyond the idea that these tapes are working because of the actual instructions and their effect, what these directives succeed in more so is allowing the mind to become distracted from itself—you are no longer fixated on the monologue or further scrying, but aimed at something designed to awake a blank. All of these ads and videos together—loops in looping—form a network, an endless hole in which to drown. Perhaps the strangest thing, and at the same time the most obvious, is that most people by now are so tuned out to this kind of influx that this video effectively does not to most people exist. We're so used to the pyramid of input that most of the day, during countless

hours trolling, we don't even see these icons and their connectors any longer, at least not consciously, or pragmatically. It's become as clear as not looking at messy spots in your apartment or gaudy billboards near your house—they are part of an environment—more, they are the environment itself: the scab woke on the skin. We are tuned in to tuning out. And yet, in surrounding, they are there. They are looking at you looking or not looking. You are taking this all in.

]

]

]

And so how the fuck under this false ceiling and its false ceiling and the house and all this meat now do we relax? What in one hour might seem the best thing might in another scream a knot, make one want to hit one in one's mouth. Beyond even just the far-off future, there is the present minute of having constant day in constant time, a hundred ways to spin in any intuition. All these arts asking questions left unsaid. All these doors and hallways prying open and looming open and awake. The weight of decades of human dreaming. And every second, seen or unseen, within and around our heads, the spread. Each idea stung with all its gather. The unindexed histories of contexts and accusational collisions and theories, exponential. Imagine our history's quantified timeline ideas translated into thicking glass—glass growing out and thicker in our air there, unseen. How difficult it can seem sometimes to breathe. And with that, the growing contention of how obvious all of this light is. How well we already know what we are underneath.

How we are expected to keep curving. Reaching. Eating. Going. Hello. Hello. Hey.

"Just get wasted" is a common response from a lot of people when sleeping trouble is brought up. Indeed, being drunk, if not quite parallel to entering the unconscious via dreaming, affords rooms within rooms, warbled hallways, multiplying doors, ones often unremembered in the sobering process, through which the body, often, when forced to return, becomes ill. Much like a role-playing game's "summoning sickness," wherein new characters are unable to act in early rounds of their invocation due to the trauma there involved in being brought into the field, coming back out of the drunk state reiterates some common side effect of sleep medication, and insomnia: dizziness, nausea, exhaustion, sweating—damage.

But drunk sleep is shallow, prone to exit. The architecture of the unconscious rooms is nearer to the brain, deflating dream components under muffle, often unremembered, zapped. Like those faking their way through exercises seeing no results, the aggregate of many consecutive days of sleep through beverage-based sedation can pile up on the body, rested and not rested, groggy, gross. Sleep without the drink then might seem even harder, and more required to feel full. The doors, as with all forms of such influx, grow wider, their halls thereafter nearer-walled. Something greased in the gears of that depressant as an entry, dragging the cells down heavy, as with the same caloric fat in breakfast cereal, though also in the loosening of the cheeks and meat around the brain—a state not that far off from early insomniac gyration, where the air feels different but also new. Staying awake seventeen hours has been equated, in the drop of performance, to a blood-alcohol-content level of 0.05 percent (one to two beers, depending on your beef), and further

corresponds in ruined performance with continued deprivation. In the same way, the effect of alcohol rising in the bloodstream begins with onset euphoria, which becomes lethargy, which becomes confusion, which becomes stupor, and, finally, coma, heading, again, toward death.

On particularly nasty nights post–high school, up late sweating in small apartments looking hard on into machines, I preferred the slur of NyQuil. At first I used the serving cup and filled it full twice, a double serving, justified by my frame. Lying down with that thick liquid purple light leaking inside me seemed to promise untold fortunes—like now, with its warnings of "marked drowsiness" and warnings against using while "operating machinery," the substance turning on all through the blank spots there inside me, I could at last go quiet, lurch off, under the warming ceiling spreading out through my insides. Its bouquet like doctor's exam-table paper and cheap tacky candy, bite like melted plastic child slides, aftertaste like licking the linings of a rarely ever worn winter coat— or something—still the head swims lightly. Still, a little jostle, slot machines, a slow stirring around the shoulders, at the skull's edge a muffle lamp. Other nights two servings would say nothing, and still hours later I'd be in the same spot anywhere, if that much more groggy underneath the antihistamine. One thing about chemically altering the door of your coming and going is that when they don't seem to click, the frustration becomes that much more severe. This door, even with these keys, did not open. So now then I need more keys that push harder. I must cut through all the locks. So I took more NyQuil. I'd swig off it fat-lipped, get half a bottle in, the slicky throttle of it enough to suggest drowse by perfume and lick alone. Maybe a few swigs in a row until it seemed right. Whichever. Drink enough until you can feel it in your head.

Still on the OTC side of the barnyard, Benadryl could work also, or any of the countless antihistamines—nonprescription sleep pills, the allergy medicines, the "night aids" and bedtime versions of other basic medications—Tylenol PM and what have you—each of which, by turns, I sucked down, depending on what there was around. Four or five Benadryl felt like light to lay inside, a humming, the warm rubbed rind of its waving coming on, if still not causing the over-thinking to black out, then at least there lapping at my body like a blanket, waiting—or *seeming waiting*, to one of the other me inside of me—for some small lapse in the obsess-chain, a slow down, so that therein we could slip in, gone, in witching hour. And the more you take the more you believe, the more you need to make yourself think it's setting in, though underneath all this expectation what you don't hear so often is that increasing antihistamine dosage doesn't cause a comparable increase in response. While they benefit from having no side effects, and working better than a placebo, there's only so much gain to glean from eating up those basic agents. A pat on the head, a little padding, but ultimately, through most hours, little more than something like a jacket, worn.

Worn, too, are the books that offer logic for the exit from the barrage, constrained advices aimed less at direct motions and more like overall life guides: **Set up regular bedtimes and rising times, including holidays and weekends**, certain books will tell you, milking on the body's wanting to be programmed, made a box. The funny thing about this advice, though, is that another common piece, often listed in the same spiel, is: **Don't get in bed until you're tired. Don't spend extra time in bed awake reading or watching TV; only sleep until you're rested; don't nap.** The wider logic here would be to set up a time in schedul-

ing when you are usually tired enough on most days to be ready when it hits, but inside the wide strain of stimulus, continuous redressing, constant input, and so on, it seems harder now than ever—and again growing by the minute—to predict where the body is meant to be. Not to mention the frequent further advice of **Don't flop in the bed for longer than thirty minutes; if you can't sleep get up and read or watch TV until you're tired**, which has the benefit of removing the frustration period, but also further displaces the timeline. The people I know who seem to tend toward those regular settings are those programmed by their nine-to-five, most of whom having been at it so long they know to fit their obsessing and consuming into a specific set of slots— I watch TV now, I shop now, I eat at this time, when I want to go to bed I go to bed. Concerns of territorializing the environment of the sleep state. Building inertia, consecrating space; the idea being that if you can decenter the errored condition in the blood, by negotiation and conditioning, rather than meds, you can change the expectation, the nature, and emerge clean. **Schedule worry time during the day**, suggests another fragment of advice, which alone seems so insane and off base, as if anxiety were a muscle one could gather up and outlay only in a 3' × 3' square section of the dining room partitioned off under thick glass— though really, such rigor and demonstrative restraint seems cozy, even expected, in the fields of office buildings and neon shopping space, where behavior out of the frame could not only cause one to look bananas, but could result in further repercussions, psychic leakage.

Another manual goes so far as to define mathematical procedures for determining sleep efficiency (SE), constructing logo-speak over what should be, at its heart, the simplest thing of all:

$$\frac{\text{Total sleep time (TST)}}{\text{Total time in bed (TIB)}} \times 100 = SE[34]$$

This SE coefficient is then to be used in maximizing efficiency by setting a "sleep window," where there is a terminal period between the concrete time one wakes up (not to vary) and the time one goes to bed (to be shifted based on level of sleepiness at bedtime, which is also given mathematical terrain, a seven-point scale known as the Stanford Sleepiness Scale, where "1 = feeling alert; wide awake" and "7 = sleep onset soon; lost struggle to stay awake." The very fact that this continuum ends in expectation—the perceived idea of "Here I go, I really am about to go under now" being, often, only one of many mirage doors in a long night's hallway. In the meantime, further comfort can occur through consecrating and reinforcing the sleep environment as a place of rest (including removing outside light, as the presence of even tiny LCD glow such as from clocks and VCR faces have been shown to dramatically influence quality of sleep), as well as carefully monitoring the substances brought into the body, particularly stimulants, and volumes of liquid large enough to make you need to pee.

What we're supposed to do, then, is spread all of this worry throughout the day, focusing on attending to these moments actively and in consideration of the night, so that by the time we hit the pillow we're not only physically rolled upon, but we've spent enough brain light on the contraindicators that we might, in our backminds, actually be settled over the idea of interruption, distraction, fright. **Do something relaxing and enjoyable**

34 Morin, 112.

before bedtime appears in the same list as the worry scheduling, seeming both a fair suggestion and one worthy of an interminable angst—*Like what? How should I relax? Look up sports scores? Eat a scone? This TV has nine hundred channels. Even my e-mail is making sales. Some nights I enjoy music, but tonight the headphones seem to be eating hard into my head. I can't sit still. My arms feel like someone else's. I keep thinking there is someone at the door, and the phone keeps ringing, and, and, and . . .* Beyond the mental, masturbation might fill the purpose, teasing the body into a definitive release, and many nights surely that unlocking can kill a body's stress, but it doesn't always serve to kill the mind—in fact, the mind sometimes I've found in those post-spaces can come even more awakened, spun with the fantasy of flesh architecture or want for want—or on the opposite dimension, a more complete sense of desperation, a silence interrupted thereafter by having peeled away the basic need and awakened again obsessive thinking into *now what*. Any act that might work one night might not the next night, or might not come again, therefore creating only more frustration or compulsion or distinct confinement to be used to rail against itself. Often the clog just wants more clog.

Mention this ever-spooling solution list to most anybody and more than half have some little trick to pass along, something that might have worked for them or their grandmother among some long night. And often, too, these things, in some desperation, these things appear rising in the wash as wishes or mirage. Regardless of what doubt the long patterns have inscribed, any new thing might still be a potential key. Inevitably, and almost by default, they fall into place on the long list of Things I've Tried That Haven't Worked. Part of the problem herein seems to have

to do with resignation—a skepticism for the cure probably leading only that much more headstrong to an awakeness. At some point, even in your want and wish for x-ing out, you almost can't help but strand yourself therein inside it and thus be cultishly committed to the idea that nothing short of hard-core overriding will make the sleeplessness desist. And so in some ways it becomes self-perpetuating, both consciously and unconsciously, as if it were a state in wanting, a terror badge. Still, no matter how deep this resignation may take hold of the unsleeper's will, there's likely no point at which, given a quick reliable out, you'd throw yourself into it whole on.

Stagnated or sealed out of the world of the public remedy, then, the next mode for many turns to more. Antidepressants are considered strong options for those with histories of depression, pain, or substance-abuse problems—the lack of sleep therein likely often a byproduct or shared terror floor. Among these medications, trazodone has been around since the 1960s, a second-generation antidepressant, and remains popular for its chemic lack of addictive properties, if still surrounded by endless potential inner destructions—drowsiness, fatigue, headaches, decreased sex drive, dizziness, as well as priapism in 1 in 6,000 men, 1 in 23,000 of whom will require surgery and suffer potential impotence for life. In addition, popular painkillers such as Oxy-Contin. Darvon. Vicodin. Percocet. Percodan, Demerol. Lortab, Norco, Lorcet, though not prescribed in cases of pure sleeplessness, are often used for that end, sometimes, under the roof of self-medication, serving as a doorway unto death. The laundry list of effects and odds in deep relation with medication has for the most part become another feature in the stream of new info we as a community receive.

]

]

]

For years inside my own mess I'd gone on simply worming, resolved to remain floated in whatever unsleeping space my brain would bring. And yet, as household orders failed, and times stretched longer, the length of night began to grow, becoming just slightly more unbearable and hated in its new reach, night after night, night in night. In general I'd avoided doctors, appearing before them only when there were no other ways around, mainly out of some aversion to the small rooms and the white paper, the waiting behind doors for bodies who make their living negotiating, feeding, feeling, peering into other bodies. In the same way I'd let my wisdom teeth barrel in reckless, creating slow screw sound inside my mouth, which some nights would keep me up or wake me, the same way some people grind their molars through their night hours. This state, known as bruxism, is actually one of the most common forms of non-thought-sound-based insomnia, wherein people will grind their whites together so hard as to cause damage, ruin their smile. In addition to the usual symptoms that accompany sleep disorders, bruxism has been related to aggressive personalities and those with suppressed anger. Because it occurs during sleep, it can be difficult to detect bruxism, outside of waking symptoms such as chewed mouth tissue, teeth cracking, earaches, unusual wear on teeth or gums, headaches, jaw pain, and so on.

My mother gave me my first few Ambien from a prescription she'd gotten for occasional relief. She hesitated placing the small football-

shaped powder-blue orbs in another orange container, also labeled with her name, and agreed only to let me have them if I'd hide the bottle in an inner pocket of my large coat. If the police were to catch me, she said, explain that they were hers, that I was bringing them to her, after a vacation. Something. I kissed my mother on the head—she who had gifted me with the brain of no sleep had gifted me again. I took the blue pills home. I carried the bottle near my heart. I felt excited, in the low lurch, to try this chemic door, this X-ing out. I did not know why it had not occurred to me before now to dig this yard up. Inside my bathroom, I shook a pill into my palm. I nudged it with my finger, saw my reflected face. It went down the way a pill does, a tiny bite of nothing. I don't remember any flavor. I do remember moving there with the pill inside me to sit down on the bed in my bedroom, the thread of expectation snowing in me, waiting for inverted fireworks, some fall. I did not know if I expected some sense of caving, a slowing blackout, or some more immediate snuffing, like a blanket over light. I was nervous, like a waiting parent. I took my clothes off, did not pee. The room waited, with its light. I don't remember the way the blank came, except that when it did, outside me, I was gone. The doors opened and I went through them, and there I hid. There was no roll. No silent chorus of selves in nothing, saying the same sounds again, again. That night, at least, I fell in.

The particular thing about Ambien is that if you don't follow its lead, it does a different job. You can't take Ambien and then walk around the house and wait to get knocked over into zzzzz. The crossover, if not played party to, if not laid down for in want and waiting for the night, might make the waking room itself take on the space of sleep. There are people there who are not there. Somewhat, in another way, like those extended colors and doors

of particularly extended periods of insomnia—the dream folds invading the conscious mind regardless, reclaiming the air. For this reason Ambien frequently ends up as a party favor, a recreational detonator, turning the self onto the rooms' air—taking pills to find the tunnels, the hidden hours, that otherwise you'd only negotiate asleep—the folding of conscious and unconscious, even if often afterward you don't remember it anymore than you would a dream, unto the self hidden in the self. A state of unwaking fused in waking, removed in the way one might find coming open after long periods of sleeplessness, though in this case invoked through chemicals. This is another self called to the front, rather than drawn up in small collapsing. Then in the morning there I was again. Untroubled, I'd gone somewhere. I felt newly rejuvenated, rested, if just in the name of having nodded off without the fight, a clipping of those flopping hours. Night was shorter now—even if, under just that first time, something about my body felt off center somewhat, slightly not right. This sleep had been fraught upon me, opened by chemistry and not by the elevators of my mind. A little glassy in the waking, copied. But that was fine. Oh, that was fine. Even underneath the slight trace of sleep hangover, I could get up on time and move throughout a day. That next night I took the sleeping pill again.

That next night's next night I took the sleeping pill again. Here, now, a triad of nights of normal sleep. Waking that third day, it seemed so open. How easy, in repetition. How quick to want so hard. If anything's the problem with eating sleep out of a doctor's bottle, it's that once you've realized there's a way, it can instantly become *the only* way. On the fourth night, then seeing the pills there, I think I thought, "Three good nights in a row, perhaps now I can roll on inside myself. Save those others for when I need

them." The bottle stayed inside the drawer of my bedside table, almost touching to the bed. Lying down unpilled-up, the room settled around me as it mostly had, again. The dark air waiting. Windows. The rhythm of the breathing. Outside the pill realm, pressed on the pillow, in want, my same old thoughts turned on again, the roll of routine of never silence. Only this time, now, there was another fold into the throes—no longer simply an endless scroll of my own thinking, but now, *I should take a sleeping pill*. I could hear the bottle right there in the room beside me, asking. Like the sublime objects of my child years, I felt its eyes. The night in this expectation went on even longer, every minute doubled in its doubling, pressing on. Every minute I did not succumb and take the pill was a moment wasted in going on. With an immediate, unnatural door now open, the door was right there, despite my want to stick most hours to the fleshy, silent self-made hall.

When I'd eaten all the Ambien my mother gave me from her surplus, I went back for the rest of what she had. I tried to make these last longer, by forgetting. I took the bottle into another room, to keep them farther from my body. I would take half a pill, a third, though sometimes this would just instigate again the idea that I had not taken enough, and keep me up inside it, waiting to take the other half. Some nights the gap herein would be enough to reduce the effect that it came not at all. Quickly taking a half or whole pill, by mood or building tolerance, might seem diluted. Even in the grips of it beginning to come on, one might disremember how much has already been eaten, how much the air around one's skin is already coming slurred. In want, you take another, the air gets deeper, you're still awake. In the pill mind it might be easy to take several without even knowing, in the mental insistence, as a drunk does, that you are casual, you feel on par. You exist inside yourself

and, in the way the walls around you go new, invite the space of dreams onto their width. Seeing sober someone pill-eating it can seem as if they are operating in altered space, unjarred: conversations with long bodies on the bookshelf, curls of color bouqueted from the TV, the room itself as several rooms.

I don't remember dreaming while on Ambien, only that the dreaming seemed to start before I was actually asleep, played into the screwed lack of light inside the room, becoming new walls—and somewhere in there I would fall. I don't remember entry or exit periods around the hole, the memory of dreaming and sleeping therein feeding into blurs around the waking and moving states, an infernal fabric, nowhere—except here from a temporal distance, they seem in relief—in multiple meanings of the idea, in that they milked me, gave me a room inside the well-hollowed curl of my on-thinking during a period in which I genuinely felt light-starved, but also, "an apparent projection of parts in a painting, drawing, etc., giving the appearance of the third dimension"[35] in the pill's lingering residual effect, often causing slowness, blank of nowhere, chalky ideas, slowing down. Whereas sleep would come on quicker, it would hold fakey, shallow, as if poured into me on film, and in waking also walls would feel flimsy, different, waiting to be knocked down. Waking hours between rest afforded by sleeping pills become also colored by that false shift, making the flesh itself somehow off. Harder to speak, to write, to move under that awning, with the trace elements eating the bloodstream, and the expectation of the next elapsed state waiting in the wings. Staring headlong into the computer, clicking, clicking, seeing even less, the fake light feeding its uncolor and its unheat to my flesh.

35 From a definition of the word *relief* (http://www.definitions.net/definition/relief).

In the unfurl of days and into weeks thereafter, however, the threat of sleep newly out from under dazing pills, the recoil came in a fast wave, a sudden and immensely stacked new wall. Whereas before in no sleep I'd learned my alleys, struck somewhat in the line of daze of saddened understanding, with my mind and body's recent foray into sleep coming to claim me, and without the easy reach of more pills, the house around me herein grew even harder. It had been only a handful of weeks, but those fingers quickly learned me to their grip. The hours of the night would squeeze and bleat me. A set of new locks on my mind. Commonly known as *rebound insomnia*, and in its surrounding horror of worry for its coming, *rebound anxiety*, this state set upon me even worse, learning my waking hours into itching over what was coming for me quicker still that evening, and thoughts of how to disrupt it, shake it off. The use of the word rebound here is particularly moving, to me, in that not only does it speak for doubling, for falling back from out of some hard plane, but the idea of *being bound again* seems apt—tied into a parcel to be thrown again and again against a flat and tiny, unforgiving board. What's worse, the prior modes that'd worked to soothe me, the OTC knobs, seemed passive jokes, hardly even denting, in my new want, the thickened pools of where I walked. The inlaid terror of not sleeping now had another layer, reflexive in its bent, which therein made the insomnia itself that much more wretched, rolling. All minutes ramping up toward one unblinking, false-faced sun.

After my supply of Ambien dried up, I moved to Lunesta—sought from a friend who could get free samples, and would share. These, he promised, were different from Ambien in their pronouncement. I'd need to be lying down. I can particularly remember that first night I pushed the thin Lunesta white globe out of its skinny back-

ing into my hand. I slid the nodule into my mouth and sat around a minute and got up and sat down in front of my computer in a mind, tried to write a seeming e-mail, a letter off into a person in my life I missed, one I'd met with the both of us inside the Ambien walls, the e-mail's title and descending text of the mouth of synthetic sleeping coming on: *i got words and together i'm trying out a new sleeping pill, half-glazed, now let's you have them* . . . , the words thereafter also honest and spilling from some glown gut of the new room, as it came quickly to sit around me. Unlike Ambien, there's little trickery to Lunesta's window—it is there and then it's there. Also unlike Ambien, I can distinctly remember the room around me as I blabbed into her, of a mind, *My brain the big suspendered burning, and you, and you, and yours,* and there at the end smashed send, threw into the mouth of the computer my dissolving dream text, then fell back into my bedroom's bed. There was the room then there was black. Upon waking, hours later, my friends in the other room would report me breathing louder than they'd ever heard me, speaking in another language, texture tongue. I also cannot, from here, remember dreaming, these hours also settled under heavy curtains of their coming, but for certain in the grip of it I had no answer. I slept on top of covers, in my clothing, in the light.

This is what we want from sleeping pills—lights out, mind out, exit. Obliterate the room. No option. Help me forget me. Under the reign of endless choices, we want none. This is the function of the medication—it delivers an intended punctuation of effect. It is to flip a switch, a removal of the I, and so therein the removal of the remembering of dream state seems distinctive, integral to this kind of sleep—as in the removal of the struggle, of the self's descent into self, the descent is rendered slightly other, slightly off.

Sleep becomes less the state of reckoning of unconscious self in its translation, and more a coverlet, a box. Pill sleep, even when remembered, wears a ring around it, another rubber, something off inside the waking self eating the curve of what the day fights to hold onto in the leak. In one instance, in 2010 in China, a man was stopped from killing himself when he took fifty sleeping pills before going to throw himself off a roof, unable to decide between two twin ways to die. The pills knocked him out before his death drive could be completed and were not strong enough to do the job themselves, so he survived, living now with his wife inside that knowing.[36] Herein the snuffing of the self provided the self's ultimate defense, blocking in the nothing of the nothing before the last black.

If sleep is for the self, then invented sleep is an invented version of the same, slightly askew, like digging into memory flesh you have not yet worn, or wore in other years, none of it quite yours. In one commercial for Lunesta, a neon lime-green butterfly flits around a bedroom among the glow of magic forests. As the insect hovers over the shape of a sleeping woman, a breathy, listless female voice-over monologues in monotonizing ad-speak the pleasures of our rest, and on in equally dreamy drabble begins to list its legal-bound strata of side effects, including dream-driving, dependency, contemplation of suicide, and so on. Oblivious to such threats, the butterfly flits down to tuck the woman in. The enormous neon bug then wobbles off to some other nowhere, remaindering the house in much less light. Lunesta does not portend to hide its strange presence even in waking, where its chemic chalky aftertaste resides inside the mouth—a second breath fit over the day's breath. This

36 http://www.weirdasianews.com/2010/10/01/chinese-suicide-interrupted-sleep.

chronic flavor, at first terrible and in want of masking in early users, can become, in its familiarity, a waking residue, a pleasured thing, a sublime tang.

Lunesta dug into my blood. These I ate quicker, with the promise of more mostly when I needed. I packed the sample packets in the long drawer of the bathroom and counted them along the road, planning nights before I'd need more. Under this black banner, everything was fine. Perhaps still slower in my days, and of a gross kiss with the stink all on my gums, but when I lay down I could be down, and stay there. Good. I talked more out loud than I would normally. In the days I would find sentence fragments written on slips of paper, in folds of books, or on my hands. Things were remembered or they were not. The room I lived in had high ceilings, and in the nights the sounds of slamming doors and people shouting would bump around the night. In the pill there was the whir. My computer sat on my bedside desk, at all times watching, its beeping lights flecking the dark. I could turn it on or off. I heard its guts sigh. I got up and got down.

Each time I ran out of the samples, I would thereafter swear no more. Then I would spend the five nights between eating, screeching, sobbing. I would get another couple and feel okay again. The supply was not as deep as it had seemed. I would wait, or wonder, calling my friend with supplies, asking. Days knowing I wouldn't have an easy out to end it made halls in buildings seem to stretch a little longer, oddly colored—food might taste slightly off, or sound might seem more loud. Sometime two days deep in no pills I went to renew my vehicle at the county tag office, a massive building located in the heart of downtown, with no easy parking. Sidewalks to glass doors to escalators, same in day as in the night. Suddenly

I found myself sitting at the glass window talking through it to a large woman and I was supposed to give her my ID, and I couldn't find my ID, it was gone, and I have a ton of shit in my wallet and I was taking all of it out and sweating and talking to myself and my hand was bleeding as I'd cut it open somehow coming through the metal detector to get into the building, and the woman said, "Sir, you can take your time," and I was laughing and almost crying and my stuff was everywhere and I was sucking the blood out of my hand so it wouldn't drip and I looked at her and said something like, "God took my ID," and the woman didn't blink and the woman just watched me put my stuff back in my wallet and stand up and leave.

That same day, in the grip of desperation, I went to a local walk-in clinic, having been so long without a regular doctor that I didn't know where to begin. I weighed in in the lobby. I weighed more than I realized, in all my clothes. They took me to another smaller room in their room queue where I would need to sit and wait. A woman who was not the woman who could give me pills wrote down things about me. I told the story of my young sleep rot oncoming, and the things I'd done to no effect. She watched me, scribbled, offered questions. She left me in the room. Some time passed with sounds through walls therein repeating. Voices in the house. Voices from bodies also sick in their own ways, asking, needing answers, needing help. I felt funny in my body there in the small room waiting. I shifted places, sat on paper. I flipped through the spindle of magazines supplied to keep your mind attuned in passing time. The doctor came in without knocking. She asked the same questions there again. She looked at the page and wrote notes down. There we were. I probably fidgeted. I tried to sound right. After further stringing, checking my chest sound,

my holes and eyes, my frame, she told me she would give me a few more samples. Then I would need to see another doctor. She left the room. I waited more time. I tried to stretch some, seeing herein that the end to this light was coming soon. After this I would not need more pills, I decided. I would wean me off in rungs. This, a last door. A help to helping. Listen, I said to myself. The first nurse came back in quiet. She handed me a page, a bill. She left in quiet, left the door cracked. The paper said, "No Lunesta. Recommend Tylenol PM." I walked out unwatched from the office, feeling a further kind of air, sunk slightly deeper. Just past the front desk, where the new sick were, I did not argue, paid the bill. I stopped to piss in their men's room, talking to no one, my limbs reflected in the bathroom mirror in that light. There I was, me. There.

]

]

]

I never took the pills again. I don't know what I have been doing. Time since then has came and went—both in past tense. There have been people with their bodies and the hours and some food. I eat still and get tired. I run and smell the sound. Sometimes I sleep better. Sometimes the air inside my home and this bed's placement are conceived ill even just walking in the door. Days go by and by inside the body. The day begins again and ends again. The beginning often feels more like the end, while all the moments between then and the end itself feel more like nothing, though there is speaking, and there are buttons, and there are people, and there are rooms.

The waking sleep and sleeping wake feed on each other. Where neither ever fully is the either or the other or itself. This veil of space wedged between spaces. A series of selves circling a leaving self. As to each eye and mouth and tongue and body there connected, the brain flesh wrinkling again. Bound in that mother body, every hour spent around her, every word, the light of rooms where you have stood together, the things you did or did not say in return. A mode of intuition held in instance. A whole life contained inside one nod, one second walking in a night. Always still another house inside this house. All those holes as little portals, rooms where one might stop and lie or turn around. Where through any wall could be another person, mouth wide open, among weather, light, water, and time. An unseen corridor around our walking. The event of no event.

So what goes on then—what turns in turning, going on alone again surrounded. What is there inside the turning off and turning on among no center in no spin and the noise and the night and the hours going, all after something that by definition, in its want, cannot be had, where the question asks itself the same question as it asked. You go on because you do. You do because in doing nothing is the going—at death, the going—in every inch toward the end—where between each lobe of time there are the days, the shapeless language. The people in you are.

]

]

]

I go to get a glass of water. I'm watching my dad again today so Mom can go to quilt guild and get out of the house. Dad in time has gotten stranger, more far gone from knowing who or when or where he is or was. Around the house he walks and knocks on glass and punches his own hand, in endless iteration. He seems continually waiting for something to happen, though when things do happen, it's not the thing. In the late years of his life, he seems newborn in certain ways, definitionless, no longer knowing where to aim, though in his eyes and in the knocking and the skin around him, you can see that he has lived. None of this is his fault, or anyone's. It is days.

When I come into the kitchen, Dad is leaning on the kitchen counter. There are no lights on in the room, which in this day of muted sun seems dark even at noon.

"What's up?" I say. "What are you doing?"

"Lost," he says. He looks not directly at me, but off to something just beside. Like I'm standing next to myself.

"I'm the only one here," he says.

"Do you want something to eat?" I say.

"Nah, we don't need that," he says.

On the counter there's a bunch of loose-leaf paper. On the paper he's written numbers, his name, illegible words. I pick one up and he says it is his ticket.

"Ticket to where?" I say.

He says, "Right."

He walks across the room toward the door. The door is glass. The light comes through it. He knocks his fists against the glass and knocks and knocks. He hasn't held a key to a door in this house for a year now.

I touch his shoulder. He doesn't look. He rubs his hands together in strong fury. He punches one hand with the other. There is something there behind his face; something awake in his aging and erasing. He hits and hits and hits his hand against his hand.

I've said most everything I can ever think of to him in these moments. The house around us.

All words seem the same words.

I leave my father and the glass door and go and walk back down the hall. I come back into the room here where the desk is and I sit down at the machine. The house is quiet when he's not banging, beyond the low whir of the hard drive and the phones. I leave the door open so I can hear him. I look and look into the white space of this file. There are all these words here.

There is the blinking cursor, its forced command prompt, waiting.

I minimize the file and cross the room and close the door.

Back at the desk, in the web browser, I look at the sites I've already

likely refreshed several dozen times. I follow a link from one of the social networking websites to a video chat website.

I click a button to begin.

In the frame I am connected to the image of a gush of yellow glow inside some dark.

> Connected, feel free to talk now

Stranger: hi

[me]: u r a light?

Stranger: yea

Stranger: i m god

[me]: what should i do

> Your partner disconnected.

> Reconnecting . . .

I close the site and lie down on the floor.

Nowhere

In my head the light goes white. I'm lying face-up on a surface, the space above me full of flattened color. There seems no sound here. Another day here. The light continues. It is a gone light, feeding off of where it is. Through my whole fat head, a warming; blood moves; I think about my knees and feel my knees. A burr wakes in my brain inside the thinking and seems to move through my cerebrum down my neck, filling my chest up, threading in the chub around my ribs. Cold fireworks squirt along my lungs where I am again aware of breathing, around the shapes that make my sternum and the cellular walls vibrate all through my guts, my organs in transmission flipping, sizzled, then again in furied silence, as if erasing in their places, into pins along my stomach. I am awake again, and I am naked. I am in here again. Here is where.

Fed with the light the stretch marks on me where I was fat once begin to glow: tiny webs of slightly lighter skin trails like water

systems in a leaf packed in where I forced my flesh to spread be-
yond itself—my want for anything around me to live inside of solid
again burnt off, leaving the kiss of where it'd been—a pack of fat
of air always around me in my mind, holding the slur. I feel glow
move to curl through my intestines, colon, kidneys, to my sacs, the
harbored swill of multimillions that could each become another
man, become a son or daughter, though I cannot imagine—there
compacted, there to be burst into the light, gobs of me abandoned
in small rooms somewhere like all those years here I've made my
motions, though now again awake in here again, I never want to
move. If seen from elsewhere than my body, I imagine, the pattern
of my spreading cells would reveal their endless errors, their rash-
ness of wish and malnutrition and nights alone, and any billion
other catalogued evidence of how I've gone wrong or stupid, the
true conduit of sleepless nights, the true milk of what could never
feed me in how I've steered this body backward and in horror and
ill fit for any air, in the remembrance of nothing, in small pleasings.
Here again in here again in here.

Along my legs, the hairs are standing up, strobing the order of my
veins. A color I cannot smell or feel or see quite circles my kneecaps
in numbing silence, washing as with cloths along the inside of great
glass domes. I am thinking of saying something but I don't—I
can't think of what to say—no good words to fill the space of this
continuing instant I am aging in with—this awareness does not
stop the want. I breathe air in spreading see-through through me,
circling downward somehow to my heels and toes and soles, and
held in long breaths through my body, blood networking, lit and
lit with all this time burnt up in rooms and thoughts and want for
feed and time and typing. I'm supposed to sit up. The day is daying.
I am right here. I am me.

In a pinch between two blinkings I see my body from overhead—the way my mother says she saw the room the day when I was born, C-sectioned. I see my body bent and leaning, whole hosed and half-lit live into a flat white shape just at my head—like the sky sunk down to sit above me—endless ceiling. It's dry and wide. Me craning fully forward wet into it, up to my waist by neck and chest, my whole half of me there given unto the white, gone sealing, my body drank as would one into a vat of milk . . . and at the windows, a great seizure, a scattering of cells, which with their color, through the window, form fine pictures splashed against my brain: flesh of piglets, humans, goats, and geese; parades of bodies aiming through a blender, giving their limbs unto the night; a child large as the sky is; liquid money; where does this come from; why these letters; *you are all right. Against the shape of sky, body coursing, getting juiced of what I'm worth, giving unto the screen my private thinking, taking from it, and this is okay, the volume of the room in here filled with small prayer; in each inch another of me, asking, asking; want large as I am, large as ways; I open eyes inside the seeing and see again and open eyes again inside that seeing and can see again here nearer still, and open eyes again inside that, and inside that, the sky there disappearing in my skin . . .*

When I can see me clear again from there inside me I am sitting in the chair, the same I sit in almost every day, here with the machine. The room has shrunk against me. My shirt has been removed. All down my chest the drool erupts in runnels from my mouth. Where the wet is, my chest appears burned. Welts, like little windows, for how my flesh within them swims see-through. The machine's face stunned in all white, blowing. My arms against me cling. I cannot stand up inside this room again. I rub along the lash of it, the inseam, looking for where upon the air the boards will bend, or a

keyhole or some fissure. I sense my mother just behind me—hear her breathing, her certain tone—but in the reflection off the screen I see no one standing. This room again. The friction my fingers on the box's want makes sound—cues in a music in me booming, a subwoofer underneath my fat, tweeters in my testes—doorbells, ringing, stones—all in singing, come combined—songs spent threaded through my years, the days arranged in their unwinding, though herein replayed into me at once, all at the same time, blistering my blood—a song's song.

Something is writing words down on my back. I can feel the ink gun on my inches. Silent laughter. I try to turn around. My arms grind where my arms are. My spine itching in time to the song in shaking versions, instruments of air. In the box a slow heat rising. My hair clings to my hair, a kind of helmet. Where I turn the room makes sticky. Batches. More spit. I flub. A stink of warm all through my stuff. I settle down. I face the front, with eyes wide. I try to focus again on the reflection in the white. The screen is too wide. My eyes, too, stinging to get stood. My arm muscles clinging to my ribs.

In my lap, I see now, seeing, a book has been spread across my lap—a white book with a white spine and no title, in the shape of the white screen, as if it had been pushed out in a silence to sit upon me. I find around it I can move my fingers, held magnetic. My neck cocks my skull to face straight down. The book is humming, warm. Inside the front cover I find my name written in childish letters, inscribed. *This book belongs to* _____. Black crayon. No numbers.

The book's pages are all blank. I thumb through them finding no word. The paper bright against my eyes.

I turn back to the front. Where the crayon inscription of my young me before had been, there is now only a cursor at the margin, blinking, waiting:

]

I can hear the cursor think—can hear it waiting for me, making, in its image rerepeated, along the book's far edge, again, again.

]

]

]

The stutter of its light. Magnetic fire.

I go to put my fingers at the paper but my arms again are not allowed to move. The cursor. Inside my brain I hear it hear me think. It wants.

My words inside my head in shaping scrolling appear again inside the book, framed a command:

] **WHAT IS GOING ON**

I hear a sound—a click—within the nothing.

Below my line, another appears, scrolling across the book's page in quick marquee, words appear there in the book in set response:

You are in a room. This is where you have always been.

The words disappear each one as I read them—my input phrase as well sunk gone—and then there again the cursor, waiting, blinking in the none:

]

]

]

My hands do not look like my hands. My tongue flips in my head a little. I am sitting.

] WHAT AM I SUPPOSED TO DO NOW

You tell me.

I look around. The walls where there had been a room before have moved against me mostly, shaped to fit me in the air. There is a smoke pulsing behind the surface.

] I WANT TO LEAVE THIS BOX

You cannot. Not by saying. The air is hard.

The air is getting harder.

I still cannot move my arms. My brain inside me gaining heat to match the book's growing gloam of burn against my thighs.

] IS THERE A KEYHOLE HERE

You cannot see any keyhole.

] A KNOB

No.

] PASSWORD

You have to try.

Some coming word. *What is the word.* I ape to speak and nothing comes out. My mouthroof sticks to something welled up around my tongue. Through my eyes, I see nothing beyond the book's blown color. I feel my body spreading out around me, getting fat again with all the warm.

] SAY MY NAME

Your voice enters a hole.

] SAY MY MOTHER'S NAME, MY FATHER'S

There is nothing.

A puddle in me runs—organ to organ, a shake like laughter.

Then, from overhead, inside myself, I feel something lurch: nails just as the white flat fold that forms the sky here, inches from my skull. In pads the scratching piles in packs as dogs do after some-

thing buried. I try to shout, again: the taste of leather. Money. Ashes and clean knives. I go again to try to say my mother's name and feel it hum hard in my neck.

Overhead the light is piling. Windows in the light.

Inside the scratch, the cursor replicating.

]

]

]

]

]

] **MAKE IT STOP**

]

]

]

]

] **PLEASE STOP**

]

]

]

] **OK HOLD ON**

] **LISTEN**

I close then open up my eyes. I squeeze my self inside me. No think.

The words come spooling out.

] THE DAY YOU FELL WHILE PLAYING BASKET-
BALL IN THE BACKYARD WITH YOUR FATHER
AND BLAMED THE ACCIDENT ON HIM, SAID HE'D
PUSHED YOU, SO YOU'D LOOK LESS DUMB IN
FRONT OF YOUR FRIENDS, SO YOU DID NOT HAVE
TO BE THE ONE WHO FELL: INVENTING BLAME.
HIM WET-EYED IN THE DARK LIGHT THAT THERE-
AFTER, THE ONE TIME YOU CAN REMEMBER WIT-
NESSING HIM IN TEARS, OVER HOW HE DID NOT
UNDERSTAND QUITE HOW TO REACH YOU.

The scratching above and below me becomes doubled. Close then
open up my eyes.

] THE DAY YOU AND THOSE FIVE OTHER KIDS SUR-
ROUNDED DARRELL ON THE PLAYGROUND IN THE
MUDYARD AND KICKED HIM BY TURNS IN THE
CHEST. YOU WENT ALONG AND LAUGHED AND
DID NOT THINK. HIM CENTERED IN THE BRIGHT

WHITE SHAKING. THE AIR LOST IN HIS BODY. HIS
COVERED EYES.

] THE DAY YOU SHOOK YOUR SISTER BY HER WHOLE
FRAME ON THE SOFA, UNDERNEATH THE PIC-
TURES OF YOU SOMEONE ELSE HAD DRAWN, FOR
HOW SHE'D GONE INTO YOUR ROOM AND COPIED
MUSIC, THE SONGS FED INTO HER HEAD, YOUR
SHUTTING DOORS, YOUR GREED, AND WHY NOW
WHEN IT COMES UP NOW SOMETIMES YOU PRE-
TEND IT NEVER HAPPENED.

] THE NEON BLUE KEY YOU STOLE FROM A HARD-
WARE STORE IN FLORIDA AND WERE QUICKLY
CAUGHT, THAT YOUNG AND ALREADY SO UN-
GRACEFUL, THE KEY BURNING IN YOUR HAND
SOMEHOW FOREVER AFTER.

] THOSE HOURS FED INTO MACHINES, TYPING
BULLSHIT FOR THE NOTHING, NO GIFT, TURN-
ING OFF IN WAYS FROM THOSE MADE NEAR AS IF
IN SPITE, KNOWING IN THE KNOWING OF THE SI-
LENCE YOU WERE HIDING. FROM WHAT. FROM
WHAT. FROM WHAT.

] THE WAY EVEN TODAY MOST DAYS YOU SPEAK TO
THOSE YOU LOVE: FLAT, IMPATIENT, STUBBORN IN
SILENCE: AND GOING ON WITH SUCH A WAY EVEN
IN RECOGNIZING, FEELING TIME END, ALLOWING
DAYS TO PASS INSIDE OF DAYS, COUNTING OFF THE
HOURS THEY WILL BE BESIDE YOU, DOWN TO NONE.

] EVERY THING YOU DID AND DID NOT DO, AND HOW YOU NEED IT, CLUNG TO GUILT WITHOUT A NAME.

] EVERY BOOK YOU'VE READ AND CAN'T REMEM-BER, LIKE A PRISON, HIDDEN WALLS AROUND YOUR HEAD. ALL THOSE INSTANTS BURNING OFF ALREADY UNREMEMBERED. FOR WHO.

] EVERY HOUR IN SUCH WANT OF NO DIRECTION.

The book in my lap has grown large. It is larger now than my whole lap. Its face is kind of milky. Around my head, wrapped. Around my backmeat. The still blank book feeds its response:

> In the room you cannot see. The sound of scratch has filled all sides here. It fits underneath your skin. A small pockmark of light appears inside your vision, jostled as you sneeze—something snaking in you, raking. You sneeze and sneeze again.

> As you sneeze the point of light expands to crust the blank air. The scratch so loud you cannot hear it. Holographic.

> There is a flat before you now. A floor.

] WALK ALONG THE FLOOR

> The floor is built of mirrors. It replicates the sky. As you move you can see yourself stretched underneath you, and so in the sky too. Onto and underneath yourself you walk.

] HOW OLD AM I INSIDE THIS IMAGE

The floor begins to incline. Your leg muscles ache with bulbs. The sky is building light. The light burns in time with the muscles, making putty around your blood. It hurts.

] **STOP WALKING FORWARD**

Your legs move faster.

] **I SAID STOP IT**

The itch is underneath your tongue. You still can't hear it, but the spit flows. Flowers blooming, on the mirror's edge and in your hand. When you look they will not be there.

In the light ahead, a form.

] **EXAMINE FORM**

It is long and it is nothing.

] **. . .**

You continue toward the form.

] **I'D RATHER NOT, PLEASE. I'D LIKE TO STOP NOW**

As you go even closer, the form has edges. It has a top and bottom. Has a front, a wall without a door.

The form, *you think,* is mottled.

You are not wrong.

] THAT IS NOT ME WHO THOUGHT THAT, THAT WAS YOU, I DON'T THINK THE FORM IS MOTTLED, I WOULD NOT SAY THAT. AT LEAST LET ME HAVE MY HEAD. I WANT TO FEEL GOOD. I WANT TO BE KIND.

The form reminds you of somewhere you have been.

There is an awful texture to the air here.

The mirror underneath you does not glow.

] TURN AROUND

. . .

] I ASKED PLEASE TURN AROUND

You are now standing right beside the form. It is smaller than you imagined, from the distance, and in how you recalled it from before.

The surface of the wall still shows no hole, no stutter. The sky has filled in on you, from behind. There is no inch or leak of where you just walked, or elsewhere forward. Above, below, so too—all mirror, which when touched won't shudder. Flat. Forever.

There are many houses, all around you, breathed in crushed upon the air.

] TOUCH THE MIRROR HARDER

Gone.

] TOUCH THE FORM

It's warm. A color appears, a wash around your head. Pops in small collision. Rashy. A fuzz that disappears, unfurls, repeals.

] SPREAD THE COLOR

Under your fingers, breathing, the form becomes a home. It is a long, cream-colored ranch-style dwelling with a lawn that appears dead.

All the bikes you've ever ridden are buried underneath the lawn. All the phones you've called in from are again calling. There is no sound. There is the hair you've grown and cut off of you in the years wove to a necklace that you wear around your neck. If you look down to see the necklace it will disappear. Your fingernails are very long now. Your heart is purple. Someone watches from behind.

There are still no doors or windows in the home's face, though you can hear a rattling inside. A smoke burst from the upper quadrant's corner, forming a column to the sky. A little ladder. Soft and risen.

] CLIMB THE LADDER

The ladder's end starts somewhere else.

] ENTER HOME

There is no entrance to that from here either, not that you can see.

] YOU ARE PISSING ME OFF

The home continues in this condition.

Blood is running from your name. All the bruises you have in-curred have returned here, on your new skin. They compile the inches into old form. You ooze. Where you can see you from inside your skull, you appear the same as you do to you now any day.

In the mirror surfaces, you see now how the house continues rep-licated in each direction, end to end, and on and on. Countless houses. Countless you. And all that glass . . .

Inside the house, something is trembling.

] DOES ANYTHING JUST HAVE DOORS HERE

Every inch.

] OPEN ANY OF THE DOORS

The trembling inside makes the walls wet. They stick to where your bruises sting, pocking the fresh parts with dust and fiberglass and crummy bits.

The pictures on the walls inside the house's front room have curled. The quilts hung along the long, dark hallway sunken back into the walls. The walls, like your heart, are purple, though they are turning. The wires frying in the frame. Every sound inside the house that's ever happened is happening again in the surround, all at once so loud it feels like nothing.

] LOOK AT THE PICTURES

They are all mottled. There are bits of eyes and bits of lips or but-tons, walls, but mostly the splotch is impossible to gather.

] GO DOWN THE HALL

Your body, near the pictures, refuses to move. It wants you there, to stay and wait beside the pictures for them to reconfigure, to ad-here from the slur into a sense. The days. The color surface. Your blood is runny. You're losing balance.

] STARE INTO THE PICTURES HARDER

Burble.

] EAT THE PICTURES, STICK THEM TO MY SKIN

The pictures won't come off the walls. They're affixed with some-thing deeper than metal.

] BREAK THE SEALANT

No.

You can't.

Do something else.

] FUCK, I CAN'T THINK, THERE'S TOO MUCH NOISE HERE

. . .

] THIS JUST FEELS LIKE ANY OTHER DAY. FEELS
LIKE A WEBSITE, IN A BOOK HERE. HOURS.

. . .

The cursor goes on winking in my skull.

]

]

]

In my lap the shape is burning, it is so warm.

]

]

]

Against the blank my head floods with an itching.

] THE COLOR OF MY MOTHER'S HAIR WHEN SHE
WAS MY AGE; WHEN SHE GAVE ME BIRTH; WHEN
SHE WAS BORN.

] THE SOUNDS OUR DOGS UNDERSTOOD ABOUT US,
SEEING. SLEEPING IN THOSE ROOMS; THE WORDS

WRITTEN ON THEIR RIBS.

The home begins to lean.

] THE KEYS I DID NOT LOSE, BUT DRANK INTO ME
IN FEAR OF NEVER FINDING THE RIGHT DOOR. MY
FATHER'S WANT FOR KEYS NOW TO A CAR HE CAN'T
DRIVE, TO A HOUSE HE CANNOT LEAVE.

] THE GROUND THIS HOUSE WAS BUILT ON, WHO
HAD WALKED UPON IT, WHO PRAYED, WHERE
THEY HAVE GONE; THE GROUND OF THE HOUSE
BESIDE THIS HOUSE, AND THE HOUSE BESIDE IT.
THE GROUND.

] HALLWAYS PARALLEL TO THESE SAME HALLWAYS
IN THE HOUSE WITH THE PICTURES FACING PIC-
TURES, MAKING SIGHTLINES IN GRIDS ACROSS
THE AIR ABOVE THE GROUND, VIVISECTING ALL
THE WANT INTO UNIQUE LOCATIONS, ASSIGNED.

] THE AIR WHERE ANYONE WAS BORN: BASEBALL,
KISSING, CANDLES, CRANES, ALL THAT AGELESS
SHIT LIKE PYRAMIDS INSIDE OF BUILDINGS, IN-
SIDE OF LIGHT.

] TWO PHOTOGRAPHS OF WHITE ON WHITE IN
EVERY HOME, TWO NAMELESS CITIES STRETCHED
INSIDE THEM, WAITING.

] THE LENGTH OF MY HAIR NOW, AND MINUTES

LATER, DECADES LATER. MONTHS AS DAYS, DAYS AS YEARS REWINDING AND REBEGINNING

] TODAY'S DATE TODAY

] THE MIRROR JUST BEHIND THE MIRROR

] WANT OF

]]

The home is bubbling. It gives a smoke.

] PRESS UPON THE HOME NOW WITH MY BODY

Where you press, the surface mumbles up a slip: a small divot in the flat's face, bending inward. You press your arms harder, teeming in—the house above you, rolling forward on its gait. Your form appears in the wall's far side, an indention. The roof becoming your roof. The sun of light becoming gone. You press and press until you find yourself slipped in the middle of the walls' meat, a space surrounding years where you have been. In the slip of the house the sweat and song and eggs of roaches and the aggregate of breathed-out air has formed a mass—a crystalline and glowing substance which in the space, into your head, glows a sound. The sound rubs the memory of where you're from even further into your blubber. You turn around.

You turn around again.

The room appears: a small room absent of all light.

As you look again, having remembered, the room becomes the den inside the house where you grew up: it holds the smell now of all the foods inside it eaten, all the bathwater, all the gush. There seems to be no air, though you can breathe.

You are in the room where several years you built another house inside it, out of bedsheets, out of books; the room where your father gave you a speech on reproduction; the room where a dot matrix printer has returned now, ejecting pages.

] READ THE PRINTING

You pick a sheet out of the spool. The sheet is covered up with nothing. No words, though the printer makes a screaming sound as if beating each page full of ink.

The white seems to be shifting.

In the room behind you, someone moves.

] HELLO

There is no one in the room.

There is a window, through which you see rain fall hard upon a yard, dotting the pool you almost drowned in, becoming drunk into the ground. It is briefly mesmerizing: you feel a pang for drinking meat. You chew your knuckle. The curtains rumple.

Further murmur from the far end of the house.

] FOLLOW THE SOUND

From the den you move into the living room where nights your mother and father watch TV. The chair leg where in running from you your sister fell and burst her head open, gushed into the light. If there is one room around which your life could be said centered, this is likely it. None of these people you remember are in this room now.

The furniture in this version of the room has been removed. A tiny house sits where the TV used to, another light inside it.

As soon as you see the house, breathe its screaming, you forget that it is there.

You will remain here for your entire life, no matter where else you think you go.

] FOLLOW THE SOUND

From the living room into the kitchen, recreated of its food—all the food you've ever eaten there inside it, pressed in, ejecting through the roof. The cereal and turkey dogs and diet soda and peanut butter rise into some small point far above, a cylinder unto the black point hanging over all things in the sky. You breathe the air and taste it, your body blubbing quickly with new fat, the calories herein recycled gaining mushmeat on your cheeks and arms and ass. The more you inhale here—in this room where days in the sink your mother washed your hair, where you would come and go into the night surrounding—the harder it is to push on.

The only thing not gathering dimension in the eating is your head.

Inside your head, the chain of commands aching, blinking, typing into or therefore out from some other, smaller machine:

]

]

]]

]]]

]]]]]

]]]]]]]]

]]]]]]]]]]]]

And therein, underneath each:

]

]

]]

]]]

]]]]]

```
] ] ] ] ] ] ]

        ] ] ] ] ] ] ] ] ] ] ]

        ] ] ] ] ] ] ] ] ] ] ] ] ] ]
        ] ] ] ] ] ]
```

Inside the sound your body goes on growing—and in the skin more made.

```
                        ] ] ] ] ] ] ] ] ] ]
                        ] ] ] ] ] ] ] ] ] ]
                        ] ] ] ] ] ] ] ] ] ]
                        ]

                        ] ] ] ] ] ] ] ] ] ] ] ] ]
                        ] ] ] ] ] ] ] ] ] ] ] ] ]
                        ] ] ] ] ] ] ] ] ] ] ] ] ]
                        ] ] ] ] ] ] ] ] ]

                     ] ] ] ] ] ] ] ] ] ] ] ] ] ] ] ] ] ]
                     ] ] ] ] ] ] ] ] ] ] ] ] ] ] ] ] ] ]
                     ] ] ] ] ] ] ] ] ] ] ] ] ] ] ] ] ] ]
                     ] ] ] ] ] ] ] ] ] ] ] ] ] ] ] ] ] ]
                     ] ] ] ] ]
```

]]]]]]]]]]]]]]]]]]]]]]]]]]]]]
]]]]]]]]]]]]]]]]]]]]]]]]]]]]]
]]]]]]]]]]]]]]]]]]]]]]]]]]]]]
]]]]]]]]]]]]]]]]]]]]]]]]]]]]]
]]]]]]]]]]]]]]]]]]]]]]]]]]]]]
]]]]]]]]]]]]]

]]]]]]]]]]]]]]]]]]]]]]]]]]]]]]]]
]]]]]]]]]]]]]]]]]]]]]]]]]]]]]]]]
]]]]]]]]]]]]]]]]]]]]]]]]]]]]]]]]
]]]]]]]]]]]]]]]]]]]]]]]]]]]]]]]]
]]]]]]]]]]]]]]]]]]]]]]]]]]]]]]]]
]]]]]]]]]]]]]]]]]]]]]]]]]]]]]]]]
]]]]]]]]]]]]]]]]]]]]]]]]]]]]]]]]
]]]]]]]]]

]]]]]]]]]]]]]]]]]]]]]]]]]]]]]]]]]]]
]]]]]]]]]]]]]]]]]]]]]]]]]]]]]]]]]]]
]]]]]]]]]]]]]]]]]]]]]]]]]]]]]]]]]]]
]]]]]]]]]]]]]]]]]]]]]]]]]]]]]]]]]]]
]]]]]]]]]]]]]]]]]]]]]]]]]]]]]]]]]]]
]]]]]]]]]]]]]]]]]]]]]]]]]]]]]]]]]]]
]]]]]]]]]]]]]]]]]]]]]]]]]]]]]]]]]]]
]]]]]]]]]]]]]]]]]]]]]]]]]]]]]]]]]]]
]]]]]]]]]]]]]]]]]]]]]]]]]]]]]]]]]]]
]]]]]]]]]]]]]]]]]]]]]]]]]]]]]]]]]]]
]]]]]]]]]]]]]]]]]]

And under each again again beginning . . .

<div style="text-align: right;">]</div>

And therein, and so on . . .

Soon you cannot see the room around you.

Soon the room is any room.

] FOLLOW THE SOUND

From the kitchen [fat] *into the hallway, down the center of this book. Down the center of the books this book wants inside it, wants as second flesh.* [the endless flesh] *The walls here, felt up close against your fattened body, are made aggregate ends of each book's paper, spine to spine. The friction makes little rips along your cushion, leaving wet upon the walls: wet of sweat and blood and self-gunk, lathering the seam. Leaking back out of your new shape-size. Mushing up the books. Between the web of walls where you are come from, your sopping leaves a film behind you on the frame, a bubble mirror glowing at the light behind your body, sealing off the way—though you can still see there, in refraction, all the bodies, all the space—your mother, father, sister, unborn brothers, all those loved in bodies on the air there, clustered in the quickly splitting lenses, their eyes broke up in spit-spins, and behind them too, a further on—each context of body there behind them, watching, their own mothers, fathers, sisters, brothers born and those unborn, and theirs loved also, and the others in them, kaleidoscopic, countless eyes. The prism of them splintered through you, held in the past sections of the house, that where you can no*

longer throttle, even in shrinking, for what is gushing in the way,
and thereby breaking in the hour where you try to think or nudge
or say, popping open into magnets where the space was, wolfing
air. It's such a song, that false silence—at once dissolving in its
way—at once becoming again, another room, an instant eaten,
into the next instant eaten, so on unto the hole.

And still, the sound around you, louder here now in the center of
the house, where in mirror to the globe of wet behind you, blur-
ring, further doors open a way.

The pictures of you on the wall, hung on the book's ends, show you
again getting older, though not as old as in this way. The shape of
any face of any picture not the one that you are wearing as you see
them in black poses, recostumed constantly with age. Even in the
way the glass over each picture shows you you inside there, looking,
the time between the seeing and the see.

] **FOLLOW THE SOUND**

The first door along the hall is your first bedroom, with no surface
windows in it, as had hid you from the light. Overhead, a skylight
looks for something: though outside the sky is flat and unrelenting:
more stupid paper. This room, too, has been filled full, not with
junk or selves or food, but air—the air breathed in while you were
sleeping, so thick you can't fit through the frame. The air appears
at first as if you could go right in, but when you press against the
space is hard—the room does not want you in it. It sticks to your
skin where you come bumping, caged like glass and very warm.
Among the glass the hour gleaming, gone hours hoarded, silent. It
eats the wet out of your eyes—a spiraled putty threading through

*into your skull where those same hours have been hidden, waking,
barking, until again you turn around . . .*

*The hallway, there again, has become split into several, broken
up along the light inside the residued refraction of the glass room
held—though at certain angles, as with eyes closed, you still see
only one hallway made there again inside the house—in the man-
ner of any day's procession—you go on.*

*At the hall's end there are three doors. Of the doors, where they focus,
two of them are closed, their seams walled off and sealed in, fit flush
on the house. One, you recall, where you sister grew up at night be-
side you, walls between the two, shared air, her own body somewhere
else now, sealed in or removed from the immediate surroundings,
where you knew her best; your shared blood's age; the other, where
your parents slept the evenings, breathing through their bodies into
a cloud above the bed, and doors therein, beyond the bed, leading
elsewhere, surfaces around holes into the ground. Behind each of
these doors, a breathing music, so loud it does not occur.*

*The third room, left wide open, emits an awful rattled hum: a
noise unto itself and almost scratching like stuck records, teeth on
teeth. You feel a spasm hit your jaw—a screaming in your fingers,
in your nostrils, in your lungs—words wanting out to fill and
match the absence: nothing.*

Your nose and eyes and ears are gushing blood now.

] **FOLLOW THE SOUND**

Through the third door, there is a darkness. Awash under a stink.

As you come through the door closes behind you. Then there is no door. All you can see here are the mirrors licked with low glow on both sides of where for all those years there was the bed—the bed you slept through well beyond puberty, half a bunk set, the other half of which was never used—as if a twin had been meant to be in it and you waited—the twin forever in an absence and alive. This same bed where you saw the boulder and learned to not sleep and so would listen to the nothing, your skin around you tight. Here the bed does not appear but in those mirrors, reflected back and forth between the two. Where the bed should be to make the image, another darkness, deeper, bending.

You go to lie down on the bed despite its absence. You stretch your arms and legs into the space where it had been and you go flat. Your brain flashes alive with words hid in a book here nowhere beside you—about how once the body has become horizontal it is impossible to knock down.

The darkness holds your size. It smothers at you, through your appendages and sternum, knowing how you go. Knowing the inches, and the holes where, and the latest cells, which it takes off. It unwraps you gently, turning over, taking bit by bit what you remain—placing silence where the words are. The more you want the more it gives you—the less need for a name.

Upon the bed, loosing and hungry, the sound so loud it seems a silence rises, muddied in counted years. It burns your ears with its impression, sudden, though it never was not there, and the ache of where it hits against your skin, in knowing, is a pleasance. Is a rowing. Is a wall. It deletes the house around you. There is no house. There is a light.

In the light, another person appears standing.

] FOLLOW THE LIGHT

As you approach, still horizontal, still in the darkness, lying down, you see that instead of standing the body is seated. Instead of facing you, it remains facing away. The light around the skull and shoulders of the person is not a sun, a bulb, or a horizon. It spills forth from a machine. An oblong screen around this other body, around this turned head, still, framed in gleam.

The speed of your approach, as you grow closer, quickens, as would disease. As would time when time is needed. As would any wanting.

In the light there you are there there.

]

You are me.

You are seated, stuck, before this machine, feeding you color. Your fingers forced against some buttons, sticky, unlabeled. This machine drinking from your body, an offering unto the light surrounding light surrounding. Your arms are heavy, older than ever. In your flesh, absence of sound.

You can hear, you think, the slew of rooms you came through somewhere behind you, still there, squashed and wanting in. Those several someones watched and washing, behind, by now, so many doors. Though, for each insistence of that age of sound, on

the glowing screen, the machine responds—its blinking cursor in eternal question, replicating in and of, around you, filling each inch with its own speech: each tender toning still a cursor, in iteration, made to wait.

]

The cursor blinks on and off on some horizon. Blown up and tiny, in the heart of some long want—as commencement of an ending—of some endless, nameless name.

]

Among the light you sit inside our body.

Among the white you start to type.

ACKNOWLEDGMENTS

Deepest gratitude and thanks to my editor Cal Morgan, without whom this book would not exist; to Carrie Kania and Bill Clegg, for the constantly amazing support and faith; to the entire tireless Harper Perennial team, particularly Gregory, Justin, Milan, Erica, Michael, and Brittany; to my family and home friends; to everyone at HTMLGiant and my internet friends and internet-flesh friends and sleep-people and the unreal; to so many who've been so kind.

SOURCES

American Psychiatric Association. *Diagnostic and Statistical Manual of Mental Disorders (DSM-IV)*. 4th ed. Washington, DC: American Psychiatric Association, 1994.

Ascher, L. M., and David E. Schotte. "Paradoxical Intention and Recursive Anxiety." *Journal of Behavior Therapy and Experimental Psychiatry* 30, no. 2 (1999): 71–79.

Bachelard, Gaston. *The Poetics of Space*. New York: Beacon Press, 1994.

BaHammam, Ahmed. "Polysomnographic Characteristics of Patients with Chronic Insomnia." *Sleep and Hypnosis* 6, no. 4 (2004): 163–68.

Barnes, Djuna. *Nightwood*. New York: New Directions, 2006.

Barthelme, Donald. *Sixty Stories*. New York: Penguin, 2003.

Basta, Maria, George P. Chrousos, Antonio Vela-Bueno, and Alexandros N. Vgontzas. "Chronic Insomnia and the Stress System." *Sleep Medicine Clinics* 2, no. 2 (2007): 279–91.

Beckett, Samuel. *Stories and Texts for Nothing*. New York: Grove Press, 1994.

Bonnet, M. H., and D. L. Arand. "Hyperarousal and Insomnia: State of the Science." *Sleep Medicine Reviews* 14, no. 1 (2010): 9–15. doi:10.1016/j.smrv.2009.05.002.

Borges, Jorge Luis. *Collected Fictions*. New York: Penguin, 1999.

Brackman, Roman. *The Secret File of Joseph Stalin: A Hidden Life*. New York: Routledge, 2001.

Brown, John. "Bloodletting in Headache with Insomnia Due to Congestion of the Brain." *The British Medical Journal* 1, no. 992 (1880): 13–14.

Cage, John. *Silence: Lectures and Writings*. Cambridge, MA: MIT Press, 1970.

Calvino, Italo. *If on a winter's night a traveler*. New York: Harcourt Brace, 1981.

Carson, Anne. *Decreation: Poetry, Essays, Opera*. New York: Knopf, 2005.

Cioran, E. M., and Jason Weiss. "An Interview with Cioran." *Grand Street* 5, no. 3 (1986): 108.

Cocteau, Jean. *The Art of Cinema*. London: Marion Boyars Publishers, 2000.

Colten, Harvey R., and Bruce M. Altevogt, eds. *Sleep Disorders and Sleep Deprivation: An Unmet Public Health Problem*. Washington, DC: National Academies Press, 2006.

Cortázar, Julio. *Cronopios and Famas*. New York: New Directions, 1999.

Daumal, René. *Mount Analogue*. New York: Overlook, 2004.

Deleuze, Gilles. *Cinema 1: The Movement-Image*. Minneapolis: University of Minnesota Press, 1986.

———. *Difference and Repetition*. New York: Columbia University Press, 1994.

——— and Félix Guattari. *A Thousand Plateaus: Capitalism and Schizophrenia*. Minneapolis: University of Minnesota Press, 1987.

DiPiro, Joseph T., Robert L. Talbert, Gary C. Yee, Gary R. Matzke, Barbara G. Wells, and L. Michael Posey, eds. *Pharmacotherapy: A Pathophysiologic Approach*. 6th ed. New York: McGraw-Hill, 2005.

Douchet, Jean. *Nouvelle Vague*. Paris: Hazan, 1998.

Foucault, Michel. *Discipline and Punish: The Birth of the Prison*. 2nd ed. New York: Vintage, 1995.

———. *History of Madness*. New York: Routledge, 2006.

Gailly, Christian. *Red Haze*. Winnipeg: Bison Books, 2005.

Goldberg, Harriet. "The Dream Report as a Literary Device in Medieval Hispanic Literature." *Hispania* 66, no. 1 (1983): 21–31.

Goldsmith, Kenneth, ed. *I'll Be Your Mirror: The Selected Andy Warhol Interviews.* New York: Carroll & Graf, 2004,

Göransson, Johannes. *Dear Ra.* Buffalo, NY: Starcherone Books, 2008.

Gove, Walter R. "Sleep Deprivation: A Cause of Psychotic Disorganization." *The American Journal of Sociology* 75, no. 5 (1970): 782–99.

Hammond, William A. "Insomnia and Recent Hypnotics." *The North American Review* 156, no. 434 (1893): 18–26.

Harvey, Allison G., and Emmeline Greenall. "Catastrophic Worry in Primary Insomnia." *Journal of Behavior Therapy and Experimental Psychiatry* 34, no. 1 (2003): 11–23.

Hejinian, Lyn. *The Fatalist.* Richmond, California: Omnidawn, 2003.

Hillman, James. *The Essential James Hillman: A Blue Fire.* Edited by Thomas Moore. London: Routledge, 1990.

Hufford, David J. *The Terror That Comes in The Night: An Experience-Centered Study of Supernatural Assault Traditions.* Philadelphia: University of Pennsylvania Press, 1982.

Iranzo, Alex, Carlos H. Schenck, and Jorge Fonte. "REM Sleep Behavior Disorder and Other Sleep Disturbances in Disney Animated Films." *Sleep Medicine* 8, no. 5 (2007): 531–36.

Kant, Emmanuel. *Critique of Pure Reason.* New York: Penguin, 2008.

Kellerman, Henry. *Sleep Disorders: Insomnia and Narcolepsy.* New York: Brunner/Mazel, 1981.

LaVey, Anton. *The Satanic Bible.* New York: Avon, 1976.

Leger, Lawrence A. "An Outcome Measure for Thought-Stopping Examined in Three Case Studies." *Journal of Behavioral Therapy and Experimental Psychiatry* 10, no. 2 (1979): 115–20.

Levinas, Emmanuel. *God, Death, and Time.* Stanford, CA: Stanford University Press, 2000.

Lispector, Clarice. *The Passion According to G.H.* Minneapolis: University of Minnesota Press, 1988.

Mack, John E. *Nightmares and Human Conflict.* Boston: Houghton Mifflin, 1974.

Mahgoub, Nahla A. "Insomnia and Suicide Risk." *The Journal of Neuropsychiatry and Clinical Neurosciences* 21, no. 2 (2009): 232–33.

Marcus, Ben. *The Age of Wire and String.* 2nd ed. Champaign, IL: Dalkey Archive Press, 1998.

Markson, David. *This Is Not a Novel.* Berkeley, CA: Counterpoint, 2001.

Massumi, Brian. *Parables for the Virtual: Movement, Affect, Sensation.* Durham, NC: Duke University Press, 2002.

Mendelson, Wallace B., Thomas Roth, James Cassella, Timothy Roehrs, James K. Walsh, James H. Woods, Daniel J. Buysse, and Roger E. Meyer. "The Treatment of Chronic Insomnia: Drug Indications, Chronic Use and Abuse Liability." *Sleep Medicine Reviews* 8, no. 1 (2004): 7–17.

Montgomery, Iain, Graham Perkin, and Deirdre Wise. "A Review of Behavioral Treatments for Insomnia." *Journal of Behavior Therapy and Experimental Psychiatry* 6, no. 2 (1975): 93–100.

Morin, Charles M. *Insomnia: Psychological Assessment and Management.* New York: The Guilford Press, 1993.

Pressman, Mark R. "Disorders of Arousal From Sleep and Violent Behavior: The Role of Physical Contact and Proximity." *Sleep* 30, no. 8 (2007): 1039–47.

Proust, Marcel. *Swann's Way.* New York: Viking, 2003.

Rao, Madhu N., Terri Blackwell, Susan Redline, Marcia L. Stefanick, Sonia Ancoli-Israel, and Katie L. Stone. "Association Between Sleep Architecture and Measures of Body Composition." *Sleep* 32, no. 4 (2009): 483–90.

Roth, Eugene F., Jr., Inge Lunde, Gudrun Boysen, and Inge Kemp Genefke. "Torture and Its Treatment." *American Journal of Public Health* 77, no. 11 (1987): 1404–6.

Sartre, Jean-Paul. *Being and Nothingness: An Essay in Phenomenological Ontology.* New York: Citadel Press, 2001.

Somerville, W. F. "High-Frequency Currents for Insomnia." *The British Medical Journal* 1, no. 2522 (1909): 1063–64.

Sparling, Ken. *Dad Says He Saw You at the Mall.* New York: Knopf, 1997.

Stearns, Peter N., Perrin Rowland, and Lori Giarnella. "Children's Sleep: Sketching Historical Change." *Journal of Social History* 30, no. 2 (1996): 345–66.

Stone, Geo. *Suicide and Attempted Suicide: Methods and Consequences.* New York: Carroll & Graf, 2001.

Strong, Stanley R. "Experimental Studies in Explicitly Paradoxical Interventions: Results and Implications." *Journal of Behavior Therapy and Experimental Psychiatry* 15, no. 3 (1984): 189–94.

Sukenick, Ronald. *The Endless Short Story.* Victoria, TX: FC2, 1986.

Thao, Vu Phuong. "Vietnam Man Handles Three Decades Without Sleep." *Thanh Nien Daily,* February 14, 2006.

Thorpy, Michael J., and Jan Yager. *The Encyclopedia of Sleep and Sleep Disorders.* New York: Facts on File, 1991.

Van de Laar, Merijin, Ingrid Verbeek, Dirk Pevernagie, Albert Aldenkamp, and Sebastiaan Overeem. "The Role of Personality Traits in Insomnia." *Sleep Medicine Reviews* 14, no. 1 (2010): 61–68. doi:10.1016/j.smrv.2009.07.007.

Vincent, Norah, and Samantha Lewycky. "Logging on for Better Sleep: RCT of the Effectiveness of Online Treatment for Insomnia." *Sleep* 32, no. 6 (2009): 807–15.

Warhol, Andy, and Pat Hackett. *Popism: The Warhol Sixties.* New York: Harcourt Brace, 1980.

Webb, Ethel. "How To Overcome Insomnia." *The American Journal of Nursing* 20, no. 1 (1919): 12–14.

INDEX